STEAM
AROUND LEEDS

1

MIKE HITCHES

To Sandra and Richard

First published 2010

Amberley Publishing Plc
Cirencester Road, Chalford,
Stroud, Gloucestershire, GL6 8PE

www.amberley-books.com

Copyright © Mike Hitches, 2010

The right of Mike Hitches to be identified as the Author
of this work has been asserted in accordance with the
Copyrights, Designs and Patents Act 1988.

British Library Cataloguing in Publication Data.
A catalogue record for this book is available from the British Library.

ISBN 978 1 84868 446 1

Typesetting and Origination by FONTHILLDESIGN.
Printed in Great Britain.

CONTENTS

Introduction 5

1 Leeds Lines 11

2 Bradford and Halifax 46

3 Wakefield 107

4 Around Huddersfield 136

5 Leeds Locomotive Builders 151

6 The Preservation Story 175

Acknowledgements 192

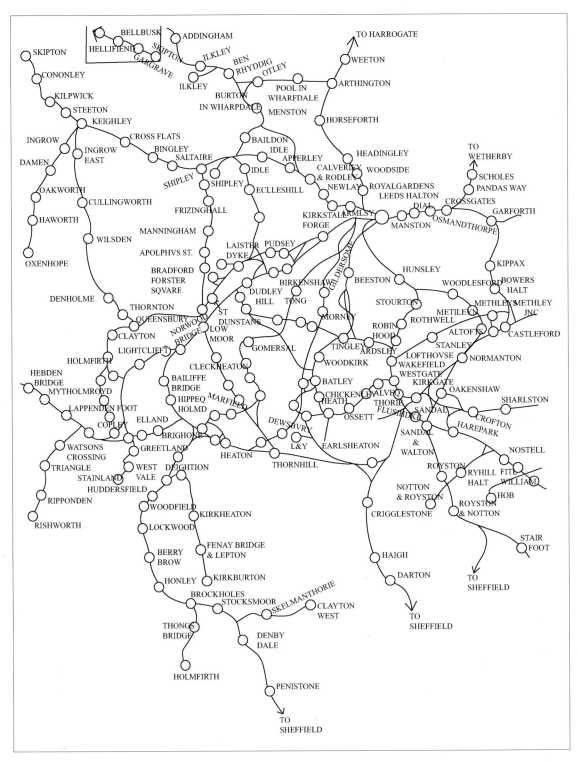

A map of the complex railway system around Leeds and the West Riding of Yorkshire in steam days. (Author)

INTRODUCTION

Already established as the centre of woollen cloth manufacture since the sixteenth century, Leeds and the West Riding of Yorkshire were destined to be very important to the fledgling railway companies as they fought to develop profitable networks in the north of England. The first line to serve the city was the Leeds and Selby Railway, opened in 1835, which was built to improve the link between Leeds and the seaport at Hull. This new line terminated at Marsh Lane, east of Leeds parish church, and was at the foot of a steep gradient, which would later create problems for heavy freight trains. As if to prove the success of this new form of transport, the line carried some 100,000 passengers in its first year of operation.

While the Leeds and Selby Railway was under construction, a proposal had been made for a railway between Leeds and Bradford in 1830. Although this proposal was destined to fail in its original form, its very conception shows how important the woollen industry was to this area of Yorkshire. One Thomas Horfall of Bradford argued that the town consumed some 24,917,877lbs of wool in 1822, increasing to around 33,279,245lbs by 1829, and 43,736,386lbs of wool in 1830. This 'long wool' was used in the manufacture of worsted cloth. By 1819, steam power was used in the manufacture of cloth in Bradford, generating around 492 horse power; this had increased to 1047 horse power by 1830. Locally mined coal was used to generate the power, bringing another source of revenue for the railway companies. As the industry grew, the population of Bradford grew from 7,767 in 1811 to 13,064 by 1821, and the estimated population in 1830 was upward of 70,000.

The wool supplied to the cloth mills came from north and west Yorkshire, as well as places as far afield as Lincoln, Nottingham, Leicester, Staffordshire, Cambridgeshire, Warwickshire, Northamptonshire, Rutland, Norfolk, Suffolk, Kent and Sussex, all coming via Leeds. Wool from Gloucestershire, Shropshire, and counties on the west coast came via Halifax, mostly by the Leeds and Liverpool Canal, which had opened in 1816, and delivery was often delayed due to ice and frost in the winter and water shortages in the summer. Some wool was carried overland by horse and cart from Selby, at a price of 7s 9d per ton carriage from Leeds, and only 50 tons could be carried in this way per week. The cost per annum for overland transport would be in the region of £1000.

Other evidence suggests there was a rapid expanse in travel as Bradford grew. Indeed, toll roads had shown increases in traffic between 1820 and 1830. Tolls paid in 1820 amounted to £4,725, increasing to £9,415 in 1830. Some thirty-two road coaches, carrying around 300 passengers, passed daily between Leeds and Bradford in 1830.

A railway between Leeds and Bradford was finally approved on 4 July 1844. It also allowed for provision of a new Wellington station in Leeds, along with a connection with the North Midland Railway at Hunslet, which had opened on 1 July 1840 and linked Leeds with Derby. The NMR had its own station at Hunslet Lane,

later becoming a goods yard. Before the L&B had been completed, a new Leeds and Bradford Railway Act of 30 June 1845 allowed construction of a line from Shipley to Colne, across the Pennines, with a branch to Haworth.

When the L&B opened on 20 June 1846, a general holiday was announced in Bradford for the event and a train of fifteen carriages from the Midland Railway, the York and North Midland Railway, and other railway companies left Leeds for Bradford at 1.14 p.m., with another soon after. On board were George Hudson, the famous 'Railway King', the board of the L&B, the Lord Mayor of York, and the Mayor of Leeds. A banquet took place in Leeds at the Music Hall with the 'Railway King' presiding. Public traffic began the following day, 1 July, although there were, as yet, no intermediate stations. The L&B was later absorbed by the Midland Railway and became one of its busiest branches.

George Hudson had become chairman of the York and North Midland Railway when it was formed in 1839, to connect with London–Leeds lines at Altofts Junction, just north of Normanton. However, in the following years, he leased the Leeds and Selby Railway so that he could close most of it to passengers and force them to make a longer journey via his own Y&NMR. He was assisted in his ambitions because shares could be bought in large numbers to allow construction of new railways, and only be partly paid for as a deposit. This meant that markets could be 'rigged' by artificially pushing share prices up or down depending on whether parties wished to buy or sell (sound familiar?). Insider dealing was not uncommon; Hudson encouraged his 'friends' to buy shares in the Leeds and Selby Railway, obtaining a 6 per cent interest on the remaining call, knowing that the remaining balance would not have to be paid for another eighteen months. Therefore, Hudson had a strong influence on the Leeds and Selby. All of these goings-on gave Hudson control of railways between the West Riding, York, and the Humber. He then struck north, taking control of lines through Darlington and Newcastle. All of these companies would eventually merge, along with the Leeds Northern Railway, to form the North Eastern Railway in 1854.

Hudson also stretched his empire south westward by winning the chairmanship of the North Midland Railway in 1842. He immediately cut wages, and when some engine drivers protested, they were sacked on Christmas Eve and replaced by such people as Stonemasons, a Platelyer, a Fireman, two unemployed drivers previously dismissed for drunkenness, and another who had overturned thirty wagons down the side of an embankment. Although Hudson was only influential due to his association with a number of railway companies, he did bring about the formation of the Midland Railway in 1844 by the amalgamation of the North Midland Railway with the Midland Counties and Birmingham & Derby Junction Railways, all of which met at Derby. The new company had a strong presence in the West Riding and North Midland areas.

Although strongly opposed by Hudson, there was much pressure for a direct railway route from York to London and, in 1846, the Great Northern Railway obtained an Act and proceeded to construct its line from Askern, north of Doncaster, to London. From Askern to York, the route crossed the Lancashire and Yorkshire Railway to a junction with Hudson's Y&NMR near Knottingley. Although Hudson would have blocked any attempt by a rival company to reach York via the Y&NMR in previous years, the GNR succeeded because Hudson's financial reputation was being questioned at various company meetings. Indeed, in 1849, it emerged that shares in the Eastern Counties Railway had been kept artificially high by paying dividends out of capital rather than profits. When these dealings were exposed, confidence in the 'Railway King' collapsed and his influence faded away.

Having established a line from London to York, the GNR struck out west and became involved with the Leeds, Bradford and Halifax Junction Railway; a working

agreement was reached between the GNR and Lancashire & Yorkshire Railway in 1854. Eventually, the GNR and LB&H were amalgamated under an Act of 1865. The GNR also had routes from Wakefield to Ossett and Batley, opened in 1864, and the Doncaster Company also took control of the Bradford, Eccleshill and Idle Railway, along with the Idle and Shipley Railway in 1875, giving the GNR a strong influence in the West Riding.

The Lancashire and Yorkshire Railway was an early influence in the development of the railway network in the West Riding; the Manchester and Leeds Railway was formed in 1825 to construct a line east of Manchester, over the Pennines into Yorkshire. The line was projected to follow traditional routes, avoiding the open moors and following a twisting course through two valleys, through Rochdale and Littleborough to the summit, and then descend to Todmorden into the Calder Valley. It would then run alongside the river until reaching Wakefield, where it would run north east to Normanton and connect with the North Midland Railway.

This choice of route led to conflict with the Rochdale Canal Company, and for five years disputes between the L&M and Canal Company were fought out in parliament. It would not be until 4 July 1836, that the L&M obtained its Act for construction. It took another five years of strenuous work, employing thousands of navvies, to build the line through the terrain. The line finally opened in 1841. From this point, the Lancashire & Yorkshire Railway, as the M&L became, expanded rapidly, and had lines to Halifax, Bradford, Huddersfield, and, of course, Leeds. The L&YR even had a presence as far afield as Goole and Hull in the East Riding.

The L&YR, however, had competition between Manchester and Leeds in the form of the London and North Western Railway. The LNWR had absorbed the Leeds, Dewsbury, and Manchester Railway, which had received its Act in 1845, along with the Huddersfield and Manchester Railway and Canal Company on 9 July 1847. The LNWR and NER later obtained powers to enlarge Leeds New station on 28 July 1891. Thus, by the end of the nineteenth century, five railway companies, the NER, GNR, MR, L&YR, and LNWR, were serving the railway transport needs of Leeds and the West Riding, no doubt, very profitably. In 1922, the L&YR and LNWR were merged. All of these companies displayed their own styles of station architecture. Locosheds, along with locomotives and rolling stock, provided a great variety in design and liveries within Leeds and the West Riding.

The early years of the twentieth century were to be a 'golden era' for the railway companies as this was the only real means of fast travel for both passengers and freight, at a time when there was full employment and plenty of exports to the empire and beyond. However, dark clouds were gathering, culminating with the outbreak of the First World War, 'the war to end all wars', in August 1914. Great social and economic change was on the horizon; the railways, along with many of the great British industries, would be affected, and the process of adjustment would be painful. As Britain stumbled into the Great War, the then Foreign Secretary, Sir Edward Grey, commented prophetically, 'the lamps are going out all over Europe and they will not be lit again in our lifetime.' This was certainly true as the nation encountered one calamity after another in the coming years, particularly regarding the railway. It could still be argued that, for the railways, those lamps are still waiting to be lit.

Prior to the outbreak of war, a Railway Executive Committee had been formed in 1912 to take control of the railways in times of need, and this was certainly a time of need. Indeed, in eight days of August 1914, some 60,000 men, along with 22,000 horses and 2,500 guns, with attendant equipment, passed through Southampton, all brought by the railways; the flow continued until the job was completed. Thus, the railways had proved their worth. Of the 600,000 staff who worked on the railways in 1914, some 30 per cent joined the forces, with women taking over many railway roles

(first steps towards feminism perhaps), although shortages of staff were to continue throughout the war. There were reductions in passenger services through the war, and travel was discouraged, although not many passengers took much notice. Demands on the railways continued to increase as constant movement of men and war material to and from theatres of war brought about 'wear and tear' on the system. When the Armistice was signed in November 1918, the railways remained under State control until 15 August 1921. The government did pay grants to the railway companies, but only slowly and nowhere near what it would cost to bring the railways back up to pre-war standards. In fact, only £60 million was paid out, to be shared among all 130 railway companies.

During the war, there had been calls for nationalisation of the railway system; central control had shown the benefits of standardisation and rationalisation of the railways. However, the government of the day was opposed to complete State control in peacetime, but could see advantages in wholesale amalgamation, this being embodied in the 1921 'Railways Act'. Thus, 120 railway companies were formed into four groups, the change taking effect on 1 January 1923. In anticipation of such a change, the L&YR merged with the LNWR in 1922. With these amalgamations, the West Riding was served by two new companies, the London, Midland, and Scottish Railway, made up of the LNWR/L&YR and MR, and the London and North Eastern Railway, made up of the NER and GNR. The other new groups were the Great Western Railway and the Southern Railway, neither of which had any interest in the Leeds and West Riding areas. Unfortunately, this 'grouping' came at a time when the nation lurched into its next crisis, this time an economic one, which was to mark the 1920s and 30s as the 'hungry years', brought about by financial collapse and a slump in export markets, bringing mass unemployment. Leeds and the West Riding were badly affected as the textile and coal industries felt the serious effects of decline, which, in turn, would cause significant loss of revenue to the railway companies.

Economic problems began early in the 1920s as the government attempted to return to the Gold Standard after the war. This brought about deflationary policies at a time when foreign trade was depressed and unemployment began to increase. Employers of the day thought that rising unemployment would make it easy to cut wages from the high wartime levels. Indeed, it was estimated that wage rates for Britain's 12 million workers had been reduced by £5 million per week between 1921 and 1925. This decline cut demand for domestic goods, thereby reducing production further with consequent loss of railway traffic. Attempted reductions in wage rates brought about industrial conflict. When textile employers issued notices of wage reductions on 24 July 1925, there were 'lock-outs' in the mills lasting for three weeks, involving between 135,000 and 170,000 workers.

The coal industry was also affected by wage cuts. There had been a coal strike by Yorkshire miners in July 1919, railway workers also went on strike in the same year, which was followed by 'lock-outs' on 15 April 1921, when the mines were handed back to the owners after the war and pay cuts were implemented. There were further threats of strike action by the miners in July 1925, when coal owners abolished the minimum wage and cut pay by 10 per cent. To prevent strikes, the government paid a subsidy to the owners which lasted nine months, while a commission investigated. When this subsidy stopped and owners gave notice of wage reductions on 30 April and 1 May 1926, it led to the General Strike, which ran from 3 to 12 May. The Trades Union Congress offered sympathetic support, and railway workers joined the dispute. In Yorkshire, all coal areas and textile towns such as Halifax, Huddersfield, and Skipton, along with many others, supported the strike 100 per cent. Large towns like Bradford, Leeds, and Wakefield offered less support.

While the miners stayed out from the end of April until November, other workers drifted back into their employment. Railway workers, in particular, were victimised by employers and forced to sign documents indicating their intention to leave their unions. This must have been particularly galling in Leeds, where ASLEF had set up its first registered office in the city at Sweet Street in 1881, having been founded a year earlier.

Effects of the economic depression were deeply felt in the West Riding textile industry, an area which had never been an industrial blackspot, and employment levels were low. Such were the effects of the depression that between 10 and 25 per cent of the textile workforce were unemployed in the 1920s. Markets disintegrated between 1929 and 1932 as the woollen industry went into structural decline; figures show that there were 206,000 people employed in textiles in 1922, reduced to 184,000 by 1939. Many of the problems in the industry were due to lack of investment in modern technology, post-war inflation and loss of export markets, and, often, subsidised foreign competition. Unemployment in textiles peaked at 25.3 per cent in 1931 (at the depth of the depression), from 24 per cent in 1930 and 13.9 per cent in 1929. The unemployment rate reduced to 20.8 per cent in 1932, and only dropped below the 1929 rate in 1935, when unemployment ran at 12.9 per cent, reducing to 10.1 per cent in 1936. Mining suffered worse effects; overall, the unemployment rate was running at 41.2 per cent in 1932, reducing to 22 per cent in 1939.

Effects of unemployment and the economic depression were felt on the railways; the LNER and LMS had not paid a dividend to shareholders during the 1930s. Worse was to come, however, with the outbreak of World War Two, when the railways had not made adequate revenue from passenger traffic and freight. Even though the companies had run excursion trains from the West Riding to places like Blackpool and Scarborough during the summer months, these were often at a loss. Indeed, by 1938, some 85 per cent of passenger receipts came from reduced fares, compared with 34.4 per cent in 1924. Revenue from freight was severely affected by the depression as well as competition from road hauliers, not least because lorry owners could undercut railway tariffs for highly rated goods, while, as 'common carriers', the railways were obliged to carry empty packing cases at the lowest rates, so they lost in both ways.

The outbreak of war brought the railways back under State control from 1 September 1939. For the first four days of the month, children were evacuated from places like Leeds, which, like many other cities, was seen as a potential target for air raids, to the relative safety of the seaside or country. Passenger timetables were substantially reduced and train speeds were slowed to reduce maintenance requirements; all to free up the system for the transit of troops and military equipment. The 'phoney war' of 1939 to spring 1940 allowed train speeds to increase to 75 mph and the railway even scheduled Whitsun excursions. However, invasion of the low-countries by Germany and the evacuation at Dunkirk put paid to that. From that point on, the railways came under ever increasing strain, first from the 'blitz', and then from great increases in freight traffic. Along with these problems, an increasing loss of staff, due to National Service and reductions in maintenance, left the system in an increasing state of disrepair. By the time the war was over in 1945, the railways were in a dilapidated state and there was little finance available to bring the system back up to pre-war standards. Although theoretical wartime traffic earnings were over £176 million, the government took the lot and did not compensate the railways sufficiently for enemy bombing damage. Even if the railways had been given adequate financial resources, post-war reconstruction of the system would have been given low priority in the queue for scarce raw materials; the British railway system had not suffered as much damage as those of mainland Europe, and reconstruction was needed elsewhere. At the same time, there was a huge post-war flow of road transport to compete with the worn out railways.

An incoming Labour government, elected by a landslide in 1945 and committed to nationalisation of key industries, brought about State control of the railways under the 1947 'Transport Act', despite opposition from the companies. On 1 January 1948, the new British Railways was born. Leeds and the West Riding became part or the London–Midland Region, covering the old LMS network, the Eastern Region (the old GNR), and the North Eastern Region (the old NER), with its headquarters at York. Despite the development of diesel and electric traction elsewhere in the world, the new BR committed itself to a continuation of steam traction, extending its life into the 1960s, introducing new BR 'Standard' types alongside existing LMS/LNER machines in the West Riding. However, things were about to change with the publication of the 1955 'Modernisation Plan', which envisaged the wholesale scrapping of steam power and its replacement with electric and diesel traction. Motivation for change was due to the perceived 'dirty' nature of the steam railway, which created problems with recruitment of staff to the industry at a time of full employment in modern factories. This was compounded by falling passenger numbers due to the 'scruffy', old fashioned, and dirty image of the railways, along with ever increasing private car ownership. The new BR did, however, enjoy something of a 'boom' during the summer months of the 1950s, as holidays with pay created a demand for seaside destinations (before the advent of package holidays abroad), and the railways operated special Saturday trains from the West Riding to coastal resorts and holiday camps during holiday weeks and weekday excursions for day trippers. But this 'boom' was short lived, and by the end of the 1950s the railways were in trouble. Outside urban areas, new diesel multiple units could not attract enough passengers away from buses and private cars to cover running costs. Freight was also losing business to the roads. Between 1958 and 1962, there was an upsurge in heavy freight road vehicles: a 60 per cent increase of lorries over 3 tons unladen weight, and nearly 50 per cent of 5 tons or more, and they could operate door-to-door traffic. Thus, between these years, while volume of freight transport increased by 13 per cent, the share of railway traffic fell by 12 per cent.

Perhaps the most significant event in railway history was the publication of Dr Beeching's infamous 'Reshaping of British Railway' report, which marked over 5,000 route miles and some 2,350 stations as hopelessly uneconomic, advocating their closure. Closures in the West Riding were not new; the old GNR line from Keighley to Queensbury Junction had closed in 1955, and Keighley also lost another branch with the closure of the line to Oxenhope in 1962. The Beeching report also forced closure or the Holmfirth and Meltham branches, and the line from Huddersfield to Penistone was downgraded to a secondary route; its closure has been threatened ever since. Perhaps the most important closure was Leeds Central station, shut in 1967 as traffic was centralised on a completely rebuilt Leeds City station. Almost at the same time, steam traction disappeared from Leeds and the West Riding as modern diesels took over all railway traffic, ending steam motive power, which had lasted for a century and a half.

In writing this book, I hope I have recreated the days when the steam locomotive was the only form of motive power, and the railways were the most important means of travel. As the different companies competed for trade in Leeds and the West Riding, many trains operated in this part of Yorkshire, hauled by so many different locomotive types. I hope I have recalled the days when it was fun to travel by train, when the population headed to the seaside in the summer for a well-earned holiday. I hope that this book is as enjoyable to read as it has been to write.

ONE

LEEDS LINES

Nowadays, the centre of Leeds is served by one major railway station, Leeds City, but this was not always the case. Due to disagreements between the railway companies which served the city in the mid nineteenth century, Leeds was left with three stations in the city centre, each with varying facilities, and none with distinguished architectural features. They all served the many suburban stations within the city limits and beyond, as well as express trains to other areas of the country.

The only terminus station was Leeds Central, which was the property of the Great Northern Railway and the London and North Western Railway. The early years at Central were rather difficult, although an Act of Parliament of 22 July 1848 confirmed an agreement for joint use of the station by the GNR, Leeds and Thirsk, Leeds and Dewsbury (later to become part of the LNWR), and Leeds and Manchester (becoming a future part of the Lancashire and Yorkshire Railway). The GNR first arrived in October 1849, but vacated Central in May 1850 for its own station at low level, due to the fact that its trains had to reverse at Geldard Junction. The GNR finally returned to Central when it obtained direct access due to its involvement with the Bradford, Wakefield and Leeds Railway. The LNWR also had a presence at Central, with three platforms by 1854. Another two platforms were used by the L&YR.

When the GNR returned to the main Central station in 1857, platforms were shared equally. The LNWR, however, decided that it needed more space, but the other two companies had no desire to invest in and develop a larger station. As a result, the Euston Company looked elsewhere for a better location. In only a short period of time, an opportunity presented itself through involvement with the North Eastern Railway.

Once difficulties between the railway companies had been resolved, Central operated passenger services to London (King's Cross), over the GNR East Coast Main Line, Manchester and Liverpool, over L&YR metals, and local services to Bradford and Wakefield, along with towns in the West and North Ridings of Yorkshire. Despite transferring its operations to its new base in 1869, the LNWR kept a presence at Central through its Joint Station Agreement of the Leeds & Dewsbury Railway, 1848, although it was down to a token one train a day.

George Hudson's York and North Midland Railway had been investigating the possibility of a more direct route from the east and into their own station in the centre of Leeds from the early 1850s. When the North Eastern Railway was formed in July 1854, a survey was undertaken which would take the railway from Marsh Lane to a new station, which was to be built in the centre of town, over a viaduct bringing the line most of the way. Parliamentary powers were sought. The plan, however, meant much demolition in the centre of Leeds, and the viaduct would have passed right through the main commercial district. This brought numerous objections to the scheme, forcing the withdrawal of the 'New Station' Bill in 1864. Only a few days later, a new Bill was presented which proposed a new station on the south side of the Midland Railway's

Wellington station, opened in 1850, with connections to the other company's lines at the west end. This meant that the line from Marsh Lane would run over a shorter viaduct and would not pass through any part of Leeds' commercial centre. This plan was accepted by Leeds residents who wanted a new station anyway, but not at the cost of damaging the city centre to the extent or the original NER plan.

It took two Bills to put the scheme into operation: one for the new railway from Marsh Lane, and the other for the station. Both received Royal Assent in July 1865, the 'New' station opening for traffic on 1 April 1869. All of the railway companies operating in Leeds had been approached by the NER prior to presenting its Bills, but only the LNWR showed any interest in investing in the new project. The Midland, who were unhappy to be next to the new station, opposed the scheme with venom, while the GNR and L&YR expressed contentment with Central. While building work was ongoing, care was taken not to encroach on to adjoining MR property, but part of the MR roundhouse locoshed was in the way of the station approach from the west, and the land was required by the contractors. The MR accepted an offer of purchase by the NER/LNWR, but negotiations were slow and the land with the roundhouse was finally sold in May 1868. Work then proceeded without further problems. Once Leeds New station was opened, the NER and LNWR kept themselves apart, each having their own platforms. Through services between the two companies were unknown until the late 1890s, when through trains from Liverpool and Manchester were operated to Newcastle-on-Tyne and Hull, via Leeds.

The other station in the centre of Leeds was the Midland Railway terminus at Wellington, opened in 1850, replacing a temporary station which had been in use since 1846. Although of no architectural merit, it was on a prime location in the city centre, with its frontage opening out into City Square. The station was built mostly on a series of bridges, some of which crossed the River Aire as it turned south from the east, through the centre of Leeds. The approach to the station from the west was over a two track main line, which spanned the Leeds and Liverpool Canal, and into a station complex consisting of eight tracks serving four platforms, for trains to Bradford, Liverpool and other parts of the West Riding and Lancashire, along with services to London, York, Hull, and Newcastle. When the Settle–Carlisle line opened in 1876, the MR began operating Anglo-Scottish expresses via Leeds, although trains had to be reversed at Wellington. Other services out of Wellington included trains to the south west of England, via Sheffield, Derby, Birmingham, and Bristol, along with services to Lancaster for ferries to Ireland, and to the seaside at Morcambe.

In 1863, the MR built the Queen's Hotel opposite Wellington station frontage. It was extended four years later, and remained as such until 1937, when it was replaced by a new structure on a different site, slightly west and north of Wellington station.

Following the 'Grouping' of 1923, commercial and civic leaders told directors of the LMS and LNER that they were less than satisfied with the state of their Leeds termini, not least the situation that led to trains from Lancashire running into two different stations some half a mile away from each other, resulting in confusion. It was also pointed out that facilities at Wellington were very poor, having, according to Mr Bruce, President of the Chamber or Commerce, 'the worst station facilities and comforts for passengers of any town with a population over 100,000 in this Country.'

The LNER Chairman, at a meeting on 5 June 1925, reacted coolly, saying that the collapse in trade in 1924 had led to the LMS/LNER paying over £4 million less than shareholders were entitled to receive under the Railways Act. However, by 1935, work commenced on physically joining Leeds New and Wellington stations (no doubt costs were being partly borne by central government, who subsidised capital costs on railway projects under its 'Guarantees Act', in an effort to find work for the unemployed affected by the Great Depression). Most of the work entailed constructing a new

concourse for the Wellington side (City North), which was to link New (City South), along with a new 200 bedroom Queen's Hotel. Most of the £700,000 allocated to the project was spent on the hotel (nearly £500,000). The concourse at Wellington was completed with ticket, booking, and parcels offices. A new office block for 400 railway staff was also built alongside, with a 270 seat cinema created beneath. This new station was renamed Leeds City when opened to passengers on 2 May 1938.

In 1952, following nationalisation, a plan was drawn up to amalgamate passenger services into one station, based on a rebuilt Leeds City station. Powers were obtained in 1959 for the full 'concentration' scheme. It would take a further fifteen years before the rebuilt station was officially opened by the then Lord Mayor, Alderman J. S. Walsh, on 17 May 1967. The financial restraints of the late 1950s and early 1960s caused many delays and demanded an amendment of the 1959 scheme, to reduce costs from £4.5 million to £2.75 million. Construction of a multi-storey office block was started in May 1961, and would dominate the site of the new station and require the partial demolition of the old train shed. It was completed in October 1963. Known as 'City House', the office block was leased to BR by owners Taylor-Woodrow. Despite objections, Leeds Central station closed in April 1967 as traffic was concentrated at the new Leeds City station, which continues to provide passenger services to the people of Leeds to the present day.

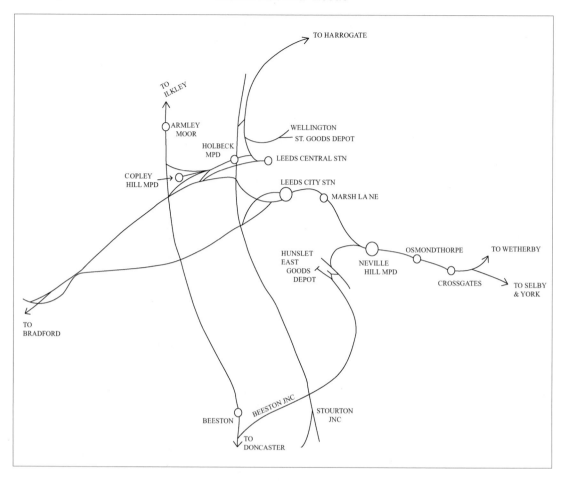

A map of the main lines in Leeds showing the location of the locosheds, which supplied motive power for trains operating out of the city by pre-grouping railway companies. (Author)

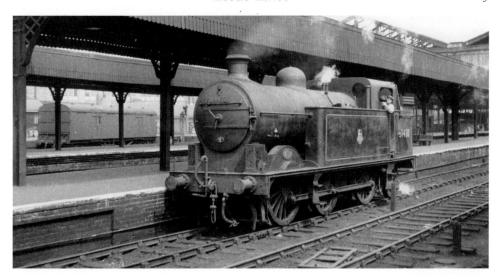

Leeds Central station platforms in 1956 with ex GNR N1 class 0-6-2T no. 69430 on pilot duties. By this time, Central station was in quite a poor condition and only basic maintenance work had been carried out after the takeover by British Railways. Surveys done at this time suggested that all platforms needed lengthening, the station concourse was not large enough, and there was poor access from the street. The roof also needed repair, which was estimated to cost some £100,000, car parking was poor, staff amenities did not exist, and the whole complex needed re-signalling. The repairs and improvements were expected to cost a total sum of £1½ million. Unfortunately, the roof was virtually non-existent and the poor passengers had very little shelter when the weather was inclement. However, by 1958, some 2.5 million passengers passed through Central station as new DMU trains were introduced; an increase of around a million on the previous year when steam had the monopoly. To provide motive power serving trains out of Central station, the GNR provided a locoshed at Copley Hill. This five road shed had an allocation of thirty-nine engines in 1950, reduced to thirty-three by 1959. This 1959 list included ten A1 pacifics among its allocation. Coded 37B when coming into BR (ER) ownership, it was transferred to the North Eastern Region and became 56C in 1956. The shed closed in 1964, three years before Central station itself. An early 1950s shed allocation is as follows:

Ex LNER A3 pacific	60044 *Melton* 60046 *Diamond Jubilee* 60056 *Centenary* 60062 *Minoru* 60112 *St Simon*
Ex LNER A1 pacific	60114 *W. P. Allen* 60141 *Abbotsford*
Ex LNER B1 4-6-0	61295
Ex GNR 0-6-0 J6	64173, 64250, 64260
Ex GNR C12 4-4-2T	67353
Ex GNR J50 0-6-0T	68913, 68978, 68984
Ex MS&LR N5 0-6-2T	69266, 69271
Ex GNR N1 0-6-2T	69430, 69436, 69437, 69439, 69440, 69444
	TOTAL: 23

(R. Carpenter)

L·N·E·R STREAMLINE TRAINS

MONDAYS TO FRIDAYS (will not run Friday 29th July to Monday 1st August inclusive)

"THE CORONATION"

Average throughout speed 65.5 m.p.h.
Accommodation limited to 210 passengers (48 First Class, 162 Third Class).

			p.m.				p.m.
King's Crossdep.	4. 0	Edinburgh (Waverley)	...dep.		4.30
York ,,	6.40	Newcastle ,,	6.33
Newcastle ,,	8. 0				
Edinburgharr.	10. 0	King's Crossarr.	10.30

Connecting trains at Edinburgh, Newcastle and York.

"THE SILVER JUBILEE"

Average throughout speed 67.08 m.p.h.
Accommodation limited to 183 passengers (58 First Class, 125 Third Class).

			a.m.				p.m.
Newcastledep.	10. 0	King's Crossdep.	5.30
Darlington ,,	10.42	Darlingtonarr.	8.48
			p.m.				
King's Crossarr.	2. 0	Newcastle ,,	9.30

Connecting trains serve Tyneside and Tees-side.

"WEST RIDING LIMITED"

Average throughout speed between Leeds and London 67.9 m.p.h.
Accommodation limited to 210 passengers (48 First Class, 162 Third Class).

			a.m.				p.m.
Bradforddep.	11.10	King's Crossdep.	7.10
Leeds ,,	11.31	Leedsarr.	9.53
			p.m.				
King's Crossarr.	2.15	Bradford ,,	10.15

Connecting trains at Leeds.

SUPPLEMENTARY FARES (for each single journey).

	1st Class	3rd Class
	s. d.	s. d.
London and Bradford	4 0	2 6
London and Darlington	5 0	3 0
London and Edinburgh	6 0	4 0
London and Leeds	4 0	2 6
London and Newcastle	5 0	3 0
London to York	4 0	2 6
Newcastle and Edinburgh	3 0	2 0
York to Newcastle	3 0	2 0
York to Edinburgh	4 0	2 6

Seats can be reserved in advance through any of the Company's Passenger Agencies or Stations.

A 1930s advertisement for LNER streamlined expresses operating between King's Cross, Leeds, and Bradford, along with such services to Edinburgh and Newcastle. These trains were usually hauled by Gresley's A4 pacifics and were all Pullman stock. Along with these trains, following BR ownership, new prestige expresses were introduced, including *The West Riding* and *The White Rose*. Such trains were hauled by A4, and A3 pacifics, followed by Peppercorn's A1 pacifics. During the 1948 Locomotive Exchanges, several express types from other regions began to appear at Central station. From the London–Midland Region came Stanier 'Duchess' pacific no. 46236, *City of Bradford*, and 'Royal-Scot' class 4-6-0 no. 46146, *The Rifle Brigade*; the Western Region supplied 'King' class 4-6-0 no. 6018, *King Henry VI*; and the Southern Region sent 'Merchant Navy' pacific no. 35017, *Merchant Marine*. As a prediction of the future, Western Region also supplied diesel railcar no. W20W, which operated trials between Leeds and Harrogate. (Author)

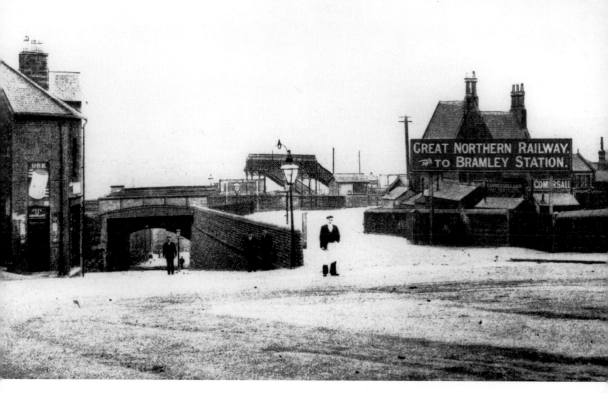

Bramley station, seen here in the early twentieth century, was on the GNR line from Leeds Central to Bradford. The station and tunnel below are still in existence and are very well kept. Indeed, apart from increases in road traffic and changes in various structures, there is little difference between this view and the modern station entrance. (LOSA)

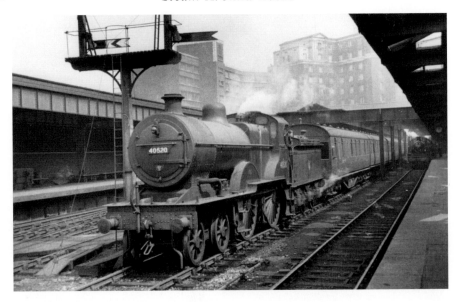

Passing through the old MR Leeds Wellington station (now part of Leeds City) is ex MR 2P 4-4-0 no. 40520 of Hellifield (20G) shed, with a local service to its home town in 1956. With the opening of the Settle–Carlisle line in 1876, the Midland began operating its Anglo-Scottish expresses through Leeds, but trains had to be reversed at Wellington. At first, this was a useful lunch stop, but as competition from LNWR and GNR increased, the MR gave up the lunch stop and accelerated turnaround times at Wellington. Despite efforts of the Derby Company to try to improve its Scottish services, including plans to build short sections of track from Wellington to Armley to avoid reversal, nothing came of it and trains were still reversed at Wellington. (R. Carpenter)

Table 23 — EXPRESS SERVICES BETWEEN LONDON, MANCHESTER, LEEDS and BELFAST via Heysham

To BELFAST

	Friday nights until Sept. 8th incl. pm	Monday to Friday nights pm / pm / pm	Saturday nights pm / pm / pm	Sunday nights July 16th to August 27th incl. pm / pm / pm
London (Euston) dep	4 55 / 6B5 / 8 4 / 9 5 / 9 42	4 40 / 5B45 / 8 6
Birmingham (New St.).. .. ,,	6B5		5B45
Crewe ,,	8 4		8 6
Manchester Victoria ,,	9 .5	9 .5	9 .5
Bolton (Trinity Street) ,,	9 25	9 25	9 29
Chorley ,,	9 44	9 44	9 49
Preston ,,	9 28 / 10 6	10 6	10 13
Leeds (City) dep	8 10			8 45
Bradford (Forster Square) .. ,,	7E40	9A10	9A10	8A45
Keighley.. ,,	8 39	9 55	9 55	9 23
Skipton ,,	8 56	10 11	10 11	9 42
.......... arr	10 15	10F15 / 10 59 / 11 21	10 59 / 11 21	10 15 / 10 54 / 11 10
Heysham dep	11 40 pm (Fri.)	11 40 pm	12 25 am (Sun.)	11 40 pm (Sun.)
Belfast (Donegall Quay) arr	7 0 am (Sat.)	7 0 am	8 0 am (Sun.)	7 0 am (Mon.)

From BELFAST

	Friday nights until Sept. 8th incl.	Monday to Friday nights am / am / am	Saturday nights am / am / am	Sunday nights July 9th to August 27th incl. am / am / am
Belfast (Donegall Quay) .. — .. dep	9 40 pm (Fri.)	9 40 pm	9 40 pm (Sat.)	9 40 pm (Sun.)
.. arr	5 0 am (Sat.)	5 0 am	5 0 am (Sun.)	5 0 am (Mon.)
Heysham.................. dep	5 35	5 55 / 6 10 / 6 30	7 0 / 7 30 / 8 5	5 55 / 6 10 / 6 30
Skipton arr	6 57	7 10		7 10
Keighley.. ,,	7 12	7 28	10 38	7 28
Bradford (Forster Square) .. ,,	8A16	8A16	11E27	8A16
Leeds (City) ,,	7 43	7 56	11 12	7 56
Preston arr	..	6 56	8 26	6 56
Chorley ,,	..	D	D	D
Bolton (Trinity Street).. .. ,,	..	7 45	8 47	7 45
Manchester (Victoria) ,,	..	8 9	9 28	8 9
Crewe ,,	8 38	9 10	8 38
Birmingham (New Street) ,,	10B46	11B 5	10B46
London (Euston) ,,	11 40	12p45	11 40

A—Change at Skipton.
B—Change at Crewe.
C—Change at Stafford and Crewe.
D—Stops to set down passengers from Belfast on notice being given to guard.
E—Change at Keighley.
F—On Friday nights arrives Heysham 10.30 pm.
RC—Restaurant Car.
TC—Through Carriages.
p—pm.

For details of Cabins, Berth Charges, Sailing Tickets and general arrangements, please see separate Folder, to be obtained at Stations and Agencies.

A timetable for Midland services between Leeds and Heysham for boats to Belfast. (Author)

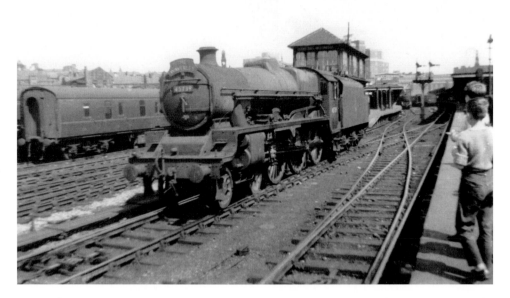

Sometime in 1959, ex LMS Stanier 'Jubilee' class 4-6-0 no. 45739, *Ulster*, backs on to the stock of *The Waverley* at Wellington station. This train had been introduced in 1957 to operate over the Settle–Carlisle line to Edinburgh. The other Scottish express was the *Thames–Clyde Express* which ran from St Pancras to Glasgow, with an engine change at Leeds. This service was introduced in 1927, the same year as a Bradford–Leeds–West of England express was introduced. This was *The Devonian* and it ran to and from Paignton via Bristol and Birmingham New Street. In BR days, *The Cornishman* was introduced in the early 1950s. Originally, this train started in the Midlands but was extended to Leeds shortly afterwards. In 1927, the LMS introduced a forerunner of *The Waverley*, known as the *Thames-Forth Express*, curtailed during the Second World War. Ex Midland types originally provided motive power for these trains, but, in the 1930s, new LMS locomotives began to appear, including 'Jubilees', 'Patriots', and 'Royal-Scots'. (R. Carpenter)

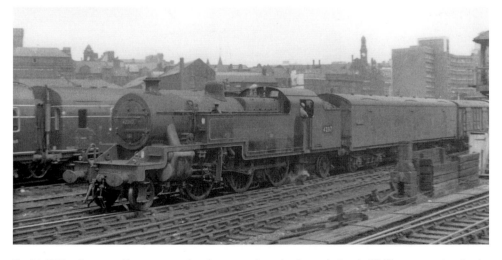

Ex LMS Fowler 2-6-4T no. 42317 heads a parcels train through Leeds Wellington station in the 1950s. On the left, new motive power is appearing here in the form of new green liveried OMUs. (LOSA)

LONDON, LEICESTER, NOTTINGHAM, DERBY, MANCHESTER, LIVERPOOL, SHEFFIELD, LEEDS, SCOTLAND, &c.—Midland.

Down. **Sundays—***continued.*

	mrn	aft	mrn	aft	non	aft	aft	aft	aft	aft	aft	aft	aft	aft	mgt	mgt	aft
ST. PANCRAS ¶....dep	9 30	...	1130	...	12 0	12 15	3 15	4 0	...	5 30	6 0	20	...	8 15	8 40	9 30	...
Kentish Town "	9 37				2 20					5 35							1221
St. Albans "	1029				2 59					6 14							1248
Harpenden "	1039				3					6 28							
Luton "	1053				3 17					6 37							4
Leagrave "	1059									6 43							
Harlington △..... "	11 7									6 51							
Flitwick "	1113									6 58							
Ampthill "	1118									7 3							
Bedford ¶ 441...arr	1130		1229			3 42	4 14			7 15	7 26				9 54	1029	

NOTES.

A Station for Toddington (2 miles).
△ Arrives at 6 45 mrn. on Saturdays.
Aa Sets down from Sheffield and South thereof.
a Via the Dore and Chinley Line.
a Does not wait the arrival of the train from London due at Derby at 3 40 aft.
B Station for Rothwell (2½ miles).
b Stops to set down from London, and to take up for Manchester and beyond.
h Via Normanton.
Bb Stop when required to take up.
β Mondays only.
C Over 1 mile to L. & N. W. Station.
c Via Derby; arrives at 3 20 mrn. on Sundays.
c Thursdays only.
Cc Stops at 5 35 mrn. when required to take up for beyond Leicester.
D Station for Mountsorrel (1½ miles).
d Stops at 7 36 mrn. when required to take up for Manchester and beyond.
Dd Stops on Thursdays and Saturdays: on other days when required to take up for Barnsley, Normanton, and beyond.
 d Via Chinley; arrives at 6 52 aft. on Saturdays.
Ee Stops at 9 3 mrn. to take up for North of Leeds.
e Except Saturdays.
E Donegall Quay, via Heysham.
f Stops to take up for Scotland.
f Does not wait arrival of 4 25 aft. from Leicester.
Ff Passengers for the North leave Rotherham at 1 30 mrn. and travel via Sheffield.
G Ludgate Hill Station.
g South Wigfield.
ɢ Stop when required to set down.
g Arrives at 5 2 aft. on Saturdays.
Gg Takes up for Manchester and beyond.
H Station for Ashover (3 miles).
h Arrives at 3 29 aft. on Sundays.
Hh Stops to set down from London and to take up for North of Derby.
h Arrives at 3 58 mrn. on Sundays.
ʜ Arrives at 8 15 aft. on Saturdays.
I Station for North Wigfield (¾ mile).
I Northampton Castle Station.
Ii Stops on Saturday nights: on other nights when required to set down from London.
i Via Stranraer.
J Stops at 5 20 aft. to take up for Selby and beyond.
Jj Set down for Chinley and beyond.
j Saturdays only, and applies to Passengers from Nottingham, Loughboro', and beyond only; via Chinley.
J Arrives at 9 31 mrn. on Sundays.
K Arrives at 9 5 mrn. on Sundays.
k Tuesdays only.
Kk Stops at 1 10 on Sunday mornings only.
K The times of arrival at Derby apply to the London and Leicester trains only; for times of arrival at Derby from Nottingham, see page 594.

(lower table)

	5	6	7	8	9	10	11	12	13	14	15	16	17	18	19	20	21	22	23	24
Derby.........dep																				
Sheffield ✠ 577. { arr																				
653, 659 { dep																				
Leeds(Well)612, 616...arr																				

Mondays only.

Ll Stops at 7 22 mrn. on Mondays when required to take up for Sheffield and beyond.
L 4 minutes *earlier* on Sunday mornings.
L Wednesdays only.
m Arrives at 7 17 mrn. on Sundays.
m Arrives at 11 40 aft. on Saturdays.
Nn Stops at 6 57 aft. when required to set down from Nottingham and Birmingham and beyond, or to take up for Leeds.
n Via Chapeltown; arrives at 8 12 on Sunday mornings, via Cudworth.
N Arrives at 12 56 aft. on Sats., via Leeds (New).
o Takes up for Sheffield, Manchester, and beyond.
o Via Butterley. 0 Via Thornhill.
P Arrives at 8 5 mrn. on Sundays.
Pp Stops on Tuesdays and Thursdays when required to set down for beyond Chinley.
p Leaves at 2 52 aft. on Mondays, via Kettering.
P Arrives at 7 40 aft. on Sundays.
q Via Trent.
q This time applies to Passengers for Scotland only.
R Stops at 4 aft. when required to set down; also to take up for the N. E. Line.
R Via Trent; applies only to Passengers for Belfast.
Rr Set down from Derby and South or West thereof.
s Saturdays only. t Via Trent.
t Takes up for North of Rotherham.
t Arrives Wakefield (Kirkgate) at 9 16 mrn. and Halifax via Normanton at 10 26mrn. on Suns.
T Wednesday, Friday, and Sunday mornings, via Barrow.
tt Stops on Thursdays when required to take up for beyond Leicester.
Uu Stops when required to take up from the Ripley Branch for Derbyshire and beyond.
U Stops at 8 10 aft. when required to take up for Belfast, from Derby, Nottingham, Leicester, and beyond.
u Applies to Passengers for the N. E. Line only.
v Except Sundays.
V Passengers from these Stations for Manchester and beyond will be allowed to travel via Nottingham and Derby.
V Change at Monk Fryston.
W Passengers in Through Carriage from Deal, Dover, Folkestone, &c. at St. Pancras the 2 39 aft. for Leicester, Derby, Manchester, &c.
W Arrives at 3 17 aft. on Saturdays.
W Arrives at 6 30 aft. on Saturdays.
X Takes up at 12 40 mrn. for Carlisle and Scotland.
Xx Takes up at 12 40 mrn. for Carlisle and Scotland; Passengers for Rotherham leave Sheffield at 12 45 mrn., arriving at 12 56 mrn.
x Via Peterboro'; applies only to North of Syston.
X Arrives at 11 7 mrn. on Sundays.
y Calls at 8 35 mrn. when required to take up for Leicester, Nottingham, and beyond.
Yy Stops when required to set down for London and Birmingham.
Y Arrives at 4 57 aft. on Saturdays.
y Arrives at 2 33 aft. on Saturdays.
Zz Stop to set down from London.

† Court House Station. ‡ Central Station.
§ 2 miles from Rothwell.
** ½ mile to Victoria Station, Great Central.
‡‡ Via Forth and Tay Bridges.
§§ Market Street.
‖ About ¼ miles to L. & N. W. Station.

A 1910 Midland Railway timetable for trains operating between London and the north, including Leeds. (Author)

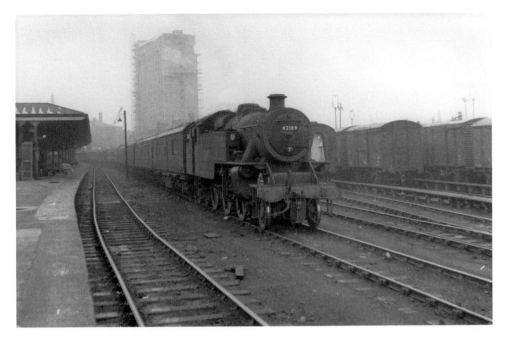

Passing Leeds Wellington station is ex LMS Fairburn 2-6-4T no. 42189 at the head of a long parcels train. Construction of new office blocks can be seen in the background which, like in many other cities, will dramatically change the skyline. (LOSA)

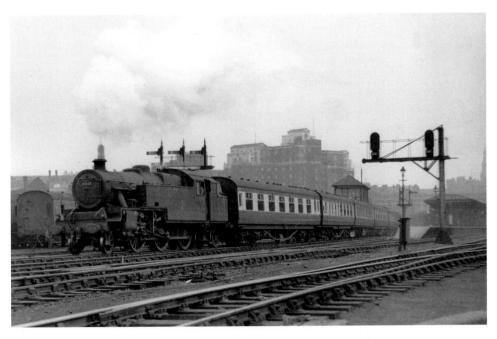

In the mid 1950s, ex LMS Stanier 2-6-4T no. 42432 departs from Wellington with a train for Bradford Forster Square. (R. Carpenter)

A Midland Railway timetable of 1910 for passenger services between Leeds, Bradford, Ilkley, and Skipton. (Author)

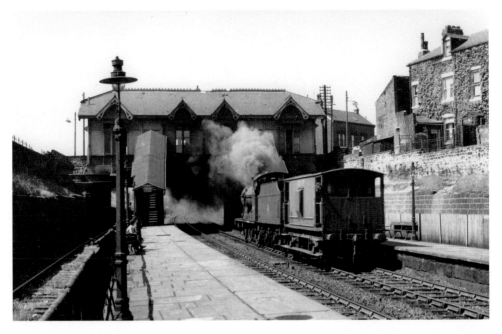

The little station at Hunslet on 18 June 1955, looking towards Holbeck, with ex LMS 4F 0-6-0 no. 44467, propelling a brake van on the Up line. Hunslet was famous as the home of several private locomotive builders, including Kitson's and the Hunslet Engine Company. (R. Carpenter)

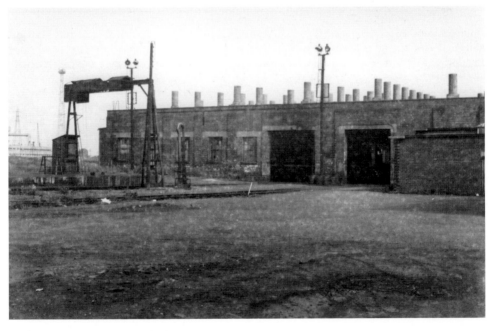

A view of a deserted Stourton locoshed on 9 June 1968, a year after its closure. (R. Carpenter)

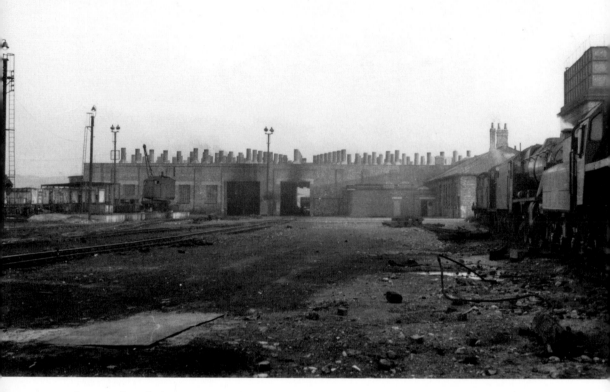

Stourton locoshed, as it appeared on 15 September 1963. This was another of the Midland Railway locosheds in the Leeds area, and was coded 20B at nationalisation. In 1950, there was an allocation of forty-eight engines. This had reduced to thirty-six by 1959, and only twenty-five engines by 1967, just before the shed's closure. In 1957, the shed came under the control of the North Eastern Region, as did many at this time, and was re-coded 55B. Most locomotives allocated here were old MR and LMS types. A 1950s allocation gives an idea of the engines to be found at the shed:

Ex MR 1F 0-6-0T	41666, 41794, 41869
Ex MR 3F 0-6-0	43392, 43449, 43456, 43476, 43579, 43678, 43681, 43705, 43737, 43781
Ex LMS 4F 0-6-0	43851, 43852, 43871, 43878, 43963, 43987, 43989, 44020, 44094, 44153, 44245, 44467
Ex LMS 3F 0-6-0T	47249, 47271, 47443, 47463, 47538
Ex LMS 8F 2-8-0	48123, 48276, 48277, 48311, 48622, 48641, 48703
Ex MR 2F 0-6-0	58136, 58212, 58245
	TOTAL: 40

(R. Carpenter)

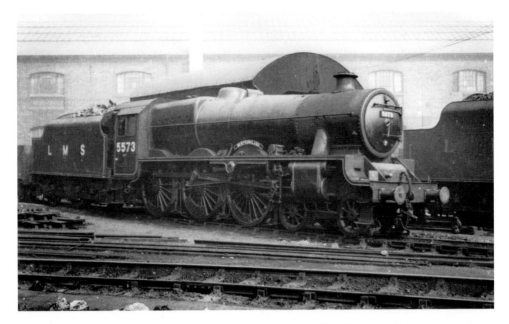

This is LMS Stanier 'Jubilee' class 4-6-0 no. 5573, *Newfoundland*, in immediate post-war livery at Leeds Holbeck shed. The engine had been allocated to Holbeck from 13 April 1946, and was probably newly arrived. *Newfoundland* was built by the North British Company in September 1934, and was then sent to Crewe for running in. It then went to Carlisle from 6 October, moving to Camden from 17 July 1937, and transferring to Willesden on 29 August. On 3 September the following year, the locomotive went on loan to Trafford Park, and then moved to Millhouses on 11 February 1939. From Millhouses, *Newfoundland* arrived at Holbeck on 13 April 1946, and remained there for the rest of its working life.

Leeds Holbeck was the principal shed of the Midland Railway in Leeds, and had a twin roundhouse. In 1942, it was modernised to help with the war effort; watering, coaling, fire dropping, and turning facilities were all improved at a cost of £18,690. Additional facilities were added at a cost of £130. Holbeck replaced a shed which had to be demolished to make way for railway access to New station. Also at Holbeck, there was another shed, the headquarters of the Leeds Northern Railway locomotive department, which was retained for locomotive purposes until 1904, when it was superseded by a new locoshed at Neville Hill. At the time of closure, there were two roundhouses and a semicircular shed at Holbeck. The first roundhouse was built in 1864 at a cost of £5,888. The other dated from 1873, having been authorised in November 1871 with an estimated cost of £8,500. This was the roundhouse nearest to Central station which had inverted 'V' roofs over the stalls. One side of the building, adjacent to the Leeds and Liverpool Canal, overlooked and opened onto canal company property; the NER agreed to pay a rent of £1 a year for seventeen windows and three doors. The original North Midland Railway shed at Hunslet Lane was used by Y&NMR trains; on 19 December 1849, three Y&NMR engines were based here. The Y&NMR used the line to the Leeds Wellington station until 1869, when the Church Fenton–Micklefield cut-off was opened and services moved to New station. Back at the MR shed at Holbeck, there was an allocation of ninety-five engines in 1950, when it was coded 20A. This was reduced to eighty-one in 1959, and forty in 1965. The shed was re-coded 55B from 1957, when control passed to the North Eastern Region. It was closed entirely in 1967. A 1950s allocation gives an indication of the locomotives allocated at Holbeck:

Ex LMS Stanier 3MT 2-6-2T	40075, 40090, 40169
Ex MR 2P 4-4-0	40326, 40351, 40362, 40514
Ex MR 3P 4-4-0	40743, 40747, 40758, 41040, 41048, 41068, 41137, 41144
Ex LMS Ivatt 2MT 2-6-2T	41267
Ex MR 1F 0-6-0T	41745
Ex LMS 'Crab' 5MT 2-6-0	42798, 42816
Ex LMS Ivatt 4MT 2-6-0	43030, 43039
Ex MR 3F 0-6-0	43665
Ex LMS 4F 0-6-0	43931, 43953, 44207, 44404, 44431, 44501, 44584
Ex LMS 'Black Five' 4-6-0	44662, 44753, 44754, 44755, 44756, 44757, 44774, 44775, 44821, 44828, 44843, 44849, 44850, 44853, 44854, 44856, 44847, 44943, 44988, 45040
Ex LMS 'Jubilee' 4-6-0	45565 *Victoria* 45566 *Queensland* 45568 *Western Australia* 45569 *Tasmania* 45573 *Newfoundland* 45587 *Baroda* 45589 *Gwalior* 45597 *Barbados* 45604 *Ceylon* 45605 *Cyprus* 45608 *Gibraltar* 45619 *Nigeria* 45626 *Seychelles* 45651 *Shovell* 45658 *Keyes* 45659 *Drake* 45675 *Hardy* 45694 *Bellerophon* 45739 *Ulster*
Ex LMS 'Royal-Scot' 4-6-0	46103 *Royal Scots Fusilier* 46109 *Royal Engineer* 46117 *Welsh Guardsman* 46133 *The Green Howards*
Ex LMS 3F 0-6-0T	47254, 47418
Ex LMS 8F 2-8-0	48067, 48104, 48126, 48157, 48158, 48159, 48399, 48454, 48537
Ex L&YR 2P/3P 2-4-2T	50622
Ex MR 1P 0-4-4T	58060
	TOTAL: 85

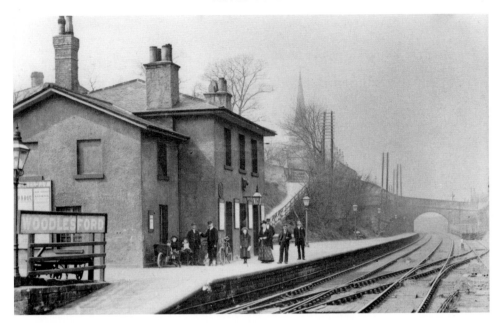

The MR station at Woodlesford on the line to Normanton, via Altofts Junction. (LOSA)

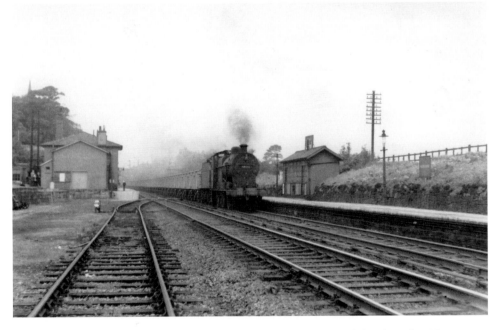

On 30 August 1957, passing through Woodlesford station and heading for Normanton and Wakefield is ex LMS 4F no. 44010 and a train of empty 16 ton mineral wagons. (R. Carpenter)

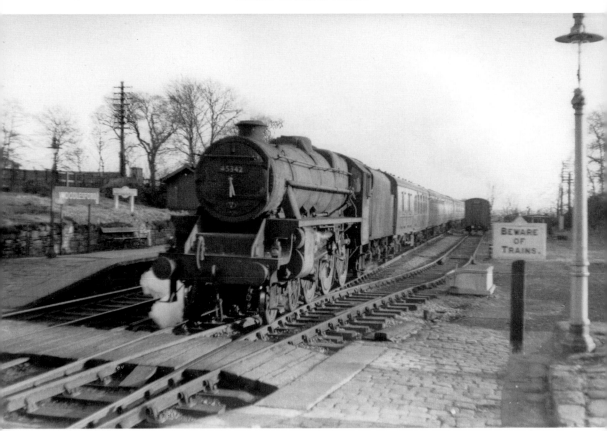

Ex LMS Stanier 'Black Five' 4-6-0 passes through Woodlesford with an express in 1960. (R. Carpenter)

Miles	Up.		Week Days.								Miles	Down.		Week Days.						
			mrn	mrn	aft	aft	aft	aft	aft	aft				mrn	mrn	aft	aft	aft	aft	aft
	Leeds { New Sta. dp	6 50	8 15	1210	1 7	3 10	6 10	9 30	1125		608	Sheffield {dep.	8 12	1240		1g45	5 40	
	Marsh Lane	6 53	8 18	1213	1 10	3 13	6 13	9 33	1130		—	Ponte- { S.&K. †dep	9 25	1 45		4 50	7 40	
4¼	Cross Gates	7 1	8 26	1221	1 18	3 21	6 21	9 41	1137	1½	fract { L.&Y. * ‖	9 29	1 49		4 54	7 44		
7¼	Garforth	7 8	8 33	1228	1 25	3 28	6 28	9 48	1144	4½	Castleford §	8 0	9 38	1 57	2 29	5 4	7 53		1017	
10¼	Kippax	7 15	8 40	1235	1 32	3 35	6 35	9 55	1151	6¾	Ledstone	8 5	9 43	2 2	2 34	5 9	7 58		1022	
12	Ledstone	7 22	8 47	1242	1 39	3 42	6 42	10 3	1158	8¾	Kippax	8 13	9 51	2 9	2 42	5 17	8 6		1030	
14¼	Castleford §	7 27	8 53	1248	1 44	3 48	6 48	10 8	12 4	11½	Garforth 726	8 21	9 59	2 17	2 50	5 25	8 14		1038	
17¾	Ponte- { L.&Y. *arr	9 2	1257		3 57	6 57			14½	Cross Gates 713	8 28	10 5	2 23	2 57	5 31	8 20		1044	
18¼	fract { S.&K. † ‖	9 6	1 1		4 1	7 1			18	Leeds { Marsh Lane	8 36	1013	2 31	3 4	5 39	8 28		1052	
44	609 Sheffield ‖ arr.	1115	2 33		5 19	9 5			18¼	708 { New Sta. arr	8 39	1016	2 34	3 6	5 42	8 31		1055	

LEEDS and PONTEFRACT.—North Eastern.

g Leaves at 3 5 aft. on Saturdays.

⁰ Monkhill Station. † Baghill Station. §¼ mile to L. & Y. Station. ‖ Midland Station.

☞ For LOCAL TRAINS between Leeds and Garforth see pages 724 and 726.

A North Eastern Railway timetable of 1910 for local train services from Leeds to Pontefract. (Author)

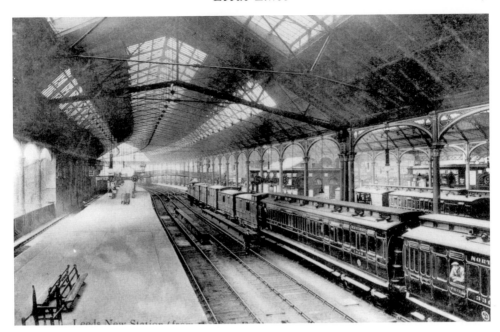

A late nineteenth-century view of Leeds New station, with a rake of North Eastern Railway coaches at the platform and an unidentified 0-6-0 tender engine at the head.

Leeds New station stood on viaducts made a little higher than those of the MR to give an impression of importance. Years later, these created problems for engineers when the MR and Leeds New were joined together to form the new Leeds City station. As well as being used for storage, many of these arches were rented out to local industries, one being a soap works. A fire started under the arches in the early hours of 13 January 1892 and burned all day, causing so much damage to the railway above that the bridge girders collapsed due to the heat. By the next day, no trains could use the railway into New station by the western end as all tracks had collapsed into the canal below. The stations here had suffered no damage, but services had to be diverted to Central station, causing much congestion. However, within ten days of the fire, a new temporary bridge had been built from timber obtained from east coast merchants, and services to New station had returned to normal by 24 January.

When Marsh Lane was the terminus of the Leeds and Selby Railway, a locoshed was used at the station to provide motive power for NER trains. This was closed when New station became the terminus in 1871. The shed at New station was built in connection with the extension of the line from Marsh Lane to New station. Although the station was built jointly by the NER and LNWR, the Euston Company did not wish to have a joint locoshed. The NER decided to build its own; a tender of £5,892 was accepted and the shed opened in 1871. The building became disused by 1908 when it was decided to install a Cowan Sheldon 60 foot turntable in the yard adjacent to the shed. The shed was demolished a few years later, but the yard remained in use for locomotive purposes until the 1950s. By October 1898, accommodation at nearby Holbeck was inadequate for NER needs, and a proposal was made to move to Neville Hill on the eastern outskirts of Leeds. In November 1899, plans were approved for sidings, an engine shed, repair shops, a coal stage, carriage and wagon sidings, and washing shed at an estimated cost of £132,971. This scheme was approved and plans for a shed to hold ninety-six engines at Neville Hill were submitted in December 1901. The shed comprised four adjoining roundhouses under one roof, and opened in October 1904. In 1939, a 55 foot turntable was replaced by a 70 foot one, to allow Gresley pacifics to be allocated to Neville Hill. By 1960, two roundhouse sections of the shed were demolished and the remainder were re-roofed. A new DMU depot was built and the repair shop was converted for diesel use. In 1969, a new carriage washing plant was installed. The shed remains open to this day. Back in the 1950s, the shed's allocation was as follows:

Code: LNER – LDS, Br – 50B, and 55H in January 1960.

Ex LNER A3 pacific	60036 *Colombo* 60074 *Harvester* 60081 *Shotover*
Ex LNER B1 4-6-0	61035 *Pronghorn* 61062, 61065, 61069, 61216, 61240 *Harry Hinchcliffe* 61256, 61257, 61258
Ex LNER B16 4-6-0	61410, 61411, 61412, 61413, 61414, 61415, 61425, 21427, 61428, 61429, 61431, 61432, 61433, 61440, 61442, 61445, 61446, 61447, 61469, 61470, 61471, 61478
Ex LNER D49 4-4-0	62775 *The Tyndale*
Ex NER Q6 0-8-0	63450
Ex LNER J39 0-6-0	64791, 64819, 64850, 64920, 64921, 64934, 64948, 64949
Ex NER J21 0-6-0	65041, 65062, 65067, 65076, 65118, 65122
Ex NER G5 0-4-4T	67240, 67262, 67266, 67274, 67290, 67293, 67308, 67319, 67337
Ex NER J77 0-6-0T	68395, 68406
Ex GER J72 0-6-0T	68672, 68677, 68681
Ex Hull and Barnsley N13 0-6-2T	69114, 69115, 69117, 69118
	TOTAL: 68

(LOSA)

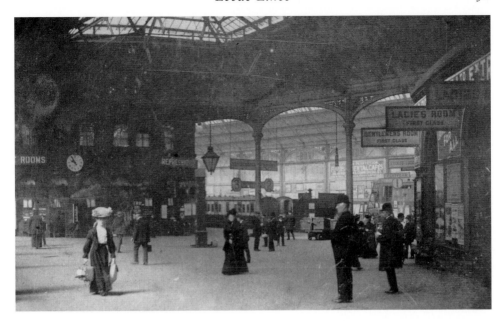

The concourse at Leeds New station during the Edwardian period, with LNWR coaches in view on platform three. In 1879, to coincide with enlargement at Leeds New station, the LNWR built a viaduct which opened for traffic in 1882. This new line was exclusively for LNWR use and took their main line westwards, passing south of Whitehall Junction and over the MR at Holbeck, meeting the old main line near Farnley, some miles away. The LNWR built this new line to avoid using Midland metals and delays at Whitehall Junction. Although the LNWR paid rent for its use of the line, the MR could still delay LNWR trains. Goods trains still used Whitehall Junction, leaving the new line clear for passenger trains. Farnley Junction was where the LNWR sited its Leeds locoshed, having declined to join with the NER for a joint shed. This was a twelve road shed and coded 25G under the Leeds Midland Region. It became 55C when it came under the control of the North Eastern Region from 1957. The shed had an allocation of fifty locomotives in 1950 and twenty-seven in 1959. The shed closed in 1966. A 1950s allocation gives an idea of the locomotives there:

Ex LMS Ivatt 2MT 2-6-2T	41255, 41256, 41257, 41258, 41259
Ex LMS 'Crab' 2-6-0	42730, 42731
Ex LMS 'Black Five' 4-6-0	44896, 45062, 45063, 45075, 45076, 45078, 45080, 45218, 45341
Ex LMS 'Jubilee' 4-6-0	45702 *Colossus* 45704 *Leviathan* 45705 *Seahorse* 45708 *Resolution* 45711 *Courageous*
Ex LMS 3F 0-6-0T	47567, 47568, 47569, 47570, 47571
Ex WD 2-8-0	90140, 90245, 90322, 90325, 90326, 90336, 90351, 90372, 90407, 90588, 90591, 90645, 90649, 90664, 90666, 90684, 90698, 90699, 90712
	TOTAL: 45

(LOSA)

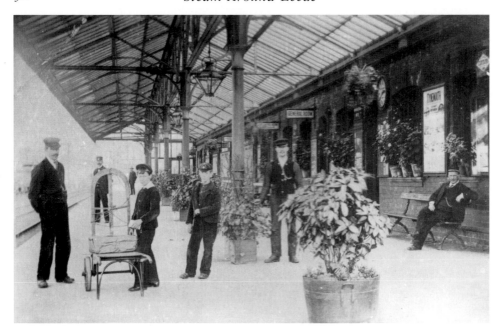

Travelling east from Leeds New station, the NER line passed through stations at Manston, Halton Dial, and Osmandthorpe, before reaching Crossgates, seen here at the end of the nineteenth century with station staff in view and a fine floral display on the platform and buildings. Such displays were a feature of many railway stations in those days, many competing for 'Best Station' prizes which were awarded by the railway companies every year. (LOSA)

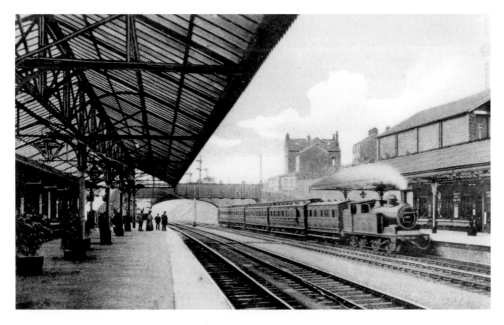

The substantial NER station at Crossgates, with a local train made up of a NER 0-4-4T and wooden coaches. Crossgates was the junction for the branch to Pontefract and the main line to Wetherby. This train is probably operating along the branch to Pontefract. (LOSA)

LEEDS and MICKLEFIELD.—North Eastern.

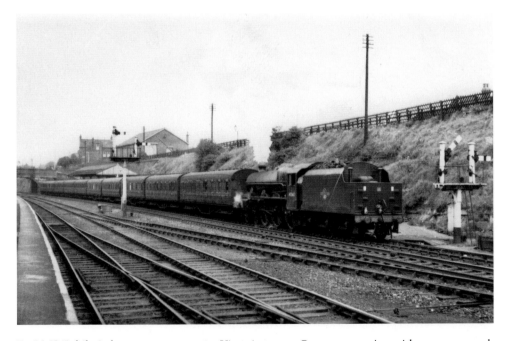

A 1910 NER timetable for trains to Micklefield. (Author)

Ex LMS 'Jubilee' class 4-6-0 no. 45565, *Victoria*, enters Crossgates station with an empty stock train in the early 1960s. No. 45565 was one of the 'Jubilees' allocated to Holbeck shed at this time. (R. Carpenter)

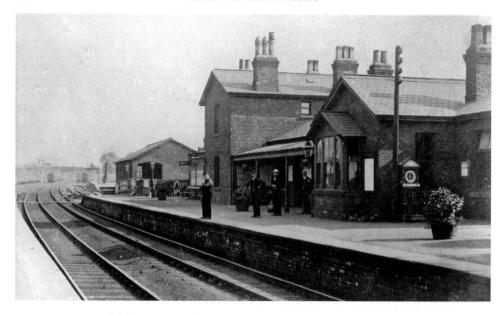

From Crossgates, the line to Pontefract next entered the station at Garforth. This station was also a junction, with a line branching off for Micklefield towards Church Fenton, where further main lines of the NER go on to Hull, York, and Scarborough. (LOSA)

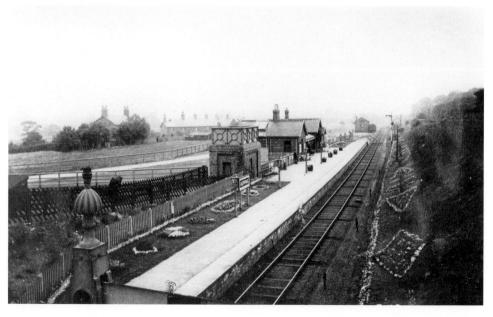

From Garforth, the branch to Pontefract becomes single line as it reaches Kippax station. This little station is seen here after winning First Prize for its station garden, and deservedly so. The amount of work involved in creating this display must have been tremendous, but the prize was the reward for all of that effort and it must have been a sight to see as passengers left trains at the station. (LOSA)

LEEDS and PONTEFRACT.—North Eastern.

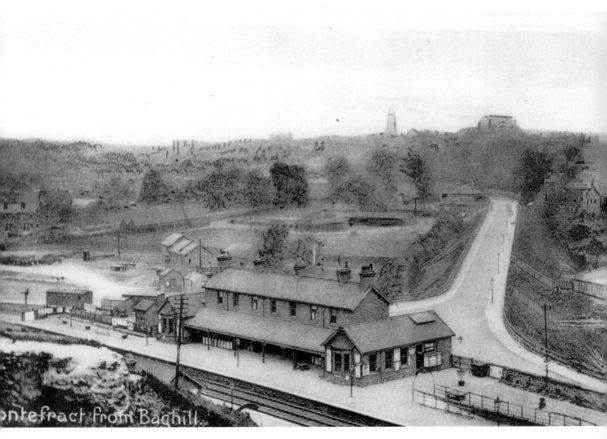

A NER timetable for local services along the branch to Pontefract in 1910. (Author)

From Kippax station, the branch passed through Bowers Halt and then joined the L&YR line at Methley Junction, and then ran through Castleford before reaching Pontefract. The town, famous for its liquorice 'Pontefract Cakes', had two stations. Here is Pontefract Baghill, seen when newly built in the late nineteenth century. The surrounding area appears quite rural at this time. (LOSA)

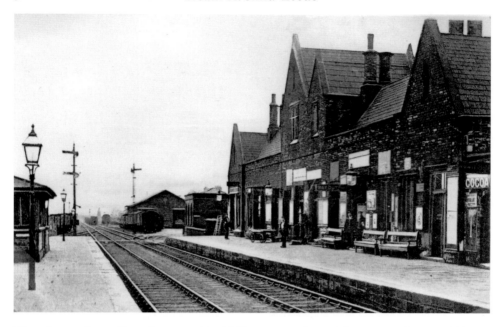

The other station at Pontefract was Monkhill, a more substantial structure than Baghill. Just beyond the platform are large sidings with a rake of wagons in view, and a goods shed. A train appears to be approaching in the distance. (LOSA)

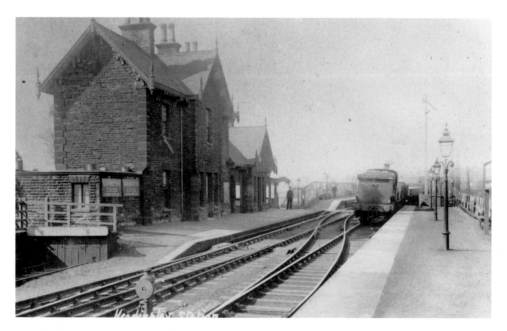

North of Leeds New station, the NER had a line which ran to Harrogate, with a branch to Ilkley, via Otley, connecting with Midland Railway at Ben Rhyddig before reaching Ilkley. From Leeds, the line passed through Royal Gardens, Woodside, and Headingley, the famous site of Yorkshire County Cricket Club and Leeds Rugby League Club. Here, Headingley station is seen in NER days with a local train waiting to depart. (LOSA)

LEEDS, HARROGATE, OTLEY, and ILKLEY.—North Eastern.

Down. — **Week Days.**

Miles	New Station.	mn	mrn	mrn	mrn	aft		aft	aft	aft	aft	aft	aft
—	Leedsdep.	7 43	7 55	9 24	1148	1 23	3 0	5 0	5 30	8 13	9 10	1010
¼	Holbeck (Low Level)...	7 47	7y59	9 28	1152	1 27	3 5	5 5	5 34	8 18	9 15	1015
3	Headingley	7 53	9 34	1158	5 11	8 24	9 22	1022	
5¼	Horsforth	8 0	9 41	12 5	5 18	8 31	9 30	1030	
9¼	Arthingtonarr.	8 6	8 13	9 47	1211	3 21	5 24	8 37	9 36	1036
—	710 Harrogatedep.	7 30	7h40	9h27	1138	1240h		2h49	5 h5	7h42	8 43	1025
—	Arthington ″	8 7	8 29	9 48	1213	.r..		3 22	5 26	8 38	9 42	1048
10	Pool	8 9	8 25	9 51	1216		3 25	5 29	8 41	9 45	1051
12½	Otley	8 31	9 57	1222	1 49		3 32	5 36	5 54	8 48	9 51	1057
15¼	Burley	8 37	10 3	1228	1 55		3 38	5 42	6 0	8 54	9 57	11 2
17¾	Ben Rhydding	8 42	10 8	1233	2 0		3 43	5 47	6 5	8 59	10 2	11 8
18¾	Ilkley 616arr.	8 45	1011	1236	2 3		3 46	5 50	6 8	9 2	10 5	1111

Up.

Mls		mrn	mrn	mrn	mrn	mrn	aft	aft	aft	aft	aft	aft
—	Ilkleydep.	7 25	8 17	9 0	1045	1250	2 16	4 0	6 15	8 25	10 5
1	Ben Rhydding	7 28	8 20	9 3	1048	1253	2 19	4 3	6 18	8 28	10 8
3½	Burley	7 33	8 25	9 8	1053	1259	2 24	4 8	6 23	8 33	1013
6	Otley 721	7 39	8 31	m	9 14	1059	1 6	2 30	4 14	6 29	8 39	1019
8½	Pool	7 43	8′ 40	9 20	11 5	1 12	4 21	6 35	8 45	1025
9¼	Arthington 708....arr.	7 48	8 43	9 22	11 7	1 15	2 35	4 23	6 37	8 48	1028
18½	708 Harrogate ″	8h14	9h51	1144	1 53	3 7	5 67	h1 9h43	1058	
—	Arthingtondep.	7 51	8 44	9 23	7.◆31	1 6	2 36	4 24	6 38	9 2	1044
13	Horsforth	8 0	8 52	1116	1 25	2 44	4 32	6 46	9 12	1054
15½	Headingley	8 5	8 56	1122	1 31	4 38	6 52	9 17	1059
18	Holbeck (Low Level)..,	8 11	8 52	1 9	1130	38	2 54	4 44	7 0	9 23	11 5	
18½	Leeds (New) 722, 726 ar.	8 15	8 55	9 4	1134	1 42	2 58	4 87	4 9	9 27	11 9	

g Wednesdays and Thursdays. h Change at Otley. m Auto-car.

☞ **For OTHER TRAINS** between Leeds and Arthington, see pages 708 to 711; Leeds and Ilkley, see pages 616 and 617.

A 1910 timetable for NER passenger services from Leeds for Harrogate, Otley, and Ilkley. (Author)

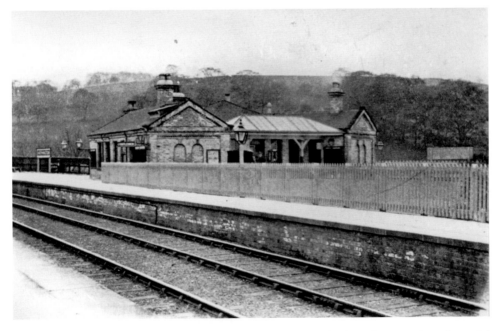

After leaving Headingley, the line then runs through Horseforth and enters the substantial station at Arthington, where the line to Ilkley branches off. From the junction, the line runs through Weeton, before continuing on to Harrogate. The attractive station at Arthington is seen here in the early twentieth century. (LOSA)

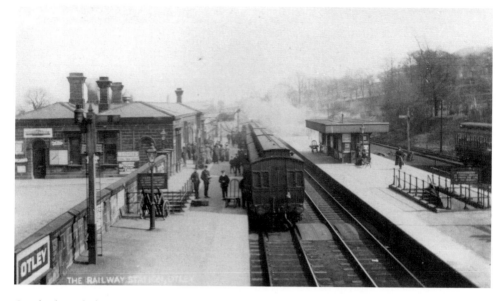

On the branch from Arthington, trains ran through Pool-in-Wharfdale before entering Otley, seen here in the years before the First World War, with a local train waiting on the platform. Otley was famous as the birthplace of Thomas Chippendale, the famous furniture maker, and, like many other West Riding towns, it has long been known for its Rugby League teams. The town has also been the home of an agricultural show since 1796, which would have brought in many visitors over the years, providing revenue for the railway company. (LOSA)

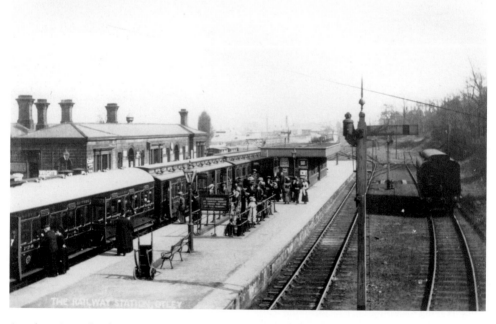

Another view of Otley station in the early twentieth century. It is a busy day, and a local train has just disgorged passengers and is awaiting departure. (LOSA)

LEEDS, HARROGATE, WETHERBY, CHURCH FENTON, and LONDON.—North Eastern.

Miles	Up.	Week Days only.	
	Leeds (New)dep.	6 30 7 25 7 55 9 45 12 15 1 28 3 35 4 16 5 20 5 30 6 45 8 27 9 55 1050	
	Marsh Lane	6 33 7 58 9 48 1 31 4 19 5 34 6 48 8 30 9 58	
4¼	Cross Gates	6 43 8 8 9 58 1 41 4 29 5 14 6 58 8 46 10 8 1059	
6½	Scholes;	6 49 8 14 10 4 12 28 1 47 4 35 5 51 7 18 47 1015 c	
8½	Thorner §	6 55 8 20 10 10 12 34 1 53 4 41 5 57 7 10 8 53 1021 c	
10½	Bardsey *	7 1 8 26 10 16 12 40 1 59 4 47 6 3 7 16 9 1027 c	
13	Collingham Bridge	7 7 8 32 10 22 12 46 2 5 4 52 5 4 26 9 7 22 9 7 c c	
14½	Wetherbyarr.	7 11 7 51 8 36 10 26 12 50 2 9 4 14 57 5 46 6 13 7 26 9 11 1038 1131	
17	Wetherbydep. 7 52 8 45 9 40 1054 1 0 4 2 7 18 9 24	
17	Spofforth[752, 753, 763	... 8 08 52 9 47 11 2 1 7 4 9 7 25 9 31	
22	Harrogate 750, 751, arr. 8 14 9 4 9 58 11 14 1 18 4 21 7 36 9 43	
—	Mls Harrogatedep.	6 45 8 20 9 15 12 32 1 55 3 43 4 33 6 37 8 45	
—	5 Spofforth	6 54 8 29 9 24 12 41 2 4 4 42 6 46 8 54	
—	7½ Wetherbyarr.	6 59 8 35 9 30 12 47 2 9 4 47 6 52 8 59	
—	Wetherbydep.	7 13 8 41 10 27 2 15 4 59 5 47 6 22 7 28 9 13	
17½	Thorp Arch †	7 20 8 48 10 34 2 22 5 7 5 54 6 28 7 35 9 20	
19	Newton Kyme ‡	7 24 8 52 10 38 2 26 5 11 6 32 7 39 9 24	
21	Tadcaster [770	7 30 8 58 10 43 2 31 5 16 6 38 7 44 9 29	
25½	Church Fenton 668, 766, arr.	7 38 9 10 105 2 40 5 24 6 46 7 52 9 37
36½	668 York 767arr.	8 17 9 46 1126 6 39 7 35 9 61014	
56¼	770 Selby ,,	8 15 9 31 1133 3 0 9 16 1012	
66½	770 Hull (Paragon) ,,	9 26 11 6 1241 5 12 1024 12 1	
208½	339 London (King's Cross).. ,,	1 35' 2 10 5 0 8 108 10 6 0	

c Stops to set down.
F Arrives at 6 mrn. on Sundays.
* Station for Harewood (3¼ miles).
† Station for Boston Spa (1¼ miles).
‡ Station for Bramham (2¼ miles).
§ Station for Bramham (4 miles).
¶ Over ¼ mile to Central Station, G. N. and L. & N. W.

☞ For Local Trains BETWEEN Leeds and Cross Gates......... 772

A 1910 NER timetable for trains from Leeds to Harrogate, Wetherby, and London, via Church Fenton. (Author)

At Otley, a branch ran through to Burley-in-Wharfdale, where it met the MR line to Ilkley. The station is seen here in the 1970s. (LOSA)

The Ilkley terminus of the NER in BR days, with a DMU awaiting departure. The scene here is of decline and overgrowth, not the way that the NER would have allowed the station to be kept, particularly as the town is famous for being overlooked by Ilkley Moor, of 'Ba t' at' fame. A cold water spring exists here, which made the town a fashionable Victorian resort, hence the competition between the NER and MR to take passengers to the town. (LOSA)

LEEDS, CHURCH FENTON, NORMANTON, SELBY, and HULL.—North Eastern.

Down. — Week Days.

| Miles from Leeds | Station |
|---|
| | 486 Liverpool (L. St.) dep. | aft 10 c0 | aft | mrn | mrn | mrn | mrn | mrn | mrn | mrn | mrn | mrn | 8 35 | mrn | 11 0 | mrn | mrn | aft | mrn |
| | 486 Manchester (Exch.) " | 10 J5 | | | | 4 25 | | 7 15 7 28 | | | | | 9 35 | 1152 | | | | | |
| | 675 Bradford (Mrkt St) dep. | | 1 28 | | | 7 44 | | 8 27 9 28 9 44 | | | | 1025 1132 1222 | | | | 1 8 | | | |
| | 675 Leeds (Wellingtn) arr. | | 1 50 | | | 8 10 | | 8 55 9 50 1025 | | | | 1048 1213 1250 | | | | 1 53 | | | |
| — | Leeds (New)dep. | 2 56 | 5 55 30 | | 6 38 8 27 | | 9 40 1017 1040 | | | 1220 1224 1 35 1 45 | | | 2 22 | | | | |
| ½ | Marsh Lane | mrn | 5 9 5 34 | | 6 41 | | 1020 | | | 1227 | | | 2 25 | | | | |
| 4½ | Cross Gates | | 5 19 5 44 | | 6 51 | | 1030 | | | 1237 | | | 2 35 | | | | |
| 7½ | Garforth † | | 5 25 5 50 | | 6 58 8 45 | | 1037 | | | 1244 | | | 2 43 | | | | |
| 9¾ | Micklefield † | | 5 41 6 6 | | 7 4 | | 1043 | | | 1250 | | | 2 49 | | | | |
| 12 | South Milford | | 5 46 6 11 | | 8 54 | | 10 1 | | | 1256 | | | 2 56 | | | | |
| 15 | Church Fenton 766 .. arr. | | 7 12 | | | 1051 | | | | | | | | | | |
| — | 512 Liverpool (Exch.) dep. | | | 4 30 | | 6 57 | 9 0 | | | | | | | | |
| — | 512 Manchester (Vic.) " | | | | | | 10A5 | | | | | | | |
| — | 606 London (St. Pan.) " | 9 15 | | 4 25 | | | | | | | 9 50 | |
| — | 607 Sheffield (Mid.) 668 " | 2 0 | | 4 32 7 57 16 | | 9 17 1120 | | | | 1 6 | 1 54 | |
| — | 512 Halifax | mrn | | 5 45 7 45 | | 1032 | | | | | |
| — | 512 Wakefield § " | | | 6 51 8 46 | | 1132 | | | | |
| — | Mls Normantondep. | | | 7 13 9 2 | | 1140 | | | | |
| — | 3¼ Castleford ** | | | 7 24 9-10 | | 1148 | | | | |
| — | 7¼ Burton Salmon ¶ .. | | | 7 32 8 31 | | 1156 1229 | | | 3 25 | |
| — | 9¼ Monk Fryston | | | 7 36 8 35 9 21 | | Stop | | 2 27 | |
| — | 11¾ Sherburn-in-Elmet.. | | | 7 42 8 41 | | mrn | | 2 33 | |
| — | 13½ Church Fentn 770 arr | | | 7 46 8 46 9 29 | | | 2 38 | |
| — | 669 York 766dep. | | | 7 25 7 35 | | 1025 | | 1 0 | |
| — | Church Fentondep. | | | 7 54 9 10 | 1059 | 1112 | | 2 41 | |
| 17¼ | Sherburn-in-Elmet | | | 7 58 | | 1116 | | 2 45 | |
| 16½ | Hambleton[765 | | | 8 7 9 22 | | 1125 | 1 4 | 3 4 | |
| 20¾ | Selby 338, 750, 761 arr. | 3 24 3 34 | | 8 15 9 69 31 | 1014 | 1110 1123 1246 1252 1 11 2 | 4 2 15 3 | 0 3 123 42 | |
| — | 332 London (King's C.) dep. | 1045 | | 4 45 | 7 15 | 8 45 | | |
| — | 327 York 338 " | 1 28 | | | 1025 | 1 35 | | |
| — | Selbydep. | 3 44 | | 7 40 8 15 | 1019 9 10 | 1114 1137 | 1256 1 18 2 9 2 17 | 3 44 | |
| 23½ | Hemingbrough | | | 8 20 9 10 | | 1143 | 2 15 | | |
| 26½ | Wressle | | | 8 26 | | 1149 | | | |
| 29½ | North Howden †† | 4 1 | | 8 38 | 1032 | 1155 | 2 24 | | |
| 32½ | Staddlethorpe ‖ | | | 8 45 | | 12 2 | | | |
| 34½ | Brough 765 | | | 8 51 | 1042 | 12 8 | 2 33 | | |
| 41 | Ferriby | 4 25 | | 9 29 36 | | 1219 | 2 44 | | |
| 44 | Hessle. [761, 765, 768, 773 | | | 9 3 | | 1225 | 1 h | | |
| 46½ | Hull (Paragon) ‡ 760, arr. | 4 47 | | 8 7 9 26 9 55 | 11 6 | 1241 1 33 3 9 | | |

A NER timetable of 1910 for services to Normanton, Selby, and Hull, via Church Fenton. (Author)

A view of the interior of Ilkley station, with its overall roof, in the 1970s. A locoshed was built here for joint use by the NER and MR and opened in July 1888 in connection with the opening of the line between Ilkley and Skipton. Due to complaints of smoke nuisance at the shed, it was decided to look for a new site. In January 1889, a new site was found, some 25 chains east of the railway station and around 10 chains away from the nearest housing and public road. Six locomotives were to be based there, three NER and three MR, the shed having a 50 foot turntable. The shed was to cost £3,800, and the Ilkley Local Board was to pay the transfer costs. However, nine months later, when the Board was asked for £1,830 they refused to pay. The shed was re-sited from the south side to the north side of the running lines in July 1891, and it had to accommodate eight locos. A tender of £3,795 15s 8d was accepted on 11 April 1892, and the new shed was completed by the end of that year, the old shed being removed on 30 December 1892. The shed lasted until 1959, closing on 1 January that year. Coded 20E in January 1954, the shed was allocated two class 3 2-6-2Ts, one class 2 2-6-2T, and three ex L&YR 2-4-2Ts. (LOSA)

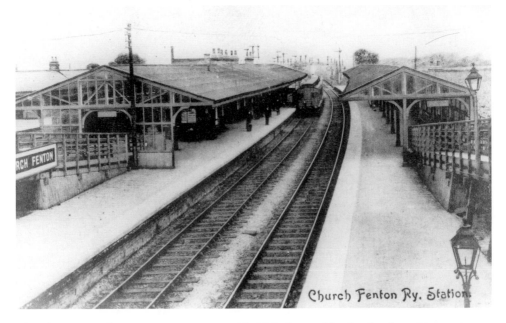

Church Fenton railway station as it appeared in NER days, with a local train waiting to depart. Church Fenton, a tiny community of around 900 people, is situated on flat arable land some 10 miles south of York. It was the Y&NMR who opened the station here in May 1839, on its line from York to Altofts. The line reached Church Fenton in July 1840. This first station sufficed until August 1847, when the early stage of a line to Harrogate was opened; its alignment meant that a new station would have to be opened just north of the original. This new station had two platforms, each 300 feet long. The Down platform, some 21 feet wide, was attached to the station building, whilst the 12 feet wide Up platform was supplied with a waiting shelter. Glass awnings were placed over both platforms, and a connecting footbridge was eventually provided. From around 1856, the station was lit by coal gas from a nearby gasworks provided by the NER, and replaced in 1870 by oil.

The line to Harrogate via Tadcaster and Wetherby was opened in its entirety by 1848; by 1876, it was possible to board a train to Leeds at Church Fenton and depart in either a northerly or southerly direction. The longer northerly route via Tadcaster and Wetherby took over an hour, while the more direct route on the Micklefield line took some twenty minutes. By April 1869, a direct line was opened from Leeds to Church Fenton, via Micklefield, and joined the York line just south of Church Fenton station. This was to become the main route from Leeds to York and the east coast resorts.

By 1876, some fifteen staff were employed by the NER at Church Fenton, including a stationmaster, two clerks, one telegraph clerk, four porters, one watchman, four signalmen, one gateman, and one cleaner. In that year, the station handled some 25,734 passengers (around seventy a day) but, by 1930, only some 16,012 (forty-four a day) passengers were using Church Fenton. Also in 1876, around 2,562 tons of coal and coke and up to 4,370 tons of other goods were arriving in the goods yard, while some 5,032 tons of goods left Church Fenton, along with around 167 wagons containing 2,075 head of livestock. With so much traffic passing through, the NER decided on a massive widening scheme in 1900, which was finally completed in 1904. A new signalbox with eighty levers was also built, and the old one came into use to supply fresh water when a new tank was placed on top of the original building. To provide facilities at Church Fenton, a new station was built with island platforms between the Up and Down Normanton lines. This new structure had actually been proposed in 1903. The station also had platforms on the east and west sides of the main line, with the island in the middle. All platforms were 200 yards long, with an over bridge, seen here, giving access to the station. (LOSA)

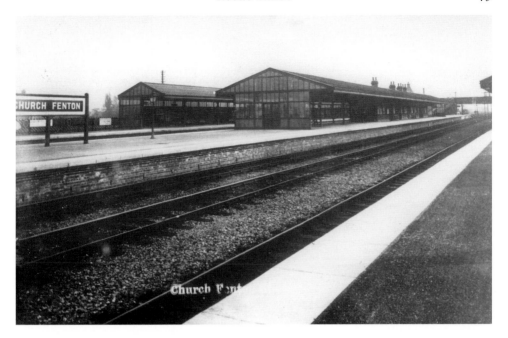

Another view of Church Fenton station after the modernisation. This new station had been built just south of the 1847 structure, and had been widened to provide five platform faces, two serving lines to Burton Salmon, two serving the Leeds route, and a bay for trains to Harrogate and Wetherby. Substantial sidings were provided here, just south of the station, with further sidings to the north and west of the station, beside the Harrogate line. This was the west yard of the Divisional Engineer and, from 1947, the Carriage and Wagon Department. After the Second World War, this area was used for timber storage, and withdrawn rolling stock was also dismantled here. The goods yards here were used extensively when a nearby airfield was constructed for the RAF early in the Second World War, and the station dealt with military personnel coming and going to RAF Church Fenton. A royal ordanance factory was opened at Thorp Arch on the Harrogate branch, and a new signalbox was built at Church Fenton station to cope with the demands on the branch for munitions traffic. The works created some extra fifteen trains a day, along with other military comings and goings, not least trains operating between Doncaster and Hull. The station remained busy during the post-war 'boom' period and still exists today, although station staff were withdrawn by 1988. (LOSA)

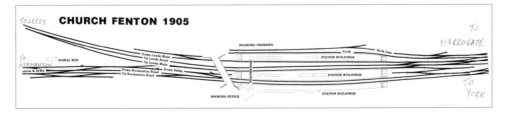

A plan of Church Fenton station as it appeared after modernisation had been completed in 1904.(Author)

LONDON, CHURCH FENTON, WETHERBY, HARROGATE, and LEEDS.—North Eastern.

	Down.	Week Days only.																		
Miles		mrn	aft	mrn	mrn	mrn	mrn	mrn	mrn	mrn	aft	aft	aft	mrn	mrn	aft	aft	aft	aft	aft
332	London (King's Cross)..dep.	B 1045		4 45	7 15	B 1010	1120	...	1 40	1 40	1 50	...		
768	Hull (Paragon) "		5 43	9 0	1015	1 55	4 0	5 52					
768	Selby "	mrn	7 5	9 58	1126	3 5	6 58	8 18					
669	York 766 "	6 47	7 25	9 55	1035	3 10	...	5 14	...	6 8	8 8				
—	Church Fenton..........dep.	7 18	7 50	1025	1154	3 32	...	5 40	...	6 46	8 53					
4¾	Tadcaster	7 28	8 0	1035	12 4	3 41	...	5 49	...	6 55	9 2					
6¾	Newton Kyme ‡		8 7	1039	1210	3 45	...	5 53	...	6 59	9 6					
8¾	Thorp Arch †	7 36	8 12	1043	1215	3 49	...	5 57	...	7 3	9 10					
10¼	Wetherby arr.	7 42	8 19	1049	1222	3 55	...	6 3	...	7 9	9 16					
—	Wetherbydep.	7 52	8 45	9 40	...	1054	1 0	...		4 2	7 18	9 24					
13	Spofforth	752, 753, 763	8 0	8 52	9 47	...	11 21	7	...		4 9	7 25	9 31				
18	Harrogate 750, 751, arr.	8 14	9 4	9 58	...	1114	1 18	...		4 21	3 45	...	6 10	7 36	9 43					
—	Mls Harrogatedep.	6 45	...	Stop	8 20	9 15	...	1232	1 55	...	4 33	...	6 37	8 45						
	5 Spofforth	6 54	...		8 29	9 24	...	1241	2 4	...	4 42	...	6 46	8 54						
	7¾ Wetherby arr.	6 59	...	mrn	8 35	9 30	...	1247	2 9	...	4 47	...	6 52	8 59						
—	Wetherbydep.	7 17	44	8 21	8 30	...	1010	1227	1 15	2 12	3 57	...	4 48	6 5	...	7 12	9 20			
12½	Collingham Bridge	7 6	7 49	8 25	8 35	...	1015	1232	1 20	2 17	4 2	...	4 53	6 10	...	7 17	9 25			
15	Bardsey *	7 12	7 56	...	8 41	...	1021	1238	1 26	2 23	4 8	...	4 59	6 16	...	7 23	9 31			
17	Thorner§	7 19	8	...	8 48	...	1028	1246	1 33	2 30	4 15	...	5 6	6 23	...	7 30	9 38			
19½	Scholes	7 25	8 9	...	8 54	...	1034	1252	1 38	2 36	4 21	...	5 12	6 29	...	7 36	9 44			
21½	Cross Gates 750, 767, 772	7 30	8 14	...	8 58	...	1039	1257	...	2 42	4 26	...	5 17	6 34	...	7 42	9 49			
25	Marsh Lane	7 41	8 26	1050	1 8	...	2 53	4 36	...	5 28	6 44	...	7 52	9 59			
25¾	Leeds (New) ¶ 489, 672 ..arr.	7 44	8 30	8 52	9 10	...	1053	1 11	1 52	2 56	4 39	...	5 31	6 47	...	7 55	10 2			

Saturdays only Luncheon Car Express

B Via York.

For LOCAL TRAINS between Cross Gate and Leeds, see page 772.

A NER timetable for passenger services to Leeds and Harrogate via Church Fenton. (Author)

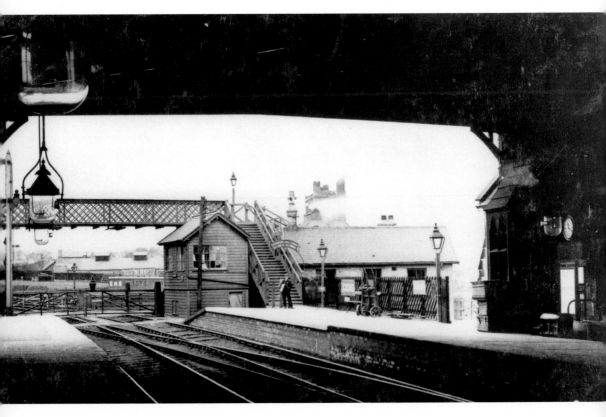

Tadcaster station, north of Church Fenton, on the line to York. (LOSA)

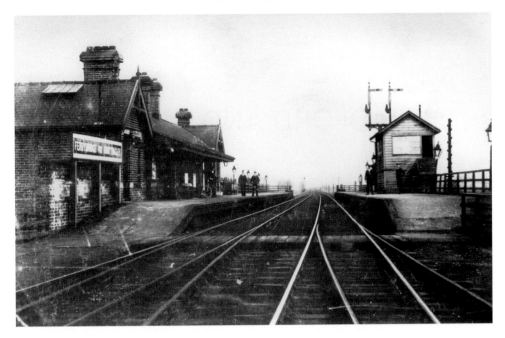

Ferrybridge station, south of Church Fenton, on the line to Goole and Hull. (LOSA)

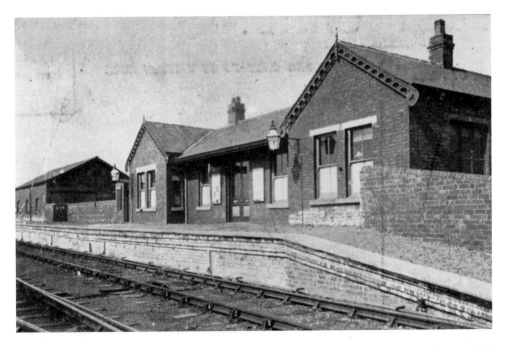

Another line ran through to Leeds, this being the East and West Yorkshire Union Railway which was incorporated under an Act of 1883. The company also obtained a further Act in 1886 so that it could compulsorily purchase land to build its line. The line lay between Hunslet, where it gained access to Leeds and ran through to Wakefield. Here is the station at Rothwell, north of the city. (LOSA)

TWO

BRADFORD AND HALIFAX

At one time, Bradford was served by three railway stations. Adolphus Street was opened in 1854 on a line built by the Leeds, Bradford and Halifax Joint Railway, and was later absorbed by the GNR by an Amalgamation Act of 1865. A spur from the West Riding Union Railway to the LB&HJR at Bowling Junction provided a more direct route to Leeds for the L&YR thanks to a working agreement between the GNR, the L&YR, and the LB&HJR in 1854. Its original route ran via Mirfield, Wakefield, and Normanton, and both the L&YR and GNR shared Adolphus Street station until Exchange was opened by the L&YR in January 1867. Eventually, Exchange was jointly owned by the L&YR and GNR, with Adolphus Street becoming a goods depot. The earliest station to serve Bradford was that of the North Midland Railway at Market Street, later to become Forster Square of the Midland Railway. While Forster Square and Exchange were only a few streets apart, they were never connected (thereby making a through station), despite several attempts to link the two.

The first line into Bradford was that of the Leeds and Bradford line of the North Midland (later the Midland) Railway, approved on 4 July 1844, and opened on 20 June 1846. A general holiday was announced in Bradford for the event and a train of fifteen carriages from the MR, Y&NMR, and other lines left Leeds for Bradford at 1.14 p.m., with another soon after containing the infamous George Hudson, the Board of the L&B, the Lord Mayor of York, and the Mayor of Leeds. There was a banquet at Leeds Music Hall with George Hudson presiding. On the following day, 1 July, public traffic began on the line, although there were as yet no intermediate stations. In 1852, the line became part of the Midland Railway, and extensions were completed to Skipton, via Shipley, in 1847, which connected with the Skipton–Lancaster Railway, providing a through route to the Irish Sea. The town of Keighley had been connected to the main line network by the extension of the line from Bradford to Skipton, and proposals were put forward to build a branch to Oxenhope, which would serve woollen mills in the Bridgehouse Valley. Plans were submitted in 1845 and 1853 which came to nothing, but a proposal by one John McLandsborough was submitted to parliament in 1861 and gained Royal Assent on 30 June 1862. However, construction difficulties over the 5 mile route meant that the line did not open until 13 April 1867, after the 'first sod' had been cut on 9 February 1864.

Unlike the MR, the L&YR entry into Bradford was more difficult. In 1844, the West Riding Junction Railway proposed a scheme, but was successfully opposed by a rival company and both plans were thrown out by parliament. Following this, an amalgamation took place resulting in the formation of the West Riding Union Railway, whose objective was to construct a branch from the Manchester and Leeds Railway to Bradford, thereby offering a route to the west. Work only reached as far as Low Moor in 1848, and only arrived in Bradford in 1850, supplemented by a line from Halifax three months later.

Halifax, situated in the Hebble Valley, was difficult to reach from the Manchester and Leeds Railway, although the wool town was only 2 miles away, and a railhead was provided at Elland with a cartage service running into Halifax. Although the M&L opened in 1841, and a branch to Halifax was under consideration, the town was not to be rail connected until 1 July 1844, and even then the line joined the town on an east facing junction at a time when most of its trade was to the west, mostly Manchester. The branch was also steeply graded, at 1 in 45 in places. This situation was to remain for some time until the line to Bradford was authorised in April 1846. This 45½ mile line would bring benefits to Halifax, as it would provide a west facing junction with the M&L. There would also be an easier ruling gradient of 1 in 120 and the branch would join the main line at Milner Road Junction, having left the old line at Dryclough Junction. The new line was due for inspection by mid 1851, but improvements needed to be made at Sowerby Bridge station, and the new 'cut-off' could not be opened until 1 January 1852.

Another branch was built which connected Halifax to Low Moor, where a connection would be made with the line from Mirfield to Bradford. This 7 mile long branch included a 1105 yard tunnel under Beacon Hill, just east of Halifax, and then a steep climb requiring substantial viaducts, bridges, tunnels, and earthworks to maintain a ruling gradient of 1 in 200. Once the line between Bradford and Low Moor had opened in May 1850, the connection from Halifax commenced on 7 August.

Following the completion of the main lines, several branches opened in the Halifax area, including a 3¾ mile line from Greetland to Stainland, opened on 1 January 1857. Some twenty years later, branches were opened to Sowerby Bridge, followed by a line from Halifax to Holmfield. This latter line had been opened by the GNR in September 1879, and was extended to Queensbury three months later. As well as giving access to the MR, it offered an alternative service between Halifax and Bradford, the GNR having taken over the Bradford, Eccleshill and Idle Railway, and the Idle and Shipley Railway (whose Acts had been granted in 1867) in 1875. Traffic was mainly coal freight from Wakefield, although seven GNR freight trains operated between Shipley and Quarry Gap Junction. One went to Keighley and another to Skipton. Although competition from the GNR forced the L&YR to improve its own services, both companies settled for peaceful coexistence, culminating in the opening of a joint station at Halifax in 1885. Both companies had their own goods yards, the L&YR at Shaw Syke, and the GNR near South Parade.

An independent company, the Halifax High Level Railway, opened in 1890 to serve the elevated suburbs of St Paul's and Pellon, west of the town. This line made a junction with the GNR at Holmfield. Its terminus was 300 feet above the main town station and was taken over by the L&YR and GNR. Passenger services were suspended in 1917, never to return: a victim of man and motive power shortages. Other casualties included closure of passenger services to Rishworth in July 1929, and to Stainland in September. Goods services to Rishworth disappeared in 1953, the branch closing completely in September 1958, and the line to Stainland closing a year later. The goods line to St Paul's closed in June 1960, although passenger services between Halifax and Holmfield had been withdrawn in 1955.

The 1960s saw severe railway cuts in the Halifax area; the only surviving passenger line is that from Milner Road Junction to Bradford. The line north east from Halifax now has no intermediate stations, and the junction at Low Moor has gone. In Bradford, Exchange station was closed on 14 January 1973, replaced by a new Bradford Interchange station in Bridge Street, which was designed to be a rail/bus/coach interchange facility. Trains from the new station included services to Leeds, York, Manchester, Liverpool, and Blackpool, and, of course, to Halifax. The MR station remains intact and services continue to run to Leeds, Skipton and beyond.

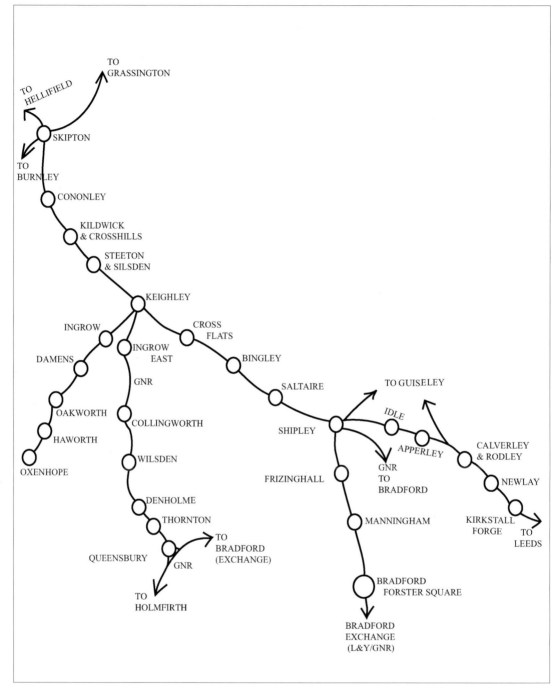

A map of the Midland Railway system around Bradford. (Author)

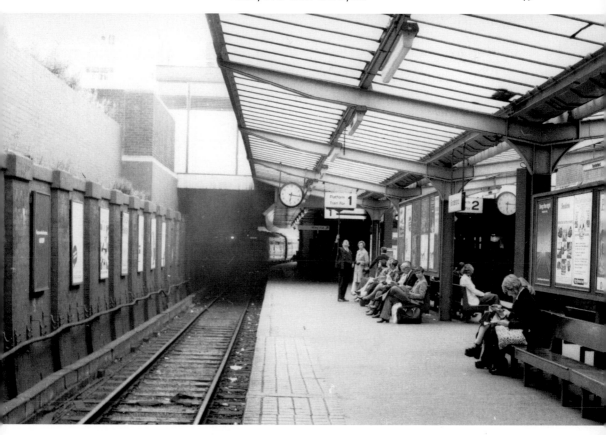

Platform one at Bradford Forster Square of the Midland Railway in the late 1960s, with a local train passing under a modern structure as it enters the station. (LOSA)

LEEDS, SHIPLEY, BRADFORD, BINGLEY, KEIGHLEY, SKIPTON, and HELLIFIELD.—Midland.

Down.	Week Days—*Continued.*															Sundays.						
St. Pancras Station,	aft	aft	aft	aft	aft	aft	aft	aft	aft	aft	aft	aft	aft	aft	aft	mrn	aft	aft	aft	mrn	ngt.	ngt.
538 Londondep.					4 55	4 55			6 0	6 0						9 30	9 30	9 30			12 0	12 0
Leeds (Wellington) .dep.		8 32		9 21	9 26		9 38	10 6	10 10		10 38	10 55		11 0	11 20		1 50	2 0	2 20	3 25	4 8	4 20
Holbeck (Low Level) ..		8 36																				
Armley		8 40					9 44			10 44									b	3 31		
Kirkstall		8 44					9 48			10 48									b	3 35		
Newlay and Horsforth ..		8 48			i		9 52		i	10 52		11 8	11 28						b	3 39		i
Calverley and Rodley		8 52		i			9 56		i	10 56		11 12	11 32						b		d	i
Apperley Bridge & Rawdn		8 57		i			10 1		i	11 1		11 17	11 37						b	3 46		i
Shipley (Station Road)*		9 5		9 45			10 10	10 32		11 9		11 25	11 45						b	3 56		4 39
Frizinghall		9 9			i		10 14		i	11 13		11 29	11 49									
Manningham		9 13			i		10 18		i	11 17		11 33	11 53				2 50			d		
Bradford †arr.		9 18		9 55			10 23	10 40		11 22		11 37	11 57				2 55			4 5		4 48
Bradford †dep.	9 0		9 20			10 20		10 32	10 47		11 5			11 35	1 15							
Manningham	9 4		9 24			10 24		10 36	10 51		11 9			11 39	f							
Frizinghall	9 7		9 27			10 27		10 39	10 54		Sat.			11 42								
Shipley (Sta. Rd.)* arr.	9 9		9 29			10 29		10 41	10 56		11 14			11 44	1 20							
Shipley (Station Rd.) dp.	9 13		9 30			10 30		10 43	10 57		11 15			11 49	1 21							
Saltaire	9 16		9 33			10 33		10 46			11 18			11 52								
Bingley	9 23		9 39	9 45		10 40		10 52	11 4		11 24			11 58	1 28							
Keighley ‡ 618	9 30		9 47	9 54		10 48		11 0	11 10		11 20	11 30		12 5	1 35		i				p	
Steeton and Silsden	9 38		9 55	10 2		10 55		11 7				12 12										
Kildwick and Cross Hills	9 43		10 0	10 7		11 0		11 12				12 17			f o							
Cononley	9 47		10 4	10 11		11 4		11 16														
Skipton 618 *and below*	9 30	9 53		10 10	10 20		11 10		11 22		11 35			12 24	1 51							
Gargrave	9 37																					
Bell Busk, for Malham..	9 44																					
Hellifield 620, 622 arr.	9 51			10 35			10 54				11 50					2 6	2 38	2 50				
622 HEYSHAM arr.				11 47			11 47															
620 CARLISLE (Citadel) ıı																4 15	4 15	4 30				6 25

Down.	Sundays—*Continued.*																					
St. Pancras Station,	ngt.	mrn	mrn	mrn	aft	aft	aft	aft	mrn	mrn	aft	aft	aft	aft	aft	aft	aft	aft	aft	aft	aft	
544 Londondep.	12 45								11 30	11 30			4 0									
Leeds (Wellington) dep.	6 30	8 0	9 30	11 15	12 55		2 10	3 55	4 52	5 12	5 25	5 30		7 30	8 30	9 0	9 25			10 35	10 55	
Holbeck (Low Level)..			9 34	11 19			2 14							7 34	8 34							
Armley	6 36	8 6	9 37	11 22	1 1		2 17	4 1			5 36			7 37	8 37		9 31			10 41		
Kirkstall	6 40	8 10	9 41	11 26	1 5		2 21	4 5	n		5 40			7 41	8 41	i	9 35			10 45		
Newlay and Horsforth..	6 44	8 14	9 45	11 30	1 9		2 25	4 9	n		5 44			7 45	8 45	i	9 39			10 49		
Calverley and Rodley ..	6 48	8 18	9 49	11 34	1 13		2 29	4 13	n		5 48			7 49	8 49	i	9 43			10 53		
Apperley Bridge & Rawdn	6 53	8 23	9 54	11 39	1 18		2 34	4 19	n		5 53			7 54	8 54	i	9 48			10 58		
Shipley (Station Road)*	7 0	8 31	10 2	11 47	1 27		2 43	4 27	n		6 1			8 3	9 3	9 19	9 56		11 7			
Frizinghall		8 35	10 6	11 51	1 31		2 47	4 31	n		6 5			8 7	9 7	i	10 0		11 11			
Manningham	7 12	8 39	10 10	11 55	1 35		2 51	4 35	n		6 9			8 11	9 11	i	10 4		11 15			
Bradford † arr.	7 17	8 44	10 15	12 0	1 40		2 55	4 40	5 20		6 15			8 15	9 15	9 30	10 8		11 20			
Bradford †dep.	6 45	8 30	10 5		1 20	2 10	3 0	4 40			5 55	7 5	8 25		9 20	9 58	10 45					
Manningham	6 49	8 34	10 9		1 24	2 14	3 4	4 44			5 59	7 9	8 29		9 24	10 2	10 49					
Frizinghall		8 37	10 12		1 27	2 17	3 7	4 47			6 2	7 12	8 32		9 27	10 5	10 52					
Shipley (Sta. Rd.)* arr.	6 53	8 39	10 14		1 29	2 19	3 9	4 49			6 4	7 14	8 34		9 29	10 7	10 54					
Shipley (Station Rd.) dp.	7 7	8 42	10 15		1 35	2 20	3 11	4 51			6 6	7 17	8 35		9 35	10 9	10 55					
Saltaire		8 45	10 18		1 38	2 23	3 14	4 54			6 9	7 20	8 38		9 38	10 12						
Bingley	7 15	8 52	10 25		1 44	2 30	3 21	5 0		5 47	6 16	7 27	8 45		9 45	10 19	11 2					
Keighley ‡ 618	7 24	9 1	10 31		1 52	2 36	3 27	5 10		5 55	6 22	7 36	8 51		9 53	10 25	11 8			11 20		
Steeton and Silsden	7 32	9 11			1 59		5 19			d		7 44			10 0							
Kildwick and Cross Hills	7 37	9 17			2 4		5 24					7 49			10 5							
Cononley	7 41	9 22			2 9		5 29					7 54			10 9							
Skipton 618 *and below*	7 52	9 28			2 20		5 35		5 50	6 13		8 0			10 15					11 35		
Gargrave	7 59				2 27				5 57													
Bell Busk, for Malham..	8 6				2 34				6 4													
Hellifield 620, 624 arr.	8 13				2 41				6 11											11 50		
624 HEYSHAM arr.																						
620 CARLISLE (Citadel) ıı																						

b Stops when required to set down.	**o** Stops to set down from Leeds.	* About ¼ mile from G.N. (Bridge Street) Station.
d Set down from South of Leeds.	**p** Sets down from London, also takes up for Carlisle and Scotland if required.	† Market Street Station.
f Takes up for Carlisle and Scotland.	**q** Saturday nights.	‡ Station for Worth Valley.
i Set down from London.		
n Sets down from South of Sheffield.		

☞ For **OTHER TRAINS** between Leeds and Calverley, see page 616; between Shipley and Bradford, see pages 613 to 617.

Above and Opposite: A 1910 Midland Railway timetable for passenger services between Bradford, Leeds, Skipton, and Hellifield. (Author)

HELLIFIELD, SKIPTON, KEIGHLEY, BINGLEY, BRADFORD, SHIPLEY, and LEEDS.—Midland.

Up. Week Days.

Miles from Hellifield	Citadel Station,	mrn	mrn	mrn	mrn	mrn		mrn	mrn	mrn	mrn	mrn	mrn	mrn		mrn		mrn	mrn	mrn	mrn	mrn	
	621 CARLISLEdep.	12 7	1227	1230			1230	1 35	1 35						6 15							
	623 HEYSHAM "																						
	Hellifield..........dep.	1245														7 10					7 32	
3¾	Bell Busk, for Malham..																				7 40	
6¼	Gargrave............																				7 47	
10	Skipton	1 1			2 20			2 25	3 23	3 30		5 0	5 30	6 45						8 0	8 22		
13	Cononley											5 7	5 37	6 54						8 6			
14¾	Kildwick & Cross Hills.											5 11	5 41	6 59						8 10			
16	Steeton and Silsden....											5 16	5 47	7 5						8 15			
19	Keighley ‡ 381, 618 ..	1 16						2 43		3 48		5b29	6r17	7 14	7r27		7 39			8 0	8 22	8 37	
22½	Bingley											5 36	6 24	7 24	7r35					8 11	8 28	8 44	
24¼	Saltaire............[616											5 42	6 30	7 30	7r41					8 17	8 33		
25½	Shipley (Sta. Rd.)* .arr.							2 54		4 0		5 44	6 32	7 32	7 43					8 19	8 35		
—	Shipley (Sta. Rd.) dep.							2 55		4 1		5 46	6 33	7 34	7 45					8 25	8 36		
26	Frizinghall											5 50	6 37	7 38	7 49					8 28			
26¾	Manningham	1 37										5 54	6 41	7 43	7 53					8 31			
28	Bradford (Mrket St.)a	1 40						3 5		4 10		5 57	6 45	7 48	7 58					8 35	8 42		
—	Bradford (Mrket St.)d		2 5									5 0	6 0	7	5 7	30			7 40	8 0	8 15	8 45	
—	Manningham											5 4	6 4	7 9						8 4	8 19	8 49	
—	Frizinghall											5 8	6 7	7 12						8 7	8 22	8 52	
—	Shipley (Station Road)*		i									5 9	6 10	7 16	7 36					8 10	8 24	8 56	
28¾	Apperley Bdg & Rawdon....											5 15	6 16	7 25	7 43					8 16	8 32	9 2	
30¼	Calverley and Rodley..											5 19	6 20	7 29						8 20	9 6		
31¾	Newlay and Horsforth..											5 23	6 24	7 33						8 24	9 10		
33	Kirkstall											5 27	6 28	7 37						8 28	9 14		
34¼	Armley............											5 32	6 33	7 43						8 33	9 19		
35¾	Holbeck (Low Level) 708											5 36	6 37	7 49						8 37	9 23		
36	Leeds (Wllngtn) 548 arr	1 50	2 27	2 34	2 50	2 52		3 56				5 39	6 40	7 50	7 55		8 3		8 18	8 40	8 45	9 26	9 6
233¾	549 London (St. Pan) arr.	7k30	7k30	7 0	7 30	7 35		8 5		x1040			12 5	12 5	1 15		12 5		1 15				

Up. Week Days—Continued.

	mrn	mrn	mrn	mrn	W	mrn	mrn	mrn		mrn	mrn	mrn	mrn	non	aft	mrn	aft	aft	aft	
621 CARLISLE (Citdel) dp																8 35				
623 HEYSHAM...... "	6 45		7 30	7 30		7 30							9 45		9 45					
Hellifield..........dep	8 14		8 35	8 50		9 23	9 37					1134		1151						
Bell Busk, for Malham..	8 21		m											1158						
Gargrave............	8 27		9 0		9 33	o								12 4						
Skipton............	8 33	8 26	9 7		9 12	9 44	9 58		10 2		1048		12 4		1214				1248	
Cononley............	Stop	8 33			9 19				10 9		1055				1221				1255	
Kildwick & Cross Hills.		8 37			9 23	9 53		1013		1059				1225					1259	
Steeton and Silsden....		8 42			9 23			1018		11 4				1231				1 4		
Keighley ‡ 381, 618 ..	mrn	8 50	9 29	21		9 36	10 2	1013	1026	1055	1112	12 0	1223	1219		1239		1 12		
Bingley............	8 32	8 57	9 28			9 44		1022	1033	11 3	1119	12 8	1231			1247		1 18		
Saltaire............[616	8 38	9 3	9 33			9 50	1012		1039	11 9	1125	1214	1237			1252		1 25		
Shipley (Sta. Rd.)* arr	8 40	9 5	9 35			9 52	1014		1041	1111	1127	1216	1239			1254		h		
Shipley (Sta. Rd.) dep.	8 41	9 6	9 13	9 37		9 40	9 54	1016	1042	1113	1128	1217	1240		1256		1 31			
Frizinghall	8 45	9 10				9 44	9 58		1046	1117	1132	1221	1244		1 0		1 35			
Manningham	8 49					9 48	10 2		1050		1136	1225	1248		1 4		1 39			
Bradford (MrketSt.) a	8 53	9 16	9 20	9 44		9 52	10 6	1023	1055	1123	1140	1230	1252		1 9		1 43			
Bradford (Mrket St.) d		9 10			9 40		9 45		1025	1045		1130			1217	1253	5	30		
Manningham		9 14			b		9 49		f	b		1134			b		1 9	b		
Frizinghall		9 17			b		9 52		f	b		1137			b		1 12	b		
Shipley (Sta Road)* dep		9 20			9 48		9 55		f	1054		1140			n	1259	1 15	b		
Apperley Bdg. & Rawdon..		9 26			b		10 1		f	11 0		1146			1237		1 21	1 39		
Calverley and Rodley..		9 30					10 5		f	11 4		1150					1 25	1 44		
Newlay and Horsforth..		9 34					10 9		f	11 9		1154					1 29	1 49		
Kirkstall		9 38					1013		f	b		1158					1 33	1 54		
Armley............		9 44					1019		f	b		12 4				1 14	1 38	2 0		
Holbeck (Low Level) 708		g															1 42			
Leeds (Wllngtn) 548 dep		9 48	9 30		10 5		1023		1042	1050	1117	12 8			1243	1250	1 20	1 45	1 56	2 4
549 London (St. Pan) arr	2 10				2 10		4 0		4 0	4 0		5 20			5 20	5 20		6 30	6 30	

Notes column (right side):
Belfast Boat Express. Leaves Belfast at 10 15 aft., see page 623.
Belfast Boat Express. Leaves Belfast at 10 15 aft. Except Mondays.
Mondays & Thursdays.
Saturdays only.
Runs 2 minutes earlier on Saturdays.
Through Train from Carnforth, see page 623.
G. N. (Bridge Street) Station.
About ⅓ a mile from G. N. Station for Worth Valley.
For Continuation of Trains, see page 614.

Footnotes:

a Take up for Sheffield & South thereof.
b Stop to take up for London.
b Arrives at 5 22 mrn.
c Stop when required to set down.
d Set down from Carlisle and Scotland.
f Takes up for Birmingham and beyond.
g Set down on Tuesdays if required.
h Stop to set down.

i Stops to set down, also takes up for Sheffield and South thereof when required.
¿ Passengers from Stations North of Shipley for Sheffield and beyond wishing to join the Express Trains at Shipley should give notice immediately on reaching that Station.

k Arrives at 7 mrn. on Mondays.
n Take up for Leeds and beyond.
o Sets down from the Furness Line.
q Stops on Tuesdays to take up.
r Arrives at 5 53 mrn.
w Through Carriage, Bradford to Folkestone, Dover, Deal, &c., see page 550.
x Mondays only.

☞ For OTHER TRAINS between Shipley and Bradford, see pages 610 to 612, 616 and 617; between Calverley and Leeds, see page 617.

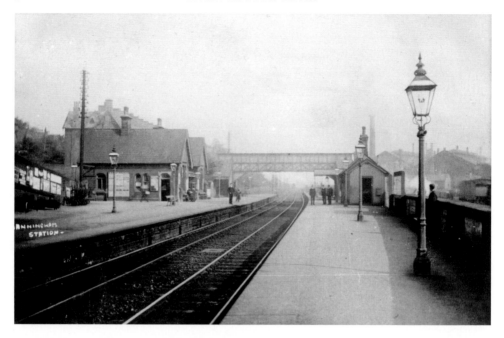

Opened on 17 February 1868, the first station on the MR line from Bradford was at Manningham, seen here in the early twentieth century. In the background to the right is the locoshed. This shed had an enclosed roundhouse of Midland design and an allocation of forty-five engines in 1950, reducing to twenty-five in 1959, and eleven in 1963. Coded 20E after nationalisation, it was changed to 55F in 1957, and was closed in 1967. An allocation from the 1950s gives an idea of the engines at Manningham at this time:

Ex MR 2P 4-4-0	40455, 40489, 40562
Ex MR 4P 4-4-0	41197, 41080
Ex LMS Fowler 4MT 2-6-4T	42380, 42685
Ex LMS 'Crab' 2-6-0	42762
Ex MR 3F 0-6-0	43178, 43351, 43770
Ex LMS 4F 0-6-0	44216, 44400, 44555, 44570
Ex LMS Ivatt 2MT	46452, 46453
Ex LMS 3F 0-6-0T	47222, 47255, 47419
Ex L&YR 2P/3P 2-4-2T	50023, 50630, 50633, 50634, 50636, 50671, 50681, 50689, 50714, 50795, 50842
Ex MR 1P 0-4-4T	58069, 58070
Ex MR 2F 0-6-0	58154
	TOTAL: 34

(LOSA)

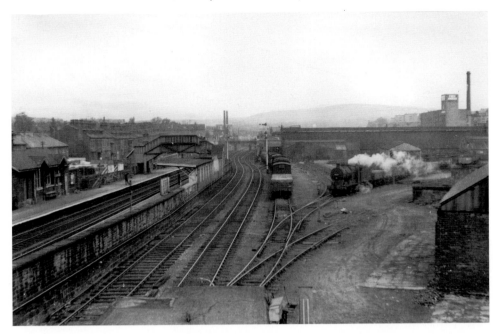

Frizinghall station in around 1950, with ex LMS 4F 0-6-0 shunting in the yard. The station opened here in February 1865. In 1874, the MR proposed a plan for a line running north from Royston, via Crigglestone and Dewsbury, to Bradford, and then to descend and join the Leeds line near Frizinghall at a cost of around £1½ million, but the Bill was rejected. However, the MR had opened the line from Keighley to Oxenhope at around the same time. (R. Carpenter)

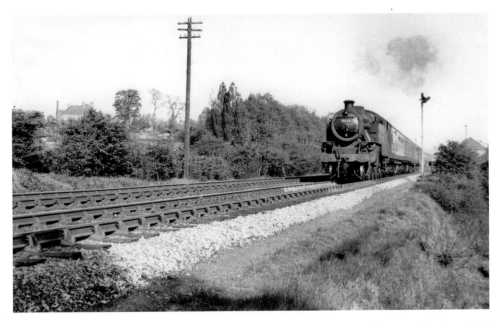

Running along the Shipley–Bradford line is ex LMS Fairburn 2-6-4T, with a train from Bradford in the 1950s. (E. Johnson)

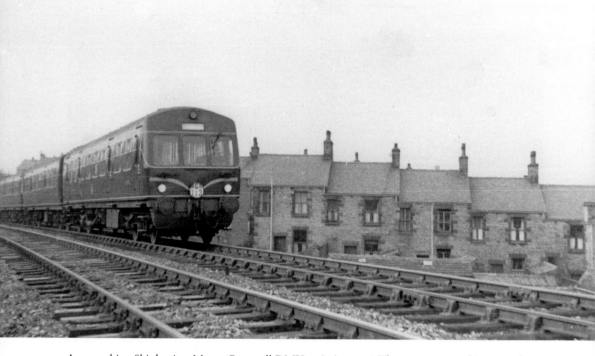

Approaching Shipley is a Metro-Cammell DMU train in 1956. These sets were taking over from steam at a rapid rate by this time, although they could be unreliable. Shipley was to be the first intermediate station to be built by the Leeds and Bradford Railway, and a temporary station was built immediately north of Dumb Lane, now Valley Road, some quarter of a mile south of the future permanent station. This original station had a single island platform made up of planks laid on the ground. As this appeared to be dangerous, the L&B agreed to have two 200 feet long outside platforms. The timber main building was 30 feet long and situated on the Up side. The railway at first crossed Dumb Lane on the level, but a road overbridge was provided for road traffic in 1847. A three track goods yard was provided with access from Dumb Lane and a 30 foot by 40 foot goods shed was also provided. This temporary station was intended to last for only a short period and plans were prepared for a new station on 29 March 1848. These were approved in May and Sugden, Simpson and Co. were given the contract for the main building in June, with work commencing in August. (R. Carpenter)

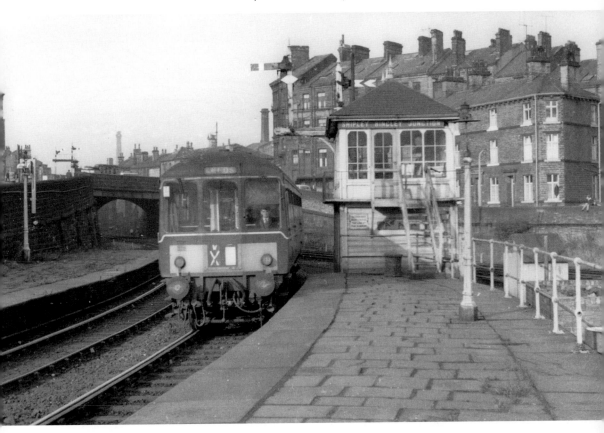

Another DMU waits at Shipley station in the late 1950s with a train for Leeds. The new station was situated in the fork immediately north of the Bradford Junction. It was provided with four platforms, nos one and two on the Bradford Junction–Bingley Junction curve, and nos three and four on the Bradford Junction–Leeds Junction curve. The main station building was designed by Andrews and Delauney and was situated in the fork at the south end of platforms two and three. The new building offered a spacious booking hall and separate waiting rooms for each class of passenger. To make the station accessible from the town, a new road named Station Road was laid from Market Place, and ran behind platform one. All passengers had to cross on the level at the south end of the platforms to reach the booking office, and only small, open shelters were provided on platforms one and four. These inconveniences were to bring many complaints later. This new station was brought into use in the summer of 1849, and the old station building was dismantled and sent to Elslack to serve as a temporary station there. A new goods shed was provided in 1849 on the Up side of the Bradford Junction; it had a 2,500 gallon water tank on its roof for station and locomotive purposes. As the line to Skipton was fast becoming the most important, plans were drawn up to move Shipley station to the north end of the triangle. Instructions were given for plans to be drawn up in 1869, but nothing further was done and it would be another 109 years before Shipley had a platform on the main line. (LOSA)

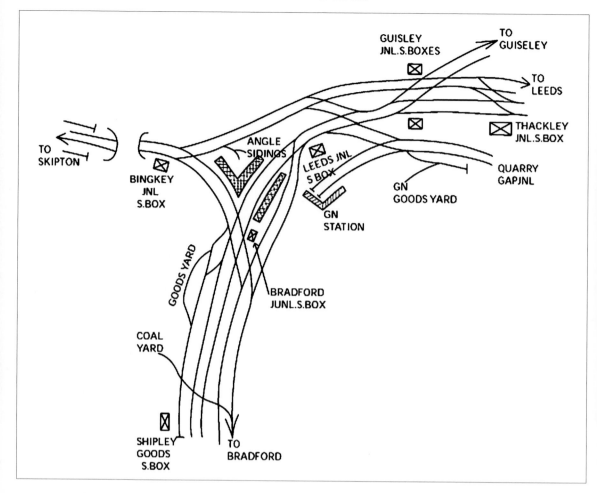

A plan of Shipley station as it appeared in 1905. As can be seen, the GNR had a presence at Shipley, thereby breaking the MR monopoly here. The GNR opened a branch from Laister Dyke to Shipley, which had been authorised in 1866/7 and opened to goods on 4 May 1874. Passenger services along the line opened on 15 April 1875. The GNR line was rather circuitous and of no real threat to the Midland as far as passengers were concerned, but freight was another matter. The GNR had provided a twelve road goods yard at Shipley, which was more spacious than that of the MR, and several coal merchants were attracted there. The MR was forced to improve its goods facilities. Work on a new South Yard was started in 1875/6, building on land newly purchased south of Valley Road. A new road viaduct was built in connection with this project. In 1877/8, the existing goods yard was given a new layout, and no further enlargement was ever needed. Quadruple track was also laid at this time from Shipley to Manningham. A line from Apperley Junction to Ilkley had been opened in 1865, and services between Bradford and Ilkley were introduced by detaching a portion of the Bradford–Leeds train at Apperley Junction and leaving it to be collected by the next Leeds–Ilkley train. To end this practice, the MR (Additional Powers) Act of 1872 authorised construction of a direct line from Shipley to Guisley, which was opened to passengers on 4 December 1876, and to goods on 13 December. This brought a new junction to Shipley (Guisley Junction), and was the last new line to be opened in the area. The MR signalbox, seen in the previous picture with a frame of forty levers, was opened in May 1901 and went out of use in 1965. (Author)

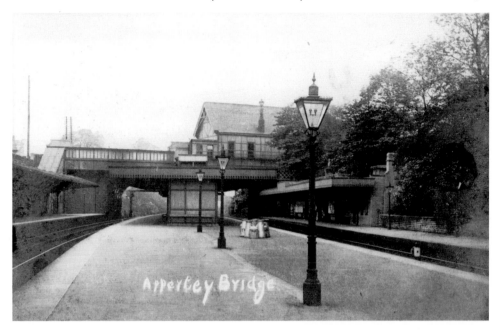

Heading towards Leeds from Shipley, the line passes through Idle and then enters Apperley Bridge, seen here in the early twentieth century. It was here that the junction to Guisley and Ilkley commenced. (LOSA)

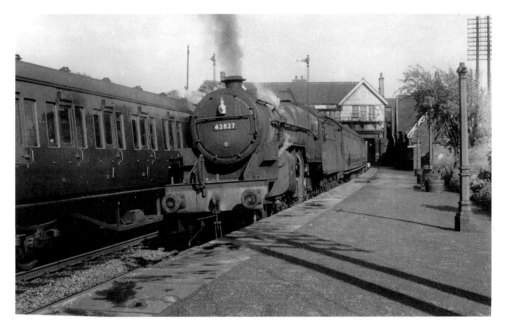

The next station on the line is Calverley and Rodley with ex LMS 'Crab' 2-6-0 no. 42827 of Saltley shed, Bimingham (21A), on a local service for Skipton. This station was another junction for Guisley, forming a triangle of trains from Leeds that used this branch to Ilkley and collected the train stock from Bradford. The locomotive is certainly a long way from home and was, perhaps, running in after overhaul at Horwich. (R. Carpenter)

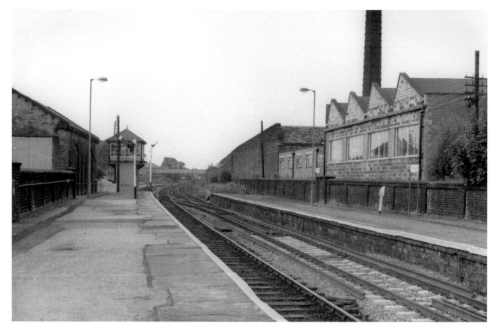

Guisley, seen here in the late 1960s, is the point where the junctions from Shipley and Calverley meet. (LOSA)

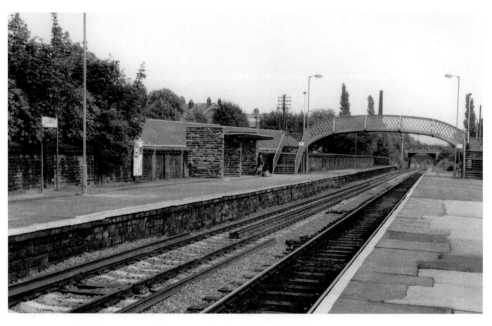

Another view of Guiseley station in the 1970s, with a new stone waiting shelter in view. From here, the line will head off to Ilkley via Manston, where a triangle was formed with the NER line. (LOSA)

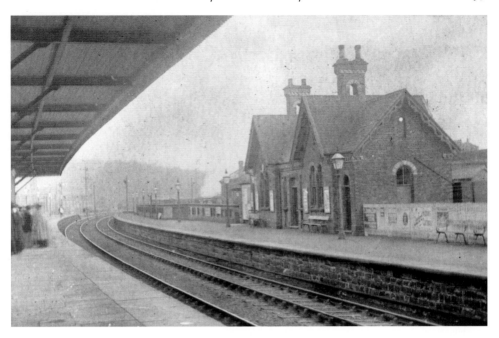

Back on the main line to Leeds, the next station was Newlay and Horseforth, seen here with its typical MR station buildings in the early twentieth century. (LOSA)

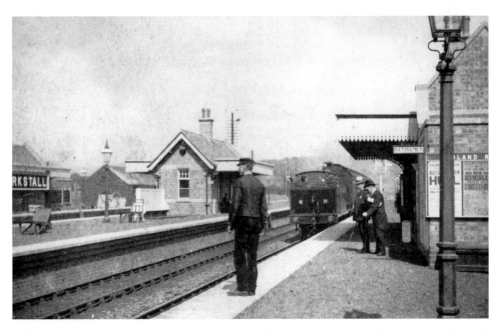

Following Newlay, the next station is at Kirkstall. Forge was once added, with a MR tank locomotive, possibly one of the Johnson 0-4-4Ts at the head of a local service. (LOSA)

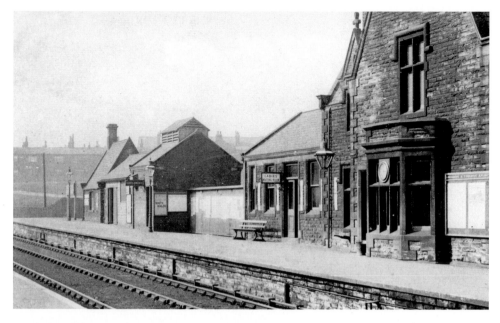

Armley station is passed on the way to Leeds Wellington. The area is famous for its local prison. (LOSA)

Heading towards Skipton from Shipley, the main line passes through Saltaire, now a World Heritage site because of the 'Model Village' built by mill owner Josiah Salt to house his mill workers. This was one of the many villages set up by philanthropic employers in the nineteenth century. Others were at Bournville in Birmingham, built by the Cadbury family, Port Sunlight on the Wirral in Cheshire, built by the Lever Brothers, and there was another in Norwich, built by the Colman's mustard family. After leaving Saltaire, the next station is at Bingley, seen here in the 1970s. This line is now electrified from Leeds to Skipton, with frequent electric trains operating through the day, proving that the railway is still very much alive. (LOSA)

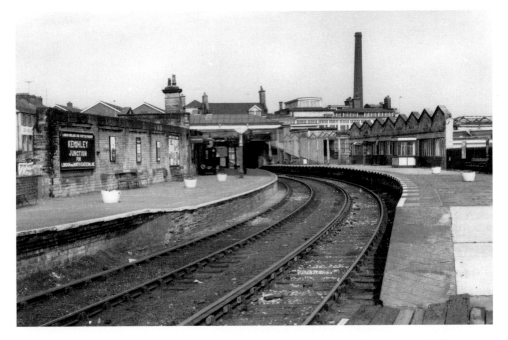

From Bingley, the line runs through Cross Flats and then enters Keighley, seen here before 1955. The 'London and North Eastern line' is the old GNR line to Queensbury for connections to Halifax and Bradford Exchange. This side of the station is now the site of the terminus of the preserved Keighley and Worth Valley Railway. The old MR station canopies can be seen over the platform. (LOSA)

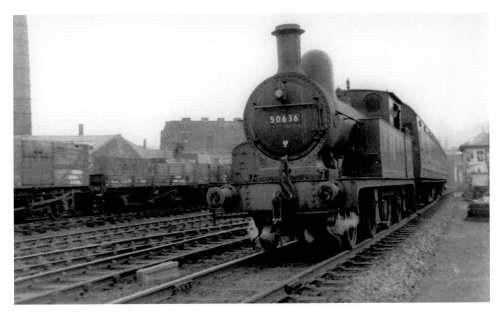

Ex L&YR Aspinall 2-4-2T no. 50636 heads a local train from Bradford through Keighley in 1956. Keighley also had a small locoshed, providing locomotives for local freight traffic and passenger services along the Worth Valley line. It was a sub-shed of Skipton. Coded 20F, it had an allocation of five engines in January 1954: two ex MR 3F 0-6-0s, one ex LMS 2MT 2-6-2T, and two 'Jinty' 3F 0-6-0Ts. (R. Carpenter)

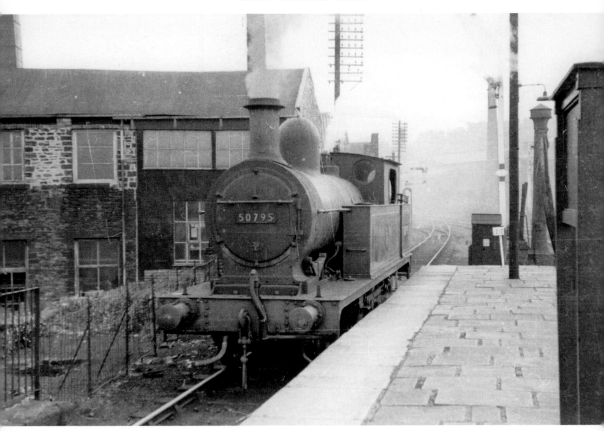

Another ex L&YR Aspinall 2-4-2T, no. 50795, sits at the platform end of Keighley station awaiting its next turn of duty. (R. Carpenter)

A MR timetable for local services between Keighley and Oxenhope on the Worth Valley Railway. (Author)

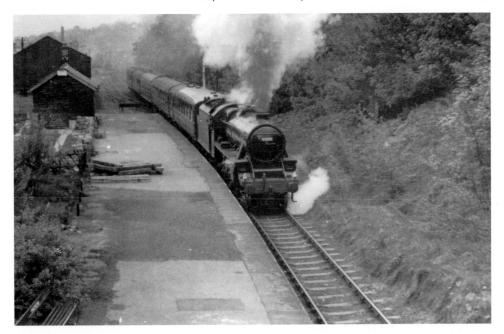

Keighley was connected to the expanding railway network on 16 March 1847, with the opening of the Leeds and Bradford Extension Railway, the line being absorbed into the MR in August 1852. Keighley was, at that time, the railhead for the Worth and Bridgehouse Valley mills, supplying large quantities of wool. In order to reduce overheads, the mill owners were quickly involved in proposals for several schemes to build a line between Oxenhope, Haworth, and Keighley. Proposals had been made in 1845 and 1853, but these came to nothing. However, a new plan by John McLandsborough was submitted to parliament in 1861, and gained Royal Assent on 30 June 1862. The railway was to leave Keighley station in a south easterly direction and climb at 1 in 58 on a 9 chain curve to follow the Worth Valley heading south west to Ingrow, Damens, Oakworth, Haworth, and Oxenhope, where it was to terminate near the junction of Weasel Lane and Moor House Lane. The ceremonial cutting of the first sod took place on 9 February 1864, but difficulties with the construction of Ingrow Tunnel meant that it was not until autumn 1866 that works trains were able operate and complete the 4 mile line between Keighley and Oxenhope. Principal civil engineering works were the 120 foot bridge over the River Worth at Keighley, Ingrow Tunnel, and Vale Mill viaduct, which was originally a 30 span wooden trestle viaduct which carried the railway over the River Worth and a mill dam at Oakworth. Violent storms on 14 November 1866 undermined embankments and cuttings which prevented the opening of the line; remedial work meant that the official opening had to be delayed until Sunday 13 April 1867. Even then, bad luck continued when the first train stalled on the 1 in 58 gradient out of Keighley, but celebrations continued regardless. The first day of normal services, on Monday 15 April, saw a timetable of six return passenger workings, with two on Sundays. Within six months, Sunday services were increased to four workings each way. The first train of the day worked from Oxenhope, necessitating an empty stock working from Keighley. Goods services were good, with the MR guaranteeing that any goods delivered to stations along the branch before 10 a.m. would be delivered anywhere in the West Riding on the same day. The line also brought cheaper coal, to the benefit of both industrial and domestic users, and allowed both Haworth and Oakworth to build their own gasworks. In 1869, a small locoshed was built on the Skipton side of Keighley station to house the branch engine, and a new station was opened at Keighley in July 1878 to accommodate the new GNR Keighley–Queensbury–Bradford–Halifax line. In this photograph of Ingrow in the late 1950s, ex LMS 'Black Five' no. 45212 arrives with a local service to Oxenhope. (LOSA)

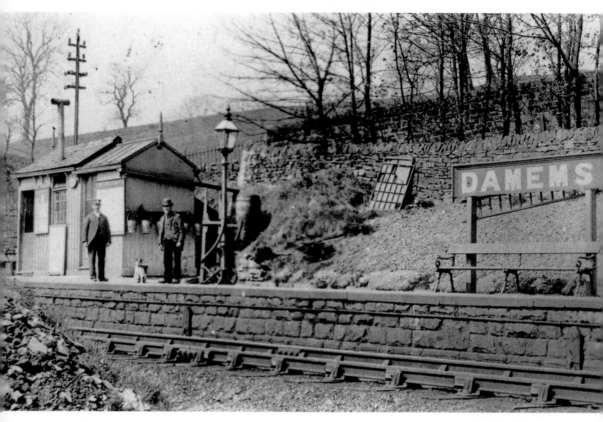

Damems station in MR days with its staff of two (and the dog). This little station was closed in 1949 and only reopened in preservation days, and then only as a request stop. The line to Oxenhope was always difficult to work, as there were no passing loops; on 9 September 1875, the 6.15 a.m. pick-up goods and empty coaching stock ran away downhill from Oakworth and hit a passenger train at Keighley, resulting in fourteen casualties. (LOSA)

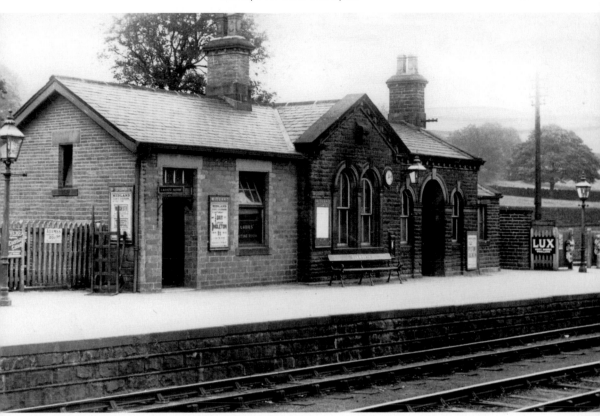

Oakworth station at the beginning of the twentieth century. By 1875, the branch was being worked by Johnson 0-6-0Ts; with the advent of heavier trains the condition of Vale Mill Viaduct was becoming a cause for concern as the foundations appeared to be shifting. Plans were drawn up to replace it with a stone viaduct and a 73 yard long tunnel. This new deviation was brought into use on Sunday 6 November 1892. By the 1890s, other improvements were being made, with good loops and signalboxes provided at Oakworth. Extensions to the station buildings at Haworth, Oakworth and Oxenhope were also in hand. By the summer of 1903, there were sixteen passenger trains each way in the week and six on Sundays. There was little change following the Grouping; ex MR 0-6-0Ts and 0-6-0 tender engines were the usual motive power. In 1935, when Keighley became a sub-shed of Skipton, push-pull trains were introduced, powered by Johnson 1P 0-4-4-Ts. There was still plenty of traffic by 1938, with seventeen daily departures from Keighley and nineteen from Oxenhope. The Second World War caused a curtailment of services; in the following years, there was a 50 per cent cut in the number of pre-war trains. On 21 May 1949, Damems station was closed. (LOSA)

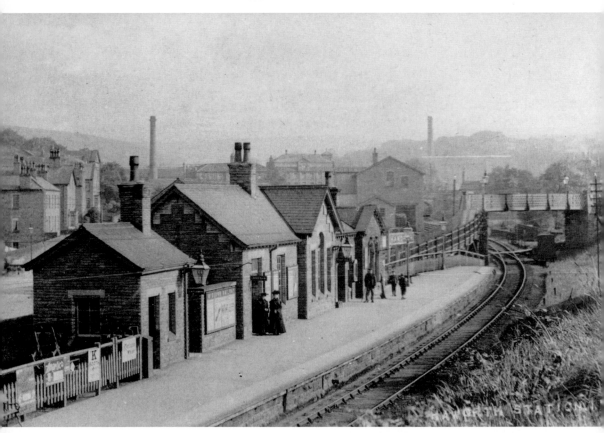

Haworth station in the early years of the twentieth century, with the village in the background. Haworth has long been famous as the home of the Brontë sisters, although they were actually born in Bradford, their parents having married at Guiseley. Their father, Revd Patrick Brontë, moved the family to Haworth in 1820. There is little doubt that the family's residence in Haworth did much for tourism in the area. This was to the benefit of the railway, both as part of the national network and in preservation. Following nationalisation, new Ivatt 2-6-2Ts worked passenger trains over the branch, eventually replacing the MR 0-4-4Ts. In 1956, three coach motor trains with gangwayed stock were introduced, these being worked by Ivatt or BR Standard 2-6-2Ts. Goods trains were still worked by 3F 0-6-0s, and a midday passenger service was hauled by an Ivatt 4MT 2-6-0 or Fairburn 2-6-4T to Oxenhope. In 1955, the ex GNR line to Queensbury was closed, resulting in increased goods traffic over the Worth Valley line. However, road haulage and competing bus services began to erode railway traffic levels and, in July 1959, BR announced its intention to close the line, despite annual passenger figures of 130,000. The line was reprieved when DMUs were introduced and peak time traffic increased. BR, however, were determined to close the line; passenger services were withdrawn on 31 December 1961. Goods traffic continued until June 1962; on 18 June, a 'last' passenger train worked over the line, hauled by ex MR 3F 0-6-0 no. 43856. As we know, however, this was not to be the final train to run over the line, but more on that later. (LOSA)

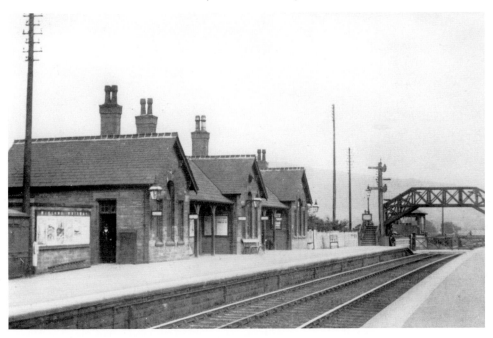

Back on the main line, the next station from Keighley on the way to Skipton was Steeton and
Silsden. The very trim station is seen here early in the twentieth century. (LOSA)

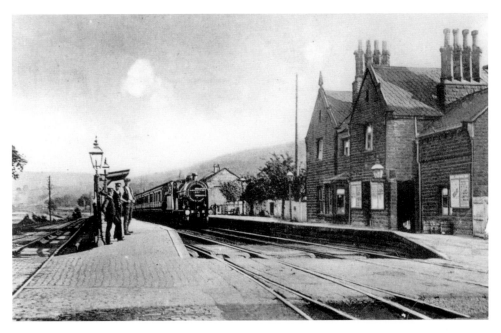

From Steeton, the line passes through Kildwick and Crosshills before entering Cononley station.
The station is seen here in MR days with a 2P 4-4-0 approaching with a passenger train. (LOSA)

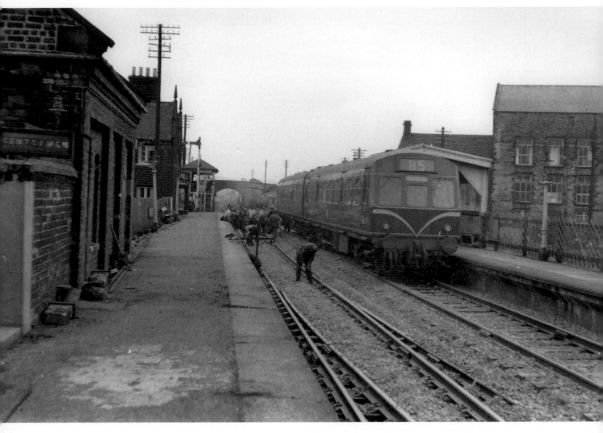

Some fifty years later, and the scene is somewhat different. New buildings have sprung up, and the local train is now a DMU as steam is beginning to be phased out. (R. Carpenter)

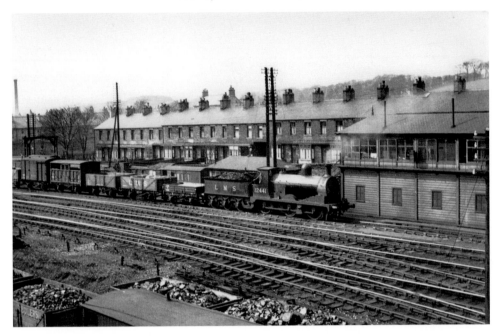

Approaching Skipton station in the 1930s is ex L&YR Barton-Wright 0-6-0, with LMS no. 12441 (on the duplicate list) at the head of a loose coupled freight train in the late 1930s. (R. Carpenter)

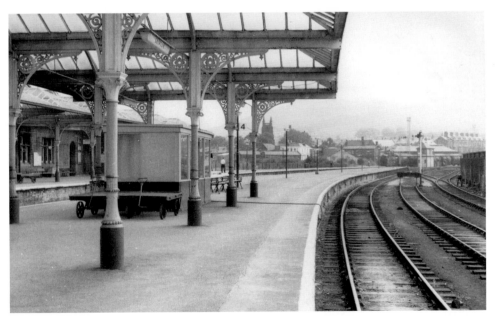

Skipton station with typical MR canopies over the island platform. Skipton was originally a trading centre for sheep and wool. The first part of the Leeds–Liverpool canal from Skipton to Bingley was opened in 1773, with its full 127 miles not being completed until 1816. Skipton also has a castle which was besieged for over a year by Cromwell's troops during the Civil War. It finally surrendered in 1645. (LOSA)

GRASSINGTON and SKIPTON.—Midland.

Miles	Up.	Mons.	Week Days.											Sundays.			
			mrn	mrn	mrn	aft	aft	aft	aft					mrn	mrn		§ Station for Cracoe and Hetton.
	Grassington & Threshfield dep.		7 15	7 45	9 12	1215	3 50	5 15	8 10	9 25	7 55	
3¾	Rylstone §		7 24	7 54	9 21	1224	3 59	5 24	8 19	9 34	8 4	
10¼	Skipton 610, 618, and above arr.		7 41	8 14	9 38	1241	4 16	5 42	8 36	9 52	8 21	

Two MR timetables for trains over the branch to Grassington in 1910. (Author)

SKIPTON and GRASSINGTON.—Midland.

Miles	Down.	Sats.	Week Days.						Sundays.		§ Station for Cracoe and Hetton; ‖ for Linton, Kilnsey, Coniston, Kettlewell, Starbotton and Buckden.		
			mrn	mrn	aft	aft	aft	aft	mrn	aft			
	Skipton dep.		8 37	1140	1 10	3 12	4 38	5 55	7 35	8 45	7 0	
7¾	Rylstone §		8 57	12 0	1 30	3 32	4 58	6 15	7 55	9 5	7 20	
10¼	Grassington & Threshfield ‖ arr.		9 5	12 8	1 38	3 40	5 6	6 23	8 3	9 13	7 28	

SKIPTON, EARBY, and COLNE.—Midland.

Miles from Skipton	Down.		Week Days.																	Sundays.			
		ngt.	mrn	mrn	mrn	mrn	mrn	aft	aft	aft	mrn	mrn	aft	aft	aft	aft	aft	aft	aft	ngt	non	mrn	aft
	610 London dep.	12 0	5 0		aft		9 30	1130	1 30		2 5	3 30	4 55	6 0	12h0	1130
	610 Leeds (Wellington)	4 56	6 35	7 0 10 0	6	1040			2 40	3 84	40	4557	5 43		7 0	7 50	9 21	1055	8 0	5 12	5 30
	610 Bradford (M. St.)	5 55	7 1	7 32 9 35		1038		1228		3 12	4 3 53	5 18	6 5		7 35	9 20	1047	8 30	4 40	7 5
	Skipton dep.	7 8	8 20	8 48 1041		12 0	1225		3 52	5 0 6 36	6 18	7 18		8 40	9 5	1032	1145	1027	5 52	8 30	
3¾	Elslack		7 10	8 26 8 58 1050		12 9	1224	1 25	4 15 7	6 24	7 27		8 47	9 14	Sat.		1036	6 1	8 39	
5½	Thornton		7 15	8 30 1054		1213	1238	1 38	4 55 11	6 28	7 31		8 51	9 18		1040	6 5	8 43
6½	Earby 619		7 22	8 36	9 5 1059	1149	1219	1244	1 42	2 32	4 10 5 15	5 47	6 36	7 36	8 30	8 55	9 23	1045	1159	1046	12 0	6 10	8 48
9	Foulridge		7 31	8 43	9 13 11 7	1156	1227	1252	1 49	2 40	4 18 5 23	5 53	6 43	7 44	8 37	9 2	9 30	‡		1055	12 8	6 18	8 57
11¼	Colne 746, 771 arr.	7 37	8 50	9 18 1112	12	1232	1258	1 54	2 45	4 23 5 29	6 0	6 48	7 49	8 42	9 7	9 35	1057	12 8	11 2	1213	6 25	9 4	

Miles	Up.		Week Days.														Sundays.				
		mrn	mrn	mrn	mrn	mrn	aft	aft	aft	aft	aft	aft	aft	aft	aft	mrn	mrn	aft	aft		
	Colne dep.	6 10	7 46	8 55 1020	11 0	1213	1 5	1 45	2 34	3 0	3 48	4 56	5 40	6 30	7 57	8 37	1035	9 32	1130	5 0 7 35	
2¼	Foulridge	6 17	7 52	9 1 Mu	11 6	1219	1 21	1 51		3 6	3 53	5 15	45	6 35	8 28	43	1041	9 38	1136	5 6 7 41	
4½	Earby 619	6 22	7 59	9 8 1029	1113	1225	1 28	1 58	2 43	3 11	3 58	5 8	5 50	6 41	8 7	8 50	1048	9 44	1141	5 12 7 47	
6	Thornton		8 3	9 12 1033	1117	1229	1 32	2 2		4 3	5 11	6 46	8 54			9 48	5 16 7 51	
7½	Elslack		8 7	9 16 1121	1234	1 36	2 7		4 9	5 16	6 51	8 59			9 52	5 21 7 56	
11¼	Skipton 610 to 617.. arr.	6 35	8 14	9 23 1041	1128	1242	1 43	2 15	2 56	3 25	4 16	5 22	6 1	6 57		9 6	1057	9 59	5 28 8 4	
25¾	613 Bradford (M.St.) arr.	7 48	9 16 1023	1140	9 1	43	3 17		3 52		5 20	6 31	7 0	8 18	10 8	1294	1055	6 55 9 34	
37½	613 Leeds (Wellington)	7 55	9 6 1042	12 8	1243	2 43	8	3 40		3 40		5 26	6 59	7 30	8 47		1045	1224 s	11 5	7 41 9 53	
285	613 London (St. P.)	12 52	10 4	0	5 20	6 30	8 15	8 15		1025	1115	4 20		5 40	7 v 30	5 0 4 20

b Leaves at 4 40 aft. on Saturdays. *g* Leaves at 4 55 aft. on Saturdays.	*h* Saturday night time. *l* Arrives at 10 23 aft. on Saturdays.	*s* Saturdays only. *t* Stops on Tuesdays and Saturdays; and on other days to set down from beyond Skipton.	*v* Sunday mornings only.

Another MR timetable of 1910 for train services between Skipton and Colne, Lancashire. (Author)

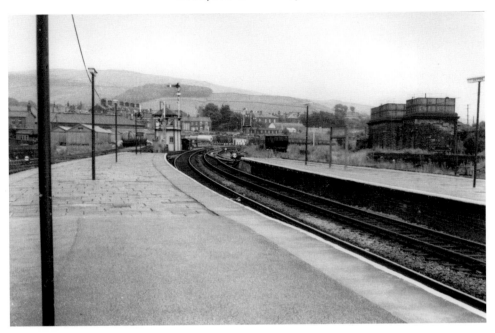

A view of Skipton station with the Pennines providing the backdrop. Skipton had its own locoshed which was built by the MR and rebuilt by BR. In 1950, a total of thirty-six locomotives were shedded there, and twenty-four in 1959. Most prominent in the allocation was the ex LMS 4F 0-6-0, fifteen being allocated in 1959. The shed was coded 20F at nationalisation, becoming 23A in 1950 and reverting back to 20F in 1951. The shed was then re-coded as 24G in 1957 and 10G in 1963. It was closed in 1967 and had a sub-shed at Keighley. (LOSA)

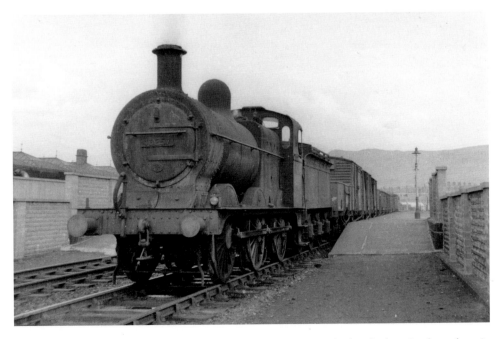

Ex MR 3F 0-6-0 no. 43257 passes through Skipton station at the head of a mixed goods train in the mid 1950s. (R. Carpenter)

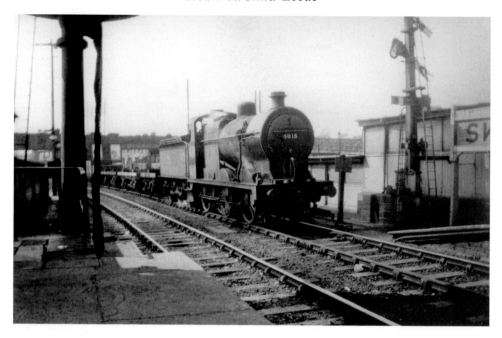

In LMS days, 4F 0-6-0 no. 4015 enters Skipton station with a class J freight. (LOSA)

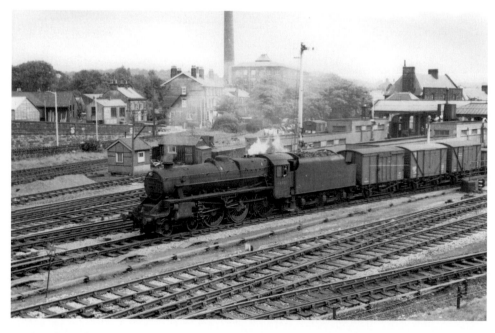

Passing through Skipton with yet another freight train is ex LMS 'Black Five' 4-6-0 no. 44983 in the mid 1950s. (LOSA)

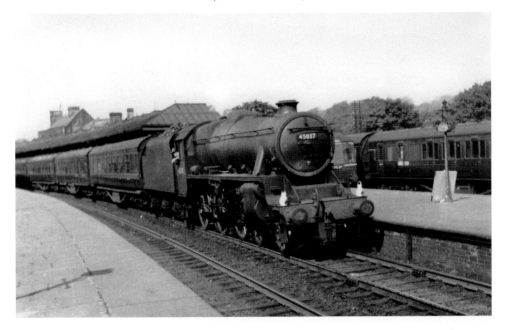

Another 'Black Five' 4-6-0, no. 45037, waits at Skipton station with a passenger train. (LOSA)

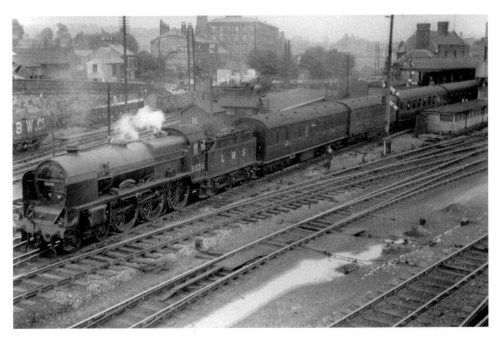

Back in the 1930s, and LMS Fowler 'Patriot' or 'Baby Scot' 4-6-0 no. 5534, *E. Tootal Broadhurst*, is leaving Skipton station with a train for Manchester. One of the many woollen mills in the area can be seen in the background. These mills and their products have provided much traffic and revenue for the railways over the years. (LOSA)

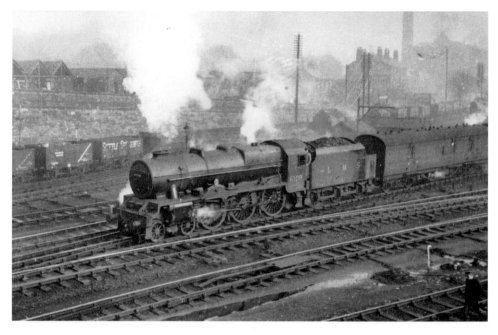

A post-war view of rebuilt 'Royal-Scot' no. 6109, *Royal Engineer*, as yet without smoke deflectors, is seen leaving Skipton station with a passenger train. (LOSA)

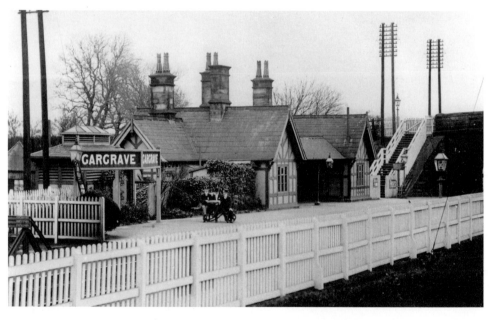

After leaving Skipton and heading for Hellifield, the line passes Gargrave station, seen here in MR days. The building is rather unusual for a Midland station. (LOSA)

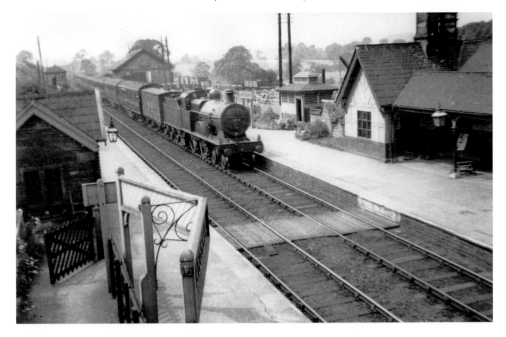

A MR 2P 4-4-0 enters Gargrave station at the head of a passenger train in the period prior to the Grouping. (LOSA)

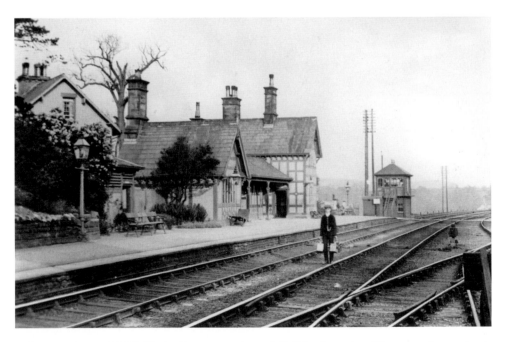

Before arriving at Hellifield, the line passes through Bell Busk station. The attractive station is seen here early in the twentieth century. (LOSA)

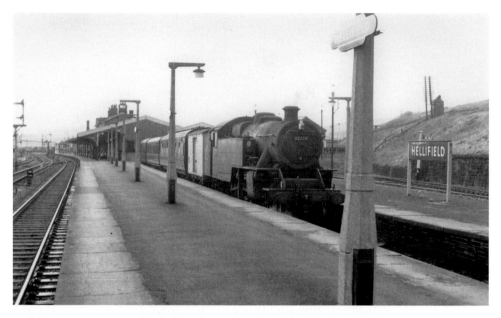

Arriving at Hellifield station is ex LMS Fairburn 2-6-4T no. 42154 of Lower Darwen shed (24D), at the head of a local passenger train to Blackburn on 14 June 1962. (R. Carpenter)

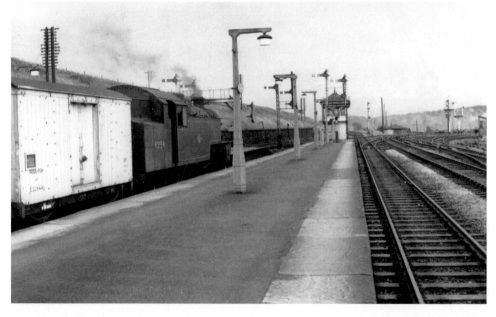

Another view of no. 42154 at Hellifield at the head of a local service to Blackburn on 14 June 1962. Hellifield also had a locoshed, coded 20G at nationalisation and re-coded 23B in 1950. The shed reverted to its original code in 1951, and later became 24H in 1957. The shed had an allocation of twenty-three locomotives in 1950, reducing to fifteen in 1959. This MR four road shed was used for the storage of historic locomotives following closure in 1963. An unusual feature of Hellifield shed was the coaling stage, which was of wooden construction. It was still in use by 1961, and would have survived until closure. (R. Carpenter)

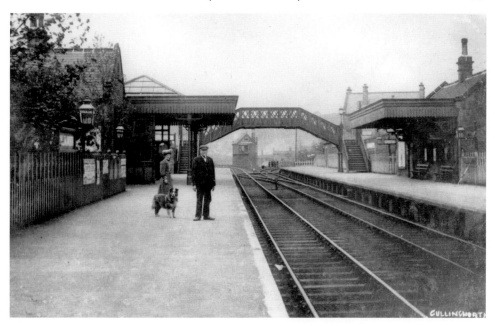

Returning to the Keighley area and the GNR line to Queensbury, the first station on that line was Ingrow East, so-named to avoid confusion with Ingrow station of the MR Worth Valley line. From there, the line entered Cullingworth station, seen here early in the twentieth century. (LOSA)

Following Cullingworth, the GNR line passed through Wilsden station, the exterior of which is seen here. (LOSA)

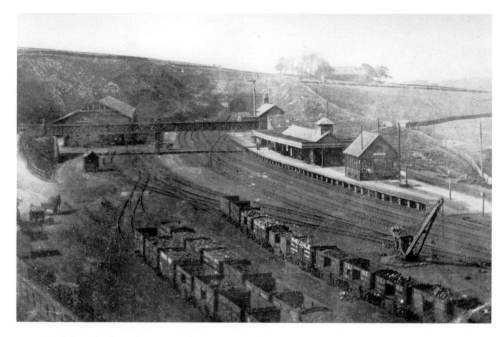

From Wilsden, the line then runs through to Denholme. The station here appears to be dwarfed by extensive goods sidings, with plenty of wagons in view. (LOSA)

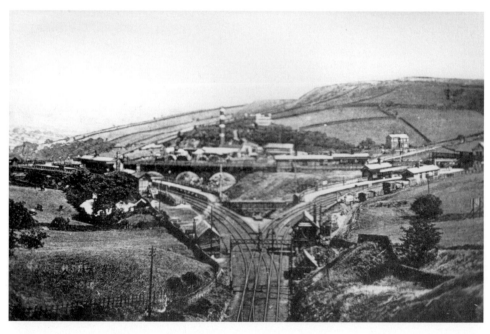

From the busy Denholme, the line enters Thornton, before reaching the junction at Queensbury, clearly visible in this view. The line branching off to the right is for Halifax and Greetland, while the branch to the left is for Bradford Exchange station. (LOSA)

Heading towards Bradford, the GNR line enters St Dunstans, where it meets the line from Wakefield, via Morley and Drightlington. The old station is seen here at the end of the nineteenth century, with a local train headed by a GNR tank engine approaching, and various woollen mills and chimneys in the background. The station fence is adorned with several metal advertisements. Like much of the railway system, this station is long gone. (LOSA)

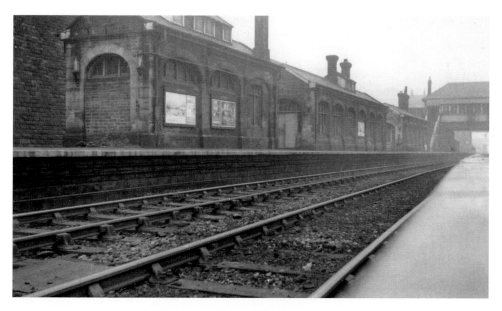

The GNR station at Laister Dyke. The line to Shipley, where it met the MR, began at this point and gave an alternative route between Bradford and Shipley, although the GNR line was a much more roundabout route. (LOSA)

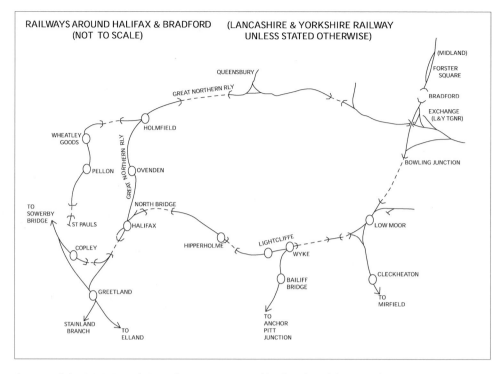

RAILWAYS AROUND HALIFAX & BRADFORD (LANCASHIRE & YORKSHIRE RAILWAY
 (NOT TO SCALE) UNLESS STATED OTHERWISE)

A map of the L&YR and GNR lines serving Bradford and Halifax. (Author)

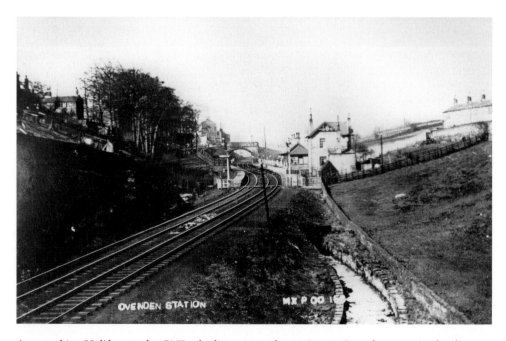

Approaching Halifax on the GNR, the line passes the station at Ovenden, seen in the distance on the curve. Like a lot of stations in the UK, Ovenden now no longer exists. (LOSA)

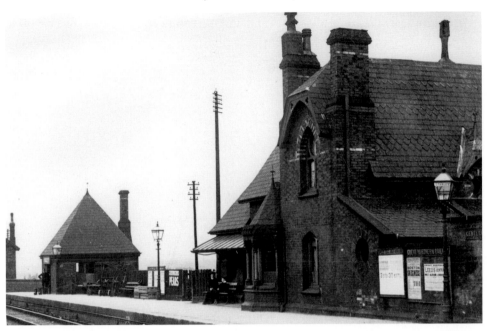

The next GNR station along the line to Halifax was at Stanley. Its impressive main building is seen here, appearing almost 'churchlike', in the early years of the twentieth century. (LOSA)

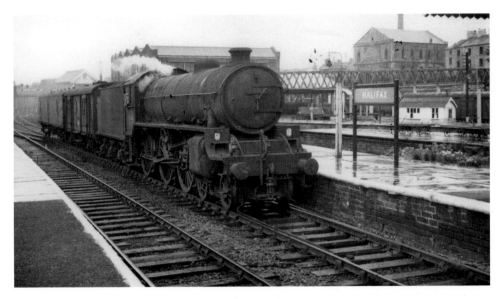

Shunting a goods train at Halifax station is ex LNER Thompson B1 class 4-6-0 no. 61161. The locomotive was built at the Vulcan foundry in 1947, with maker's number 5519, and entered traffic on 16 May 1947. She was first shedded at Gorton, Manchester, before being moved to Leicester on 30 May 1959, and returning to Gorton two months later. The engine became locally based when she went to Mirfield on 17 July 1960. From there, she moved to Low Moor on 20 August 1961, and then to Wakefield on the 10 September of the same year. Thus, when this picture was taken in 1963, she was based at the old L&YR shed at Wakefield. The engine was condemned on 6 December 1966 and sold to Arnott Young of Parkgate for scrap in February 1967. (LOSA)

BRADFORD, HALIFAX, HUDDERSFIELD, and HOLMFIRTH.—Lancashire and Yorkshire.

Up. — Week Days.

Miles	Exchange Station																									
		mrn	mrn	mrn	mrn	mrn	mrn	mrn	mrn	mrn	mrn	mrn	mrn	mrn	mrn	mrn	mrn	aft	aft	aft	aft	aft				
	Bradforddep.	5/15	5 15	5 56	6 38	6 58	7 20	7 53	8 16	8 32	9 17	9 28	1012	1030	1120	1110	1155	12 7	1245	1 30				
1¼	Bowling Junction	5/20	5 20	6 43	7 3	7 25	7 58						1035	1125				1212	1250	1 35				
3	Low Moor 730	5 30	5 30	6 4	6 49	7 8	7 30	8 3	8 27	8 40	9 25	9 36	1020	1040	1130		12 4		1217	1255	1 40				
4¾	Wyke & Norwood Green		5 34	6 8		7 12		8 7	8 44	9 29	9 40	1044			12 8		1221	1 0	1 44				
6	Lightcliffe		5 37				7 15		8 10	8 47	9 32		1047					1224	4 1	1 47				
6½	Hipperholme		5 40				7 18		8 13	8 51	9 35		1050					1227	1 7	1 50				
8½	Halifax 381 and { arr.		5 44				7 22		8 17	8 35	8 55	9 39		1028	1054		1125			1231	12 1	1 54				
	below { dep.		5 50	6 15			7 47		8 23	8 43	9 45		1036	1115		1140		1217		1 20	2 2				
10½	Greetland		5 55	6 20			7 52		8 35			9 50		1041	1120		1145		1222		1 25	2 7				
11	Elland		5 58	6 23			7 55		8 38			9 53		1044	1123		1148		1225		1 28	2 10				
13¾	Brighouse, for Rastrick		6 5	6 30			8 3		8 47	8 53		9 59		1050	1129		1156		1240		1 35	2 16				
19	Huddersfield { arr.	6 0	6 15	6 27	6 40	7 37	8 14	8 6	8 57	9/26		10 9	10 0	1059	1141	12 3	12 5	1227	1250		1 45	2 25				
	519, 523, 791 { dep.	6 3		6 43	7 52	8 55				1022			12 9			1 20								
20¼	Lockwood	6 7		6 47	7 56	8 59				1027			1213			1 24								
21½	Berry Brow	6 10		6 50	7 59	9 2				1030			1216			1 27								
22½	Honley	6 14		6 54	8 39	9 6				1034			1220			1 31								
23½	Brockholes	6 18		6 58	7 9	9 10				1038			1224			1 35								
24½	Thongs Bridge	6 22		7 2	8 11	9 14				1042			1228			1 39								
25½	Holmfirth arr.	6 26		7 6	8 15	9 18				1046			1232			1 43								

Up. — Week Days—Continued.

Exchange Station	aft	aft	aft	aft	aft	aft	aft	aft	aft	aft	aft	aft	aft	aft	aft	aft	aft		
Bradforddep.	2 22	12	2e5	4 20	5 0	5 18	5 45	6 20	6 25	6 53	7 35		8 30	9 59 30		
Bowling Junction	2e10	4 25		5 23	5 50	6 25	6 58	7 40		8 35			
Low Moor 730	3e16	3 26	4 30	5 28	5 55	6 30	6 33	7 3	7 47		8 40	9 21 9 38		
Wyke & Norwood Green	2 22	32	3e20	3 30	4 35	5 33	6 0		6 37		7 51		8 44			
Lightcliffe	2 13	25	35	3e23	3 33	4 39	5 37	6 4		6 40		7 54		8 47			
Hipperholme	2 16		38	3e26	3 36	4 42	5 40	6 7		6 43		7 57		8 50			
Halifax 381 and { arr.	2 20	31		3e31	3 40	4 47	5 44	6 11		6 47		8 1		8 54	9 29		
below { dep.			2 55		3 38	4 50	5 48	6 17		6 50		8 15		8 57	9 50		
Greetland					3 43	4 10	4 55	5 53	6 22		6 55		8 20		9 2	9 55	
Elland					3 47	4 13	4 58	5 56	6 25		6 58		8 23		9 5	9 58	
Brighouse, for Rastrick			3 9		3 54	4 20	5 6	6 3	6 34		7 5		8 31		9 12	10 5	
Huddersfield { arr.			3 21		4 4	4 30	5 17	5 23	6 13	6 45	7 27	7 15	8 1	8 41		9 21	1015 1022
519, 523, 791 { dep.					4 10	4 53	5 50		7 5		8 13		8 45	9 23		
Lockwood					4 14	4 57	5 54		7 9		8 17		8 49	9 27		
Berry Brow					4 17	5 0	5 58		7 12		8 20		8 52	9 30		
Honley					4 21	5 4	6 3		7 16		8 24		8 56	9 34		
Brockholes					4 25	5 8	6 7		7 20		8 28		9 0	9 38		
Thongs Bridge					4 29	5 12	6 11		7 24		8 32		9 4	9 42		
Holmfirth arr.					4 33	5 16	6 15		7 28		8 36		9 8	9 46		

Saturdays only. *1&3 class.* *Via Clifton Road, 1&3 class.* *Via Mirfield.* *Via Mirfield.* *Saturdays only.* *Via Mirfield, Except Saturdays.*

Up. — Week Days—Continued. / Sundays.

Exchange Station	aft	aft		aft	aft				mrn	mrn	aft	aft	aft	aft	aft	aft	aft	aft
Bradforddep.	9 50			1035	1045				9 10	1122	1 42	1 53	4 0	4 55	6 15	8 27	9 5
Bowling Junction	9 55			1043	1052				9 15	1 47	2 0	5	0 6	20 8	32 9 10	
Low Moor 730	10 0			1043	1053				9 21	1138	1 58	2 6	4 9	5	6 6	27 8 37	9 15
Wyke & Norwood Green	10 5			1047	1057				9 26	1143	2 3		4 14	5 11		8 42	9 20
Lightcliffe..............	10 9			1050	11 0				9 30	1147	2 7		4 18	5 15		8 46	9 24
Hipperholme	1012			1053	11 3				9 34	1151	2 11		4 22	5 19		8 50	9 28
Halifax 381 and { arr.	1016			1057	11 7				9 38	1155	2 15		4 26	5 23		8 54	9 32
below { dep.	1022			11 1	1111				9 50	1225	2 35		3 12	4 29	5 25		8 55	9 43
Greetland	1027			11 6	1116				9 55	1230	2 40		3 17	4 33	5 30		9 0	9 48
Elland	1030			11 9	1119				9 59	1234	2 45		3 22	4 38	5 35		9 5	9 52
Brighouse, for Rastrick	1038			1116	1126				10 6	1241	2 52		3 40	4 45	5 56		9 10	9 59
Huddersfield { arr.	1048		11 0	1152	1152				1032	1251	3 2	3 50	4 55	6 6	7 0	10 9	
519, 523, 791 { dep.		11 4			h				1035		3 4						7 35	1013
Lockwood		11 8							1039		3 8						7 39	1017
Berry Brow............		1112							1042		3 11						7 42	1020
Honley		1116							1046		3 15						7 46	1024
Brockholes		1119							1050		3 19						7 50	1024
Thongs Bridge		1123							1054		3 23						7 54	1032
Holmfirtharr.		1127							1058		3 27						7 58	1036

Saturdays only. *Except Saturdays.* *Saturdays only.* *Via Mirfield.*

d Departs at 10 22 mrn. *h* Via Mirfield. *k* Arrives at 5 41 aft.
e Except Saturdays. *i* Arrives at 3 28 aft. *s* Saturdays only.
g Change at Low Moor.

☞ For **OTHER TRAINS** between Halifax and Brighouse, see pages 730 to 735; between Huddersfield and Brockholes, see page 787; between Bradford and Halifax, see pages 736 to 741; between Bradford and Huddersfield, and between Huddersfield and Lockwood, see pages 787 and 791; between Wyke and Halifax, see page 778.

A 1910 L&YR timetable for passenger services between Bradford, Halifax, and Holmfirth. (Author)

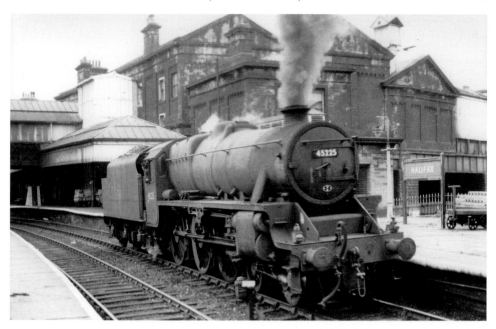

Ex LMS Stanier 'Black Five' 4-6-0 no. 45225 waits at Halifax station for its next turn of duty. The once impressive main station building can be seen in this 1963 view; it appears to have lost much of its former glory. In much the same way, the British railway system had, at this time, been allowed to quietly 'run-down' to give the impression that the roads, many built by the Marples–Ridgeway Civil Engineering Co., were the bright future of transport. We are now paying the price with gridlocked traffic and pollution in our towns and cities, not to mention such things as 'global warming'. (LOSA)

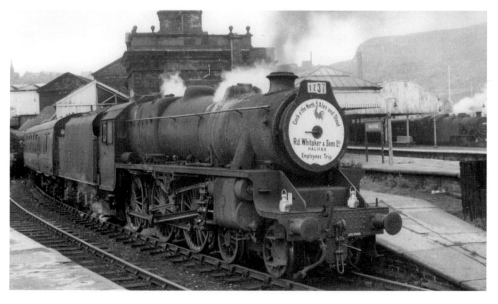

Ex LMS 'Black Five' 4-6-0 waits at Halifax station at the head of an employee day trip from Rd. Whitaker and Sons, probably to Blackpool, with an ex LMS 2-6-4T in the background. This trip was run in 1964 and was a common feature, since lost, of industrial working life, when many companies organised day trips for their employees. (LOSA)

HOLMFIRTH, HUDDERSFIELD, HALIFAX, and BRADFORD.—Lancashire and Yorkshire.

Down. Week Days.

Miles		mrn	mrn	mrn	mrn	mrn	mrn	mrn	mrn	mrn	mrn	mrn	mrn	mrn	mrn	mrn	aft	aft	aft	aft	aft	aft	aft	
	Holmfirthdep		5 40		6 35		7 22		8 25		9 30			1055					1250					Saturdays only.
1	Thongs Bridge		5 43		6 38		7 25		8 28		9 33			1058					1253					
2	Brockholes 787		5 47		6 42		7 29		8 32		9 37			11 2					1257					
3	Honley		5 51		6 46		7 33		8 36		9 40			11 6					1 1					
4½	Berry Brow		5 54		6 49		7 36		8 39		9 44			11 9					1 4					
5½	Lockwood 791		5 58		6 52		7 39		8 42		9 47			1112					1 7					
6½	Huddersfield 519, { arr		6 6		6 58		7 45		8 48		9 53			1119					1 13					
	523, 730 { dp.	5 35	6 9	6 40	7 11	7 38	7 47	8 20	8 52	9 12	9 55	1018	1040	1121	1145		1218	1 15	1 43	1 50				
12	Brighouse, for Rastrick	5 13	5 45		6 52	7 31		7 59	8 30	9 7	9 34	10 8		1124	1133		1229	1 25	2 1					
14½	Elland	5 19	5 51		6 58	7 37		8 6	8 36	9 13	9 40	1014		1110	1139		1235	1 31	2 7					
15½	Greetland 736, 788 ..	5 21	5 53		7 1	7 39		8 8	8 39	9 15	9 42	1016		1113	1142		1237	1 33	2 9					
17½	Halifax 381 { arr.	5 27	5 59		7 7	7 45		8 14	8 44	9 21	9 48	1022		1119	1149		1245	1 39	2 15					
	{ dep.	5 29	6 4		7 10	7 55		8 22	8 48	9 28	9 53	1116		1122	1210		1226	1 7	2 2	2 24				
18½	Hipperholme........	5 34	6 9		7 15	8 0		8 27	8 53		9 58			1127	1215		1231		1 52	2 29				
19½	Lightcliffe	5 37	6 12		7 18	8 3		8 30	8 56		10 1			1130	1218		1234		1 55	2 32				
20½	Wyke & Norwood Green	5 40	6 15		7 21	8 6		8 33	8 59		10 4		1038	1133	1221	1237		1 56	1 58	2 35				
22½	Low Moor 730, 790..	5 44	6 19	6 55	7 25	8 10		8 28	8 37	9 49	3610	8 1124	1042	1138	1225	1242		2 0	2 22	2 39				
23½	Bowling Junction......	5 51	6 27	7 2	7 32	8 17		8 44	9 11			1238	1216	1248			1 7	2 29	2 46					
25	Bradford (Ex.) 610 arr.	5 55	6 31	7 6	7 36	8 21	8 12	8 12	9 15	9 48	1018	1137	1052	1150	1242	1220	1252	1 9	1 51	2 33	2 42	2 53		

Down. Week Days—*Continued.*

	aft	aft	aft	aft	aft	aft	aft	aft	aft	aft	aft	aft	aft	aft	aft	aft	aft	aft	aft	aft	aft
Holmfirthdep	1 53			3 5		4 42			5 55		7 10			8 59							
Thongs Bridge	1 56			3 8		4 45			5 58		7 13			8 6	8 53						
Brockholes 787	2 0			3 12		4 49			6 2		7 47			8 10	8 57						
Honley	2 4			3 16		4 53			6 6		7 21			8 14	9 1						
Berry Brow	2 7			3 19		4 56			6 9		7 24			8 17	9 4						
Lockwood 791	2 10			3 22		4 59			6 12		7 27			8 26	9 13						
Huddersfield 519, { arr	2 16			3 28		5 5			6 19		7 34			8 29	9 16						
523, 730 { dp.	2 24	2 40	3 30		4 20	5 8	5 25	6 0	6 32	6 37	7 36	8 10		5 9	9 19	9 30					
Brighouse, for Rastrick		2 51	3 27	4 0	4 33		5 20		6 12		6 48	7 47	8 22		9 32						
Elland		2 57	3 33	4 7	4 39		5 26		6 18		6 54	7 53	8 28		9 38						
Greetland 736, 788 ..		2 59	3 35	4 11	4 41		5 29		6 21		6 56	7 55	8 30		9 40						
Halifax 381 { arr.	2 42	3 16	3 41	4 18	4 48		5 34		6 27		7 2	8 1	8 36		9 46						
{ dep.	2 43	3 43	4 24	4 55	5 30		5 6	37	6 39	7 9	7 37	8 31	8 47	9 15							
Hipperholme........	2 47	3 48		4 50	5 10	5 35		6 10	6 42	7 9	7 42	8 36	8 52	9 19		9 48					
Lightcliffe	2 50	3 51		4 53	5 13	5 38		6 13	6 45	7 12	7 45	8 39	8 55	9 23		9 51					
Wyke & Norwood Green	2 53	3 54		4 56	5 16	5 41		5 47	6 16	6 48	6 52	7 15	7 48	8 42	8 58	9 26					
Low Moor 730, 790..	2 57	3 24	3 58	4 33		5 20	5 46		5 51	6 20		6 56	7 19		8 47	9 29	9 41		9 55	9 58	
Bowling Junction......						5 27			6 0	6 27		7 7	7 26		8 58			9 48		10 2	10 9
Bradford (Ex.) 610 arr.	2 50	3 11	3 38	4 8	4 47		5 31	5 55		6 46	31	7 7	7 30		9 2	9 12		9 52		10 6	1013

Down. Week Days—*Continued.* **Sundays.**

	aft	aft	aft	aft	aft				mrn	mrn	aft	aft		aft	aft	aft	aft	aft
Holmfirthdep	9 15			1020					9 0	1110			5 5		8 33			
Thongs Bridge	9 18			1023					9 3	1113			5 8		8 36			
Brockholes 787	9 22			1027					9 7	1117			5 12		8 40			
Honley	9 26			1031					9 10	1121			5 16		8 44			
Berry Brow	9 29			1034					9 13	1124			5 19		8 47			
Lockwood 791	9 32			1037					9 16	1127			5 22		8 50			
Huddersfield 519, { arr	9 33			1043					9 22	1135			5 30		8 58			
523, 730 { dp.	9 50	1025	1045	1136					9 36	1138	2 29	2 50	5 45	6 25	9 0		1027	
Brighouse, for Rastrick	10 1	c	1056	1149					9 46	1148	2 40	3 5		6 35	9 11	9 33	1037	
Elland	10 6	c	11 2						9 52	1155	2 46	3 11		6 42	9 18	9 40		
Greetland 736, 788..	10 8	c	11 4						9 54	1157	2 49	3 14		6 49	9 21	9 42		
Halifax 381 { arr.	1014	c	1110	12 0					10 0	12 3	2 55	3 20		6 57	9 27	9 48	1047	
{ dep.	1018		1112						10 7	1226	3 16	3 26		6 9	9 41	9 50	1049	
Hipperholme........	1023		1117						1231		3 31			7 13		9 55		
Lightcliffe	1026		1120						1235		3 34			7 17		10 3		
Wyke & Norwood Green	1029		1124						1239		3 38			7 21		10 3		
Low Moor 730, 790..	1033	1057	1129						1015	1243	3 43	3 46	19 7	26	9 49	10 8		
Bowling Junction......	1040	Sat.							1256		3 56			7 34				
Bradford (Ex.) 610 arr.	1044	11 7	1139						1030	1 0	3 53	3 55	6 30	7 38	10 0	1018	11 5	

c: Stops at Brighouse 10 34, Elland 10 39, and Halifax at 10 47 aft. to set down from Sheffield and beyond.

h Arrives at 3 40 aft.
i Mondays and Thursdays.
k Arrives at 10 50 mrn.

r Arrives at 9 22 mrn.

☞ For **OTHER TRAINS** between Halifax and Bradford, see pages 730 to 735; between Huddersfield and Bradford, and between Lockwood and Huddersfield, see pages 786 and 791; between Brockholes and Huddersfield, see page 786; between Brighouse and Halifax, see pages 736 to 741; between Halifax and Wyke, see page 778.

Lancashire and Yorkshire Railway timetable for trains from Holmfirth to Halifax and Bradford. (Author)

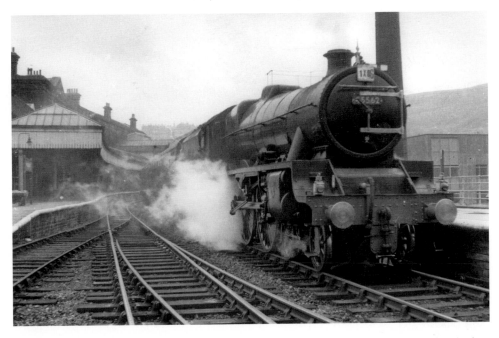

Ex LMS Stanier 'Jubilee' class 4-6-0 no. 45562, *Alberta*, at Halifax station at the head of an excursion train in the mid 1960s. (LOSA)

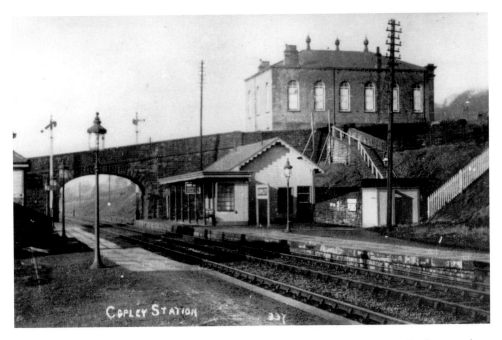

On the line from Halifax to Sowerby Bridge was the little L&YR station at Copley, seen here in the early years of the twentieth century, complete with wooden main buildings on each platform. A small woollen mill dominates the background. (LOSA)

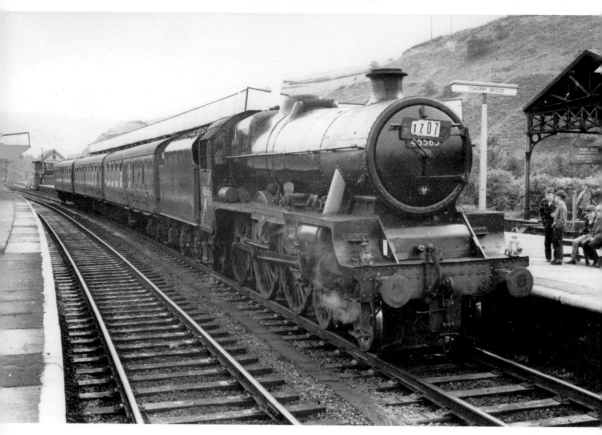

Sowerby Bridge station in the late 1960s with ex LMS 'Jubilee' class 4-6-0 no. 45565, *Victoria*, at the head of an excursion. Sowerby Bridge also had its own locoshed, which was built by the L&YR with six roads. It was rebuilt by BR in 1954. Coded 56E, the shed had an allocation of thirty-three engines in 1950, reducing to twenty-six in 1959. Upon nationalisation, the shed was coded 25E and was closed in 1964, only ten years after it had been rebuilt. A late 1950s allocation gives an idea of the locomotives which were allocated at Sowerby Bridge:

Ex LMS Fairburn 2-6-4T	42149, 42150, 42151, 42639
Ex LMS 3F 0-6-0T	47508, 47509
Ex LMS Fowler 0-8-0 class 7F	49540
Ex L&YR 2P/3P 2-4-2T	50765
Ex L&YR 2F 0-6-0ST	51348, 51381, 51479, 51488, 51503
Ex L&YR 3F 0-6-0	52189, 52243, 52376, 52400, 52452 52575, 52587, 52616
Ex WD 2-8-0	90277, 90321, 90531, 90724, 90728 90731
	TOTAL: 27

(LOSA)

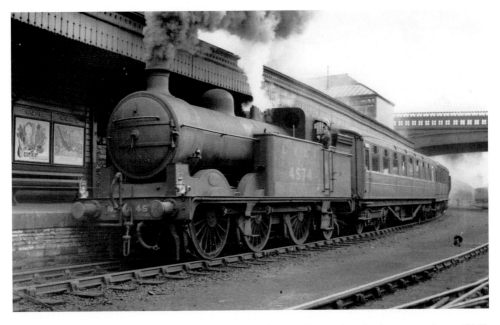

Halifax North Bridge station of the GNR, seen under LNER auspices in the 1930s. An ex GNR
N1 class 0-6-2T no. 4574, at the head of a local train made up of Gresley teak stock, is about
to depart for Halifax. (R. Carpenter)

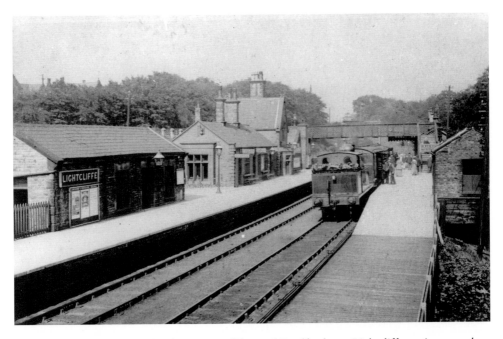

On the L&YR GNR joint line between Halifax and Bradford was Lightcliffe station, seen here
sometime between 1905 and 1910 with a L&YR tank locomotive at the head of a local train.
The handsome station buildings can be seen clearly and they give an impression of permanence,
even at such a small semi-rural station. (R. Carpenter)

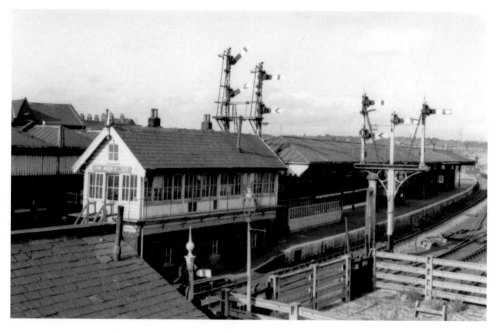

Low Moor was on the approaches to Bradford Exchange, where the line from Halifax met the L&YR line from Wakefield, via Mirfield. Here, the ex L&YR station at Low Moor is visible on 11 September 1964, with cattle pen, signal box, and island platform buildings in view. (R. Carpenter)

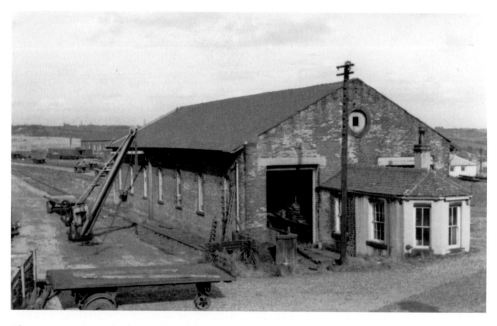

The overgrown goods shed at Low Moor as it appeared on 11 September 1964. Very soon, this structure would be swept away in the name of progress. (R. Carpenter)

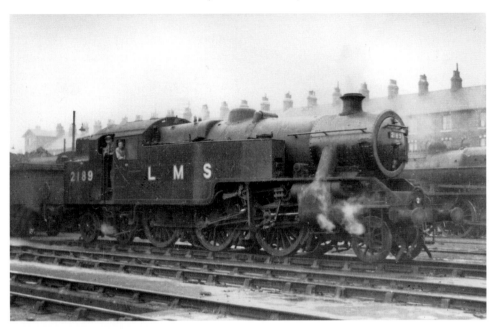

The virtually new LMS Fairburn 2-6-4T no. 2189 is awaiting its next turn of duty at Low Moor locoshed in October 1948, just prior to nationalisation. Low Moor shed was a six road depot built by the L&YR, and had thirty-seven locomotives in its allocation in 1950, increasing to as many as seventy in 1959 (certainly bucking the trend at this time), and reducing to seventeen in 1965. The shed was coded 25F at nationalisation and re-coded 56F in 1956. It was closed in 1967. An allocation of the 1950s gives an idea of the engines allocated there:

Ex LMS Fairburn 4MT 2-6-4T	42107, 42108, 42109, 42110, 42111, 42112, 42113, 42114, 42115, 42116, 42188, 42189*
Ex LMS 'Crab' 5MT 2-6-0	42726, 42727, 42732, 42828, 42865
Ex LMS 'Black Five' 4-6-0	44912, 44951, 44990, 45201, 45207, 45208
Ex L&YR 2P/3P 2-4-2T	50806
Ex L&YR 2F 0-6-0ST	51404
Ex L&YR 3F 0-6-0	52092, 52104, 52237, 52309, 52410, 52411, 52427, 52461
Ex L&YR 7F 0-8-0	52857
	TOTAL: 34

* The locomotive no. 2189 (now 42189) was still shedded at Low Moor. In 1959, ex LNER engines appeared at Low Moor shed, including six Thompson B1 4-6-0s and ex GNR 0-6-0s.

Back in LMS days, Low Moor was scheduled to have a new roof in 1947, but nothing materialised.
(LOSA)

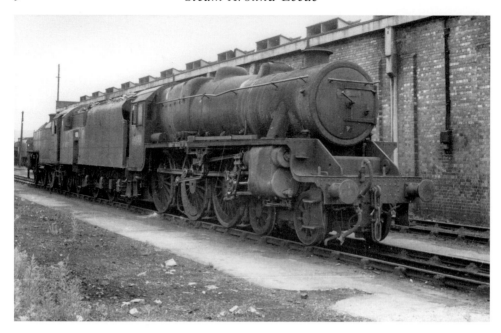

Ex LMS Stanier 'Black Five' 4-6-0 sits outside Low Moor shed in dilapidated condition while awaiting her fate. No. 44693 is in company here with ex LMS Fairburn 2-6-4T. (LOSA)

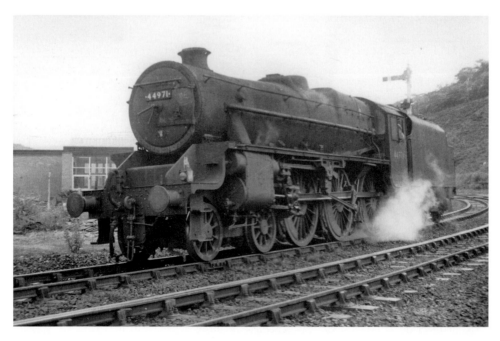

Ex LMS Stanier 'Black Five' 4-6-0 no. 44971 is waiting her turn of duty at Bradford in 1965. (LOSA)

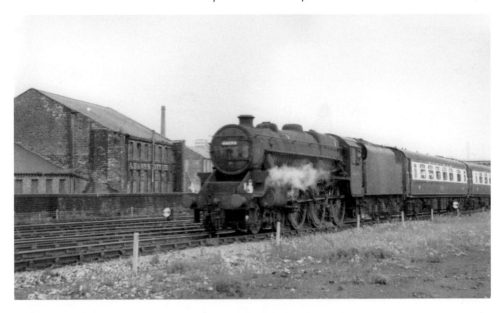

Another 'Black Five' is at the head of an express leaving Bradford in 1967. No. 44694 is at the head of new BR liveried blue and white coaches and is passing the works of A. B. & W. Stott Ltd. (LOSA)

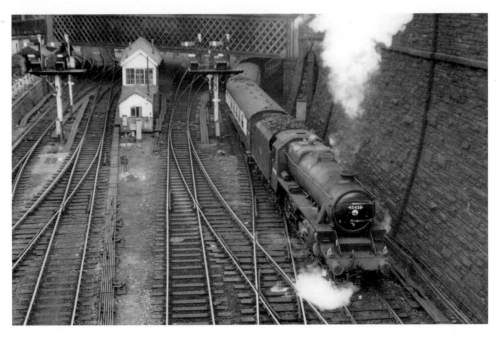

Leaving Bradford Exchange station in 1966 is another 'Black Five' at the head of an express with coaches in the new blue and white BR corporate livery, heralding the approach of an all diesel railway here. (LOSA)

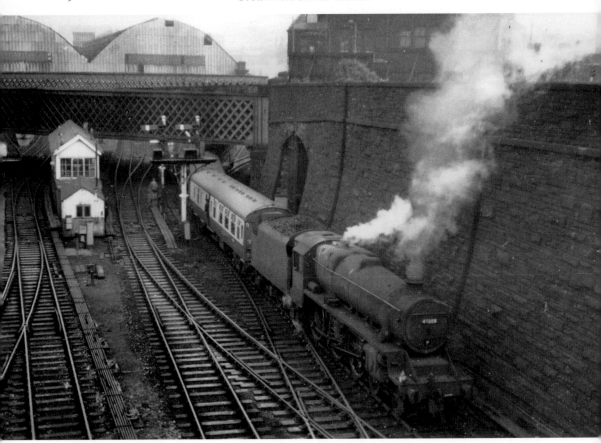

Another of the ever popular 'Black Fives' leaves Bradford Exchange. The locomotive, no. 45208, is at the head of yet another express in the mid 1960s. (LOSA)

HARROGATE and BRADFORD.—North Eastern.

Miles.		Week Days.									Miles.		Week Days.										
		mrn	mrn	mrn	mrn	aft	aft	aft	aft	aft				mrn	mrn	mrn	mrn	aft	aft	aft	aft	aft	
	Harrogatedep.	7 40	8 25	9 27	1130	1240	2 49	5 56	6 47	7 42			Market Street Station,		mrn	mrn	mrn	mrn	aft	aft	aft	aft	aft
3¼	Pannal..................							**n**				1	Bradforddep.	7 20	9 5	9 55	1118	1 13	3 20	5 27	6 8	8 55	
6¼	Weeton................		**i**						**œ**			2¾	Manningham..........	**œ**	**œ**	**œ**	**œ**	**œ**	**œ**	**œ**	**œ**	**œ**	
12¼	Otley 718.............	8 3	8 45	9 47	1151	1 0	3 9	5 25	7 7	8 4		4¾	Shipley †..............	7 27	9 14	10 3	1 20	3 27	5 34	6 17	9 0	
15¼	Menston................									**b**		7¾	Baildon...............										
16¼	Guiseley...............	8 12	8 54	9 56	12 0	1 10	3 20	5 36	7 16	8 14		9	Guiseley...............	7 38	9 24	1013	**œ**	1 31	3 36	5 43	6 29	9 10	
20	Baildon................							**v**				11¾	Menston................			**l**							
21¼	Shipley † 610	8 21	9 3	10 5	12 9	1 19	3 33	5 47	7 25	8 23		11¾	Otley 718.............	7 50	9 32	1023	1138	1 40	3 45	5 51	6 39	9 18	
23¼	Manningham [736, 788	**b**	**b**	**b**	**b**	**b**	**b**	**b**	**b**	**b**		17¾	Weeton................					**o**			**o**		
24¼	Bradford(MarketStreet)379,	8 30	9 12	1012	1218	1 28	3 40	5 57	7 33	8 30		21	Pannal............ [714	8 5		**n**		**h**		**n**	**d**		
												24¼	Harrogate 705, 708, arr.	8 14	9 51	1042	1156	2 3	4 8	6 12	7 1	9 43	

b Set down if required from Harrogate and beyond. **d** Stops if required to take up, and on Thursdays if required to set down. **h** Stops if required to set down.	**i** Takes up if required for Otley and Bradford. **l** Takes up if required for Harrogate and beyond. **n** Stop if required on the 11th and 25th instant.	**o** Set down if required from Bradford, Manningham, or Otley. **v** Sets down on Fridays if required from Newcastle. **œ** Takes up for Harrogate on Saturdays.	**œ** Take up if required for Otley and beyond. † Station Road: rather less than ¼ mile from the G.N. (Bridge Street) Station.

☞ For OTHER TRAINS between Bradford and Otley, see pages 616 and 617.

A NER timetable for trains from Bradford Market Street to Harrogate. Evidence that the North Eastern Railway had a foothold in Bradford. (Author)

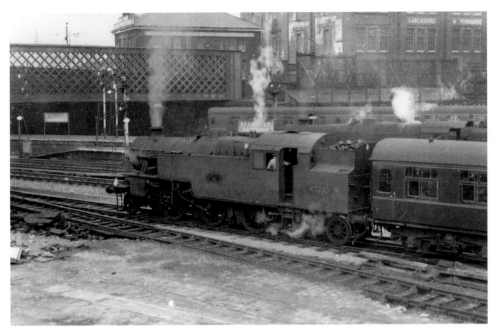

Leaving Bradford Exchange station with a local service is ex LMS Fairburn 2-6-4T no. 42235. (LOSA)

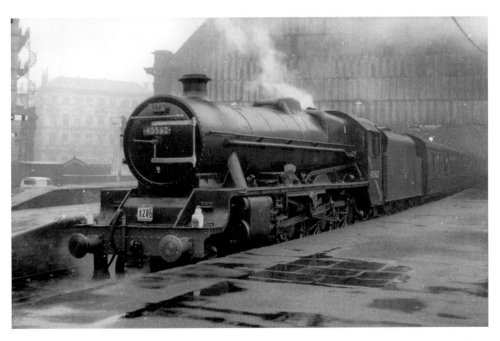

Just for a change, ex LMS Stanier 'Jubilee' class 4-6-0 no. 45562, *Alberta*, waits at Bradford Exchange station with excursion IZo6. Note the yellow stripe on the cab side which precluded the engine going 'under the wires' on the newly electrified West Coast Main Line. (LOSA)

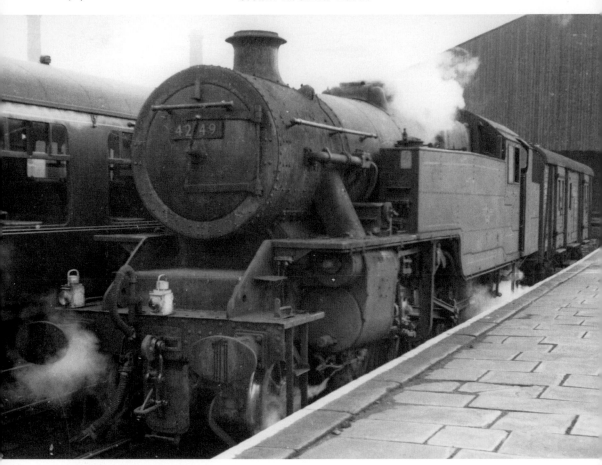

Ex LMS Fairburn 2-6-4T no. 42149 waits in the bay with a single wagon. Bradford was also the home of a GNR locoshed. Known as Bradford Hammerton Street, this was a shed of eleven roads and was modified to accept diesel trains in 1954. In 1950, the shed had an allocation of forty-nine engines and was coded 56G. Despite being converted for diesel use, the shed was closed as early as 1958. A 1950s allocation gives an idea of the steam locomotives shedded at Bradford Hammerton Street:

Ex LNER B1 4-6-0	61229, 61230, 61267, 61268, 61294, 61296
Ex GNR J6 0-6-0	64170, 64203, 64205, 64226, 64268, 64271, 63274
Ex GCR C14 4-4-2T	67447, 67448, 67450
Ex GNR J50 0-6-0T	68892, 68895, 68897, 68898, 68902, 68906, 68908
Ex GNR N1 0-6-2T	69443, 69447, 69448, 69449, 69454, 69459, 69464, 69474, 69478, 69479, 69482, 69483, 69485
	TOTAL: 37

(LOSA)

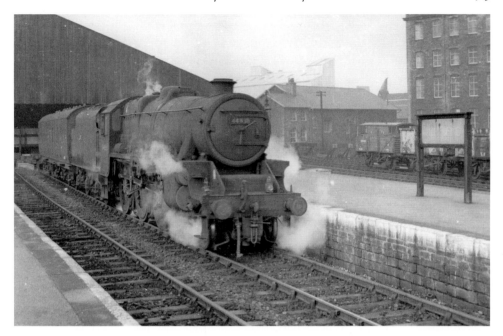

Waiting at Mirfield station with a single van is ex LMS 'Black Five' no. 44838. The goods yard is in the background and another of the ubiquitous woollen mills can be seen overshadowing the yard. (LOSA)

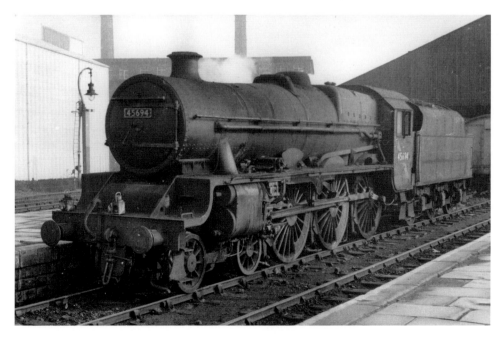

Waiting at Mirfield station is ex LMS Stanier 'Jubilee' class 4-6-0 no. 45694, *Bellerophon*. (LOSA)

BRADFORD, KEIGHLEY, and HALIFAX.—Great Northern.

Down. — Week Days.

Miles from Bradford	Exchange Station	mrn		mrn	mrn	mrn	mrn		mrn	mrn	mrn	mrn		aft	aft		aft	aft	aft	aft		aft	aft	aft	aft
	Bradforddep.	4 58		6 12	6 43		8 4		9 17	10 7		12 8	12 55	1 22	2 15	3 18	4 32		4 50	5 22	5 35	6 7			
	378 London (King's Cr.).dep.	10 45 d				3 15			5 5		7 15			10 10	10 35			1 30	1 30	1 30					
	343 Doncaster "	2 26				6 9			8 36		10 30		11 25	11 2	16	2 20			4 27	4 27	4 27				
	378 Wakefield (Wstgate) "	2 57			5 22	6 37		7 3	2 9 7		11 1		12 8	1 41	2 50	3 15			4 58	4 58	4 58				
	394 Leeds (Central) "	3 30		5 30	6 17	7 20		8 50	9 45		11 45	12 15	1 0	1 5	2 25	4 2			4 53	4 53	5 35				
¼	St. Dunstan's	5 1		6 15	6 46		8 7		9 20	10 10		12 11		Sat.	2 18	3 22	4 35			5 25	5 38				
1	Manchester Road........	5 3		6 17	6 48		8 9			10 12		12 12		1 26	2 20	3 25	4 37			5 27	5 40				
1½	Horton Park	5 5		6 19	6 50		8 12			10 14		12 15		1 28	2 22	3 27	4 39				5 42	6 12			
2¼	Great Horton	5 8		6 22	6 53		8 15		9 25	10 17		12 18	2 1	1 31	2 25	3 31	4 42			5 31	5 45	6 14			
3½	Clayton	5 13		6 27	6 58		8 20		9 30	10 22		12 23	7 1	1 36	2 30	3 37	4 47		4 57	5 36	5 50	6 20			
4½	Queensbury arr.	5 17		6 31	7 2		8 24		9 34	10 26		12 27	1 11	1 40	2 34	3 41	4 51		5 1	5 40	5 54	6 24			
—	381 Halifax (Old)dep.			5 37	6 38		7 57		9 25	10 13		12 3		1 13		3 5	4 35				5 40				
	Queensburydep.	5 22		6 33	7 7		8 26		9 41	10 53		12 29	1 12	1 41		3 42	4 55				6 0				
6	Thornton	5 25		6 36	7 10		8 29		9 44	10 36		12 32	1 16	1 44		3 45	4 58				6 3				
7¼	Denholme	5 29		6 40	7 14		8 33		9 48	10 40		12 36	1 18	1 48		3 50	5 2				6 7				
8½	Wilsden	5 32		6 43	7 17		8 36		9 51	10 43		12 39		1 51		3 54	5 5				6 10				
9½	Cullingworth	5 35		6 46	7 20		8 39		9 54	10 46		12 42		1 54		3 57	5 8				6 13				
12½	Ingrow	5 43		6 54	7 28		8 47		10 2	10 54		12 49		2 1		4 5	5 15				6 21				
13½	Keighley 610, 618 .. arr.	5 46		6 57	7 31		8 50		10 5	10 57		12 52		2 5		4 8	5 18				6 24				
—	Queensburydep.	5 27		6 36	7 5	7 54	8 30	9	1 9 35	10 36		12 28	1 15	1 45	2 35	3 49	4 54		5 2	5 41		6 26			
6½	Holmfield *	5 30		6 39	7 8	7 57	8 33	9	4 9 38	10 39		12 31	1 18	1 48	2 38	3 52	4 57		5 5	5 44		6 29			
—	Holmfielddep.	5 33			7 12				9 41			10 42	12 41	1 25		2 41			5 7	5 50		6 33			
8½	Pellon	5 40			7 19				9 48			10 49	12 41	1 32		2 48			5 7	5 15	5 57	6 40			
9½	Halifax (St. Paul's) .. arr.	5 42			7 21				9 50			10 51	12 43	1 34		2 50			5 10	5 17	5 59	6 42			
7½	Ovenden	5 34		6 43	7 12	8 1	8 37	9	9 42	10 43		12 35	1 22	1 52	2 42	3 56	5 1		5 9	5 48		6 33			
8½	Halifax (North Bridge)..	5 38		6 47	7 16	8 5	8 41	9 2	9 46	10 46		12 39	1 26	1 56	2 46	4 0	5 6		5 13	5 52		6 38			
9½	" (Old Station) .. arr.	5 40		6 49	7 18	8 7	8 43	9 14	9 48	10 48		12 41	1 28	1 58	2 48	4 2	5 8		5 15	5 54		6 40			

Down. — Week Days—Continued. / Sundays.

Exchange Station	aft	aft	aft	aft	aft	aft	aft						mrn	mrn	aft	aft	aft	aft	aft	aft
Bradforddep.	6 15	6 50	7 28	8 20	9 0	10 22	11 12						7 55	9 15	12 18	1 30	2 40	5 35	7 20	8 45 9 55
378 London (King's Cr.).dep.	11 40	1 40	4 0		5 45	6 5								8 55			12 0			5 0
343 Doncaster "		5 0	5 0	7 19		8 51	9 30							8 20	9 36		3 39			8 42
378 Wakefield (Wstgate) "	5 15	5 5	5 17	5 17	5 58	9 18	10 7							8 15	9 58	1 32	4 13			9 14
394 Leeds (Central) "	5 46	6 15	6 45	7 20	8 35	9 50	10 45							8 15	9 58	12 25		5 5		8 45
St. Dunstan's	6 18	6 53	7 31	8 23	9 3	10 26	11 15						7 58	9 18	12 21	1 33	2 43	5 38	7 23	8 48 9 58
Manchester Road.........	6 20	6 55	7 33	8 25	9 5	10 28 Sat.							8 0	9 20	12 23	1 35	2 45	5 40	7 25	8 50 10 0
Horton Park	6 22	6 57	7 36	8 28	9 8	10 31	11 19						8 3	9 23	12 27	1 39	2 48	5 43	7 28	8 53 10 3
Great Horton	6 25	7 0	7 39	8 31	9 11	10 34	11 22						8 6	9 26	12 29	1 41	2 51	5 46	7 31	8 56 10 6
Clayton	6 30	7 5	7 44	8 36	9 16	10 39	11 27						8 11	9 31	12 34	1 46	2 56	5 51	7 36	9 1 10 11
Queensbury arr.	6 34	7 9	7 48	8 40	9 20	10 43	11 31						8 15	9 35	12 38	1 50	3 0	5 55	7 40	9 5 10 15
381 Halifax (Old)dep.		6 44	7 32		8 54	10 25	10 57						7 45		10 10		2 30	4 25	7 18	9 50
Queensburydep.	6 35	7 10	7 51	8 41	9 21	10 46	11 32						8 20		12 39		3 1	6 0	7 44	10 16
Thornton	6 38	7 13	7 57	8 44	9 24	10 49	11 35						8 23		12 42		3 4	6 3	7 47	10 19
Denholme	6 42	7 16	8 1	8 48	9 28	10 53	11 39						8 27		12 46		3 8	6 7	7 51	10 23
Wilsden	6 45		8 4	8 51	9 31	10 56	11 42						8 30		12 49		3 11	6 10	7 54	10 26
Cullingworth	6 48		8 7	8 54	9 34	10 59	11 45						8 33		12 52		3 14	6 13	7 57	10 29
Ingrow	6 55		8 15	9 2	9 42	11 7	11 53						8 41	1 0			3 22	6 21	8 5	10 37
Keighley 610, 618 ... arr.	6 58		8 18	9 5	9 45	11 10	11 56						8 44	1 3			3 25	6 24	8 8	10 40
Queensburydep.	7 5	7 55		9 25	10 45		11 34						8 17	9 36		1 51		5 56	7 42	9 6
Holmfield *	7 8	7 58		9 28	10 48		11 37						8 20	9 39		1 54		5 59	7 45	9 9
Holmfielddep.				9 30										9 42		1 56		6 5	7 47	9 11
Pellon				9 37										9 49		2 3		6 12	7 54	9 18
Halifax (St. Paul's) .. arr.				9 39										9 51		2 5		6 14	7 56	9 20
Ovenden	7 12	8 2		9 32	10 52		11 41						8 24	9 43		1 58		6 3	7 49	9 13
Halifax (North Bridge)...	7 16	8 6		9 36	10 56		11 45						8 28	9 47		2 2		6 7	7 53	9 17
" (Old Station) .. arr.	7 18	8 8		9 38	10 58		11 47						8 30	9 49		2 4		6 9	7 55	9 19

b \ Via Bradford. *c* Leaves at 2 10 aft. on Saturdays. *d* Except Sunday nights. *g* Leaves at 1 18 aft. on Saturdays.
h Leaves at 5 17 aft. on Saturdays. *i* Except Mondays. *s* Saturdays only. * Station for Illingworth (1 mile).

Above and opposite: As if to show that Bradford Exchange was shared with the GNR, a 1910 timetable for that railway's trains between Bradford, Keighley, and Halifax is presented here. (Author)

HALIFAX, KEIGHLEY, and BRADFORD.—Great Northern.

Up. — Week Days.

Miles	Old Station,	mrn	mrn		mrn	mrn	mrn	mrn	mrn	mrn	mrn	mrn	aft	aft		aft	aft	aft	aft	aft	aft	aft	aft		
	Halifaxdep.		5 37	...	6 38	7 27	7 40	7 57	8 46	9 25	1013	1115	12 3	...	1 13	...	1 48	3 5	4 35	5 8		
¾	" (North Bridge) ...		5 40	...	6 41	7 57	4 38	8 0	8 49	9 28	1016	1118	12 6	...	1 16	...	1 51	3 8	4 38	5 11		
1¼	Ovenden		5 44	...	6 45	...	7 47	8 4	8 53	b	1020	a	1210	...	1 20	...	1 55	3 12	4 42	5 15		
—	Halifax (St. Paul's)..dep.			...	6 35	8 40	1012	1112	12s5	...	1 12		1 48	3 5				
—	Pellon	6 38	8 43	1015	1115	12s8	...	1 15		1 51	3 8				
—	Holmfield *arr.			...	6 43	8 48	1020	1120	1213s	...	1 20		1 56	3 13				
2¾	Holmfield *		5 48	...	6 49	7 10	7 51	8 8	8 57	9 34	1024	1123	1214	...	1 24		1 59	3 16	4 46	5 19		
5	Queensbury 380 ...arr.		5 54	...	6 55	7 16	7 57	8 14	9 3	9 40	1030	1129	1220	...	1 30		2 5	3 23	4 52	5 25		
Mls	Keighleydep.	4 53		...	6 25		7 25	7 50	8 36	...	10 5		1150	1244	...	1 43		...	3 20	4 15	...				
1	Ingrow	4 57		...	6 29		7 30	7 54	8 39	...	10 9		1154	1248	...	1 47		...	3 24	4 19	...				
3¾	Cullingworth	5 5		...	6 39		7 38	8 3	8 47	...	1017		12 2	1256	...	1 55		...	3 32	4 28	...		r...		
5	Wilsden	5 9		...	6 45		7 42	8 7	d	...	1021		12 6	1 0	...	1 59		...	3 36	4 33	...				
6	Denholme	5 12	5 45	...	6 49		7 45	8 10	8 53	...	1024		12 9	1 3	1s24	2 2		...	3 39	4 36	...				
7¾	Thornton	5 16	5 49	...	6 54		7 49	8 15	8 57	...	1029		1213	7	1 29	2 6		...	3 43	4 40	...				
9	Queensbury 380 ...arr.	5 19	5 52	...	6 57		7 52	8 19	9 0	...	1031		1216	1 10	1 32	2 9		...	3 46	4 43	...				
14	380 Halifax (Old) ...arr.	5 40	6 49	...	7 18		8 7	8 43	9 14	...	1048		1241	1 28	1 58	...		2 48	...	4 2	5 8	...			
—	Queensburydep.	5 24	5 55	...	7 0	7 17	7 58	8 19	9 4	...	1035	1130	1221	...	1 35	2 6		2 10	3 24	3 85	4 44	...		5 27	
6	Clayton	5 27	5 58	...	7 3	7 20	8 1	8 23	9 7	...	1038	1133	1224	...	1 38	2 9		2 13	3 27	3s54	4 47	...		5 30	
7¼	Great Horton	5 30	6 1	...	7 6		8 4	8 27	9 10	...	1041		1227	...	1 41	...		2 16	3 30	3s57	4 50	...		5 33	
7¾	Horton Park	5 32	6 3	...	7 11		8 6	8 29	9 12	...	1043		1229	...	1 43	2 13		2 18	3 23	3s59	4 53	...		5 35	
8½	Manchester Road	5 34	6 5	...	7 14		8 8	8 31	9 14	...	1045	1139	1231	...	1 45	2 15		2 20	3 34	4s24	4 55	...		5 37	
9	St. Dunstan's 379, 382, 394	5 36	6 7	...	7 16	7 26	8 10	8 33	9 16	...	1047	1141	1233	...	1 47	2 17		2 22	3 36	4s44	4 57	...		5 39	
18¾	394 Leeds (Central) ...arr.	6 29	6 45	...		8 17	8 38	9 24	9 44	...	1124	1242	1 17	...	2 17	2 53		2 54		7s5	8 75	31	...		6 8
26	379 Wakefield (W'gate) "	6 31	7c8	...	8 18	8 1	...	9 10	1016	...	1138	1 17	2 7	...	2 47			3 54	2 6s	5s33	5 40	...		6 42	
45½	348 Doncaster "	...	7g58	9 44	1057	...	1213	2 3	3 21	...				3 40			6 15	...		7 22	
201¼	379 London (King's C.). "	...	1130	...	1130	1130	...	1 5	1 55	...	3 55	...	5 30	...				0		...	9 25	...		1045	
9¾	Bradford (Exchange) ..arr.	5 39	6 10	...	7 19	7 30	8 13	8 37	9 19	...	1050	1144	1236	...	1 50	2 20		2 26	3 40	4s75	5 0	...		5 42	

Up. — Week Days—Continued. / Sundays.

Old Station,	aft	aft	aft	aft	aft	aft			mrn	mrn	mrn	aft	aft	aft	aft	aft	aft	aft	
Halifaxdep.	5 40	...	6 44	7 32	8 54	1025	10 57			7 45	...	1010	...	2 30	4 25	7 18	8 32	...	9 50
" (North Bridge) ...	5 43	...	6 47	7 35	8 57	1028	11 0			7 48	...	1013	...	2 33	4 28	7 21	8 35	...	9 53
Ovenden	5 47	...	6 52	7 39	9 1	1032	11 4			7 53	...	1017	...	2 37	4 33	7 25	8 39	...	9 57
Halifax (St. Paul's)..dep.	5 38	...	6 17	7 33	...	1025					...	1010	...	2 30	...	7 20	8 33	...	9 30
Pellon	5 41	...	6 20	7 36	...	1028					...	1013	...	2 33	...	7 23	8 36	...	9 33
Holmfield *arr.	5 46	...	6 25	7 41	...	1033				7 57	...	1018	...	2 38	...	7 28	8 41	...	9 38
Holmfield *	5 51	...	6 56	7 44	9 5	1036	11 8			7 57	...	1021	...	2 41	4 37	7 31	8 43	...	10 1
Queensbury 380 ...arr.	5 56	...	7 2	7 50	9 11	1041	11 14			8 3	...	1027	...	2 47	4 43	7 37	8 49	...	10 7
Keighleydep.	5 45	6 37	7 25	8 40	1012	10s45				7 30	9 5	...	1 10	...	4 5	7 3	...	8 35	
Ingrow	5 49	6 41	7 29	8 44	1016	10s49				7 35	9 9	...	1 14	...	4 9	7 7	...	8 39	
Cullingworth	5 57	6 49	7 37	8 52	1024	10s57				7 44	9 17	...	1 22	...	4 20	7 15	...	8 47	
Wilsden	6 1	6 53	7 41	8 56	1028	11 s1				7 49	9 21	...	1 26	...	4 25	7 19	...	8 51	
Denholme	6 4	6 56	7 44	8 59	1031	11 s4				7 53	9 24	...	1 29	...	4 30	7 22	...	8 54	
Thornton	6 8	7 0	7 49	9 3	1035	11 s8				7 58	9 28	...	1 33	...	4 34	7 26	...	8 58	
Queensbury 380arr.	6 11	7 3	7 52	9 6	1038	11s11				8 1	9 31	...	1 36	...	4 37	7 29	...	9 1	
380 Halifax (Old)arr.	...	6 40	7 18	8 8	9 38	1058	11s47			8 30	9 49	...	2 4	...	6 9	7 55	...	9 19	
Queensburydep.	5 58	6 12	7 7	7 56	9 13	1045	11s15			8 8	9 32	1023	1 37	2 48	4 50	7 38	8 50	9	2 10 8
Clayton	6 1	6 15	7 10	7 59	9 16	1048	11s18			8 12	9 35	1031	1 40	2 51	4 53	7 41	8 53	9	5 1011
Great Horton	6 4	6 18	7 13	8 2	9 19	1051	11s21			8 16	9 38	1034	1 43	2 54	4 56	7 44	8 56	9	8 1014
Horton Park	6 6	6 20	7 15	8 4	9 21	1053	11s23			8 19	9 40	1036	1 45	2 56	4 58	7 46	8 58	9	10 1016
Manchester Road	6 9	6 22	7 17	8 6	9 23	1055	11s25			8 24	9 42	1038	1 47	2 58	5 0	7 48	9 0	9	12 1018
St. Dunstan's 379, 382, 394	6 11	6 24	7 19	8 8	9 25	1057	11s27			8 26	9 44	1040	1 49	3 0	5 2	7 50	...	9 14 1020	
394 Leeds (Central)arr.	...	6 54	7 55	9 9	10 7	1155	11s55			9 55	...	1240	2 49	3 52	6 10	...	9 27	1010 11 5	
379 Wakefield (W'gate) "	7 15	7 36	8 42	9 29	1027	12 5				9 31	11 21	1 03	58	...	5 36	9 11	...	1012	
348 Doncaster "	...	8 38	1122	...				1058	1146	2 2	6 14	1112	
379 London (King's C.). "	3 10	3 15	5 45	9 40	3 10	
Bradford (Exchange). arr.	6 14	6 29	7 22	8 11	9 28	11 0	11s30			8 30	9 47	1043	1 52	3 3	5 7	53	...	9 17 1023	

a Stops when required to take up 1st class Passengers for Bradford. b Stops when required to take up for beyond Keighley. c Arrives at 6 38 mrn. on Mondays. d Stops when required to take up for London. g Arrives Doncaster 7 21 and King's Cross 10 40 mrn. on Mondays. s Saturdays only. * Station for Illingworth (1 mile).

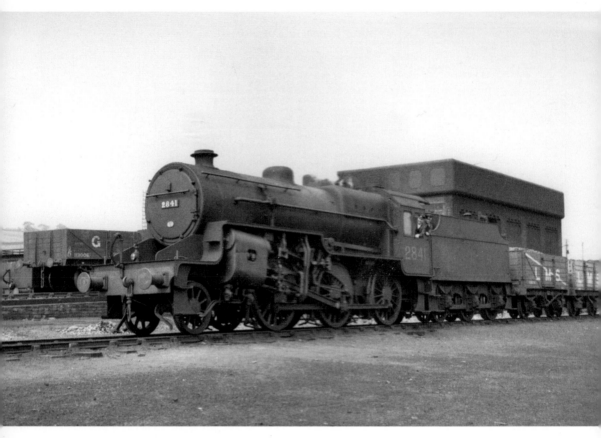

Back in LMS days, Hughes-Fowler 'Crab' 2-6-0 no. 2841 is seen at the water tower of Mirfield shed with a train of locomotive coal wagons. (LOSA)

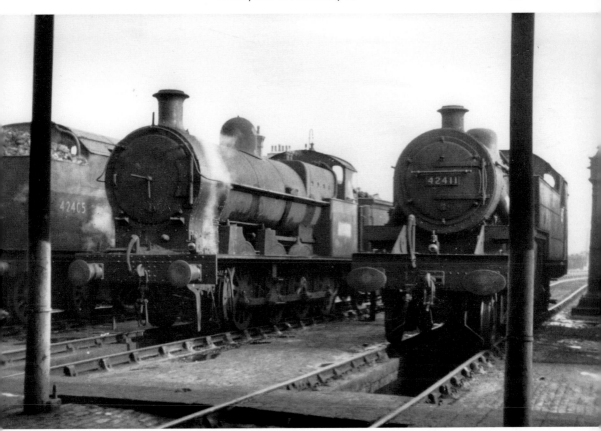

Standing outside Mirfield lococshed in 1956 are ex LMS Fowler 2-6-4T no. 42411 and ex LNWR 7F 0-8-0 no. 49200. The L&YR had originally opened a shed here with eight roads to supply engines for services from Bradford. In 1950, the shed had an allocation of forty engines, reducing to thirty in 1959, and falling still further to nineteen in 1965. Coded 25D at nationalisation, the shed was re-coded 56D in 1956. An allocation of the 1950s gives an idea of the locomotives based there:

Ex LMS Fairburn 4MT 2-6-4T	42152, 42324, 42405, 42406, 42407, 42553
Ex LMS 'Crab' 5MT 2-6-0	42700, 42712, 42719
Ex LMS 4F 0-6-0	44291, 44471, 44474, 44483
Ex LMS 8F 2-8-0	48720, 48751, 48755
Ex LMS Fowler 7F 0-8-0	49598, 49062, 49618, 49620, 49659, 49660, 49661, 49662, 49663, 49666, 49667
Ex L&YR 2F 0-6-0ST	51358, 51453
Ex L&YR 3F 0-6-0	52124, 52164, 52165, 52166, 52191, 52331, 52515
Ex WD 2-8-0	90543, 90578, 90723
	TOTAL: 39

(LOSA)

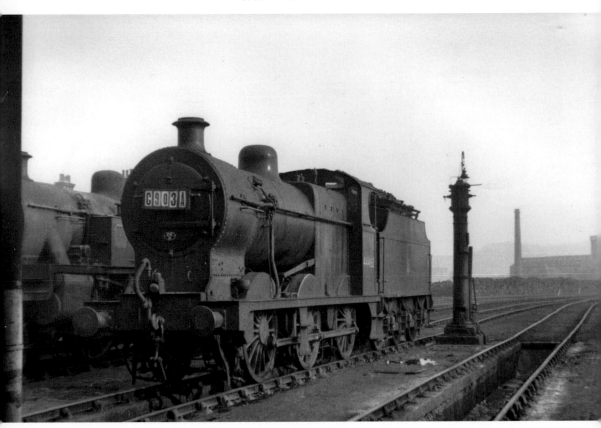

Ex LMS 4F 0-6-0 no. 44462 sits by the water column at Mirfield shed, waiting to take an excursion train from Bradford Exchange. In 1946, the Ministry of Fuel announced that 1,200 steam locomotives were to be converted from coal to oil burning to save 1 million tons of coal a year. The resultant expenditure reached £268,650 in 1946/7 and £1,335,309 in 1947/8. In September 1947, when ninety-three locomotives had been, or were being, converted, the Ministry of Transport was warned that the 840,000 tons of oil needed annually may not be available. Work on the locomotives was then stopped, but the storage depots were completed. The British Transport Commission told the Ministry of Transport that the additional cost of operating the ninety-three converted locomotives would be £279,000 a year, and the cost for the full programme would be more than £3½ million a year. The commission maintained that the extra expenditure on the scheme could not be justified and, in May 1948, it was abandoned. The ninety-three oil burning locomotives were to be converted back to coal burning at a cost of £200 each. Initial expenditure was estimated at £11,000 a year, incurred by the Ministry of Transport for care and maintenance of the oil depots, and in November 1948 the estimated total expenditure was nearly £3 million. Depots with oil installations in West Yorkshire were Normanton, Wakefield, and Mirfield. After nationalisation in 1948, a campaign was launched to reduce the BR coal bill, which amounted to £36 million in 1948 for the 15 million tons of coal used. Coal consumption per mile had risen by 25 per cent over the pre-war figure, which is not surprising given the rundown state of locomotives in the post-war period, and the fact that poor quality coal was being used so that the best coal could be exported to help the British economy, which was facing an 'export or die' period. Amongst the converted LMS locomotives were 8F 2-8-0s, 'Black Five' 4-6-0s, 4F 0-6-0s, and 7F 0-8-0s. The last engine converted back to coal burning was 7F 0-8-0 no. 9511 in the summer of 1948. The remaining four 7Fs were not so converted and were withdrawn from their home shed at Wakefield in July 1948. (LOSA)

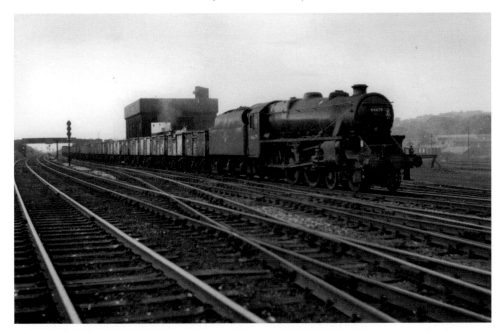

Ex LMS 'Black Five' 4-6-0 no. 44679 is seen passing Mirfield shed with a class F freight in the 1950s. (LOSA)

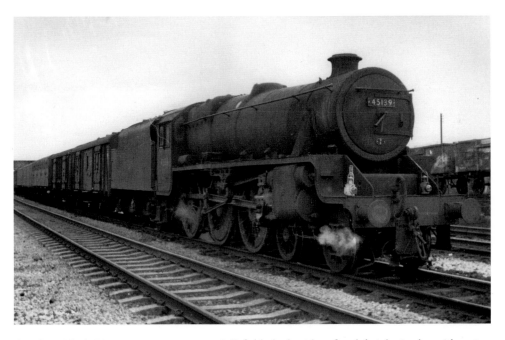

Another 'Black Five', no. 45139, passes Mirfield shed with a fitted freight in the mid 1960s. (LOSA)

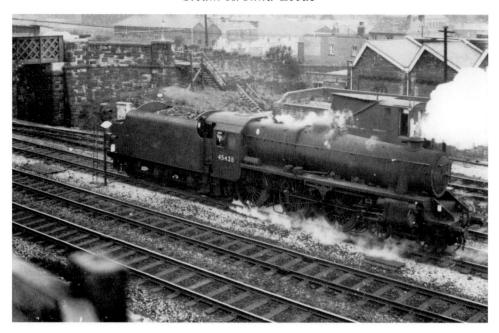

Running tender first, ex LMS 'Black Five' no. 45428 runs past Mirfield shed as it heads towards Bradford in the 1960s. (LOSA)

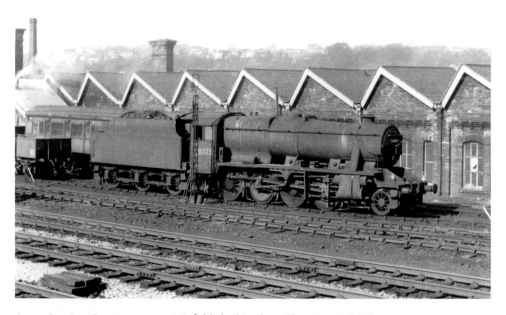

An ex Stanier 8F 2-8-0 rests at Mirfield shed in the mid 1960s. (LOSA)

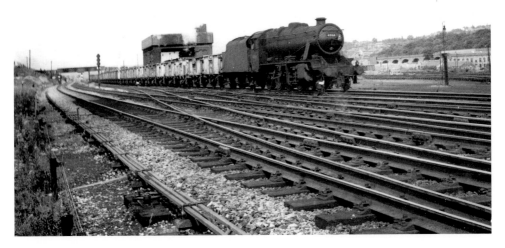

Another ex LMS 8F, no. 48166, passes Mirfield shed in the 1960s. The ash plant can be clearly seen in this view as the loose coupled train passes. (LOSA)

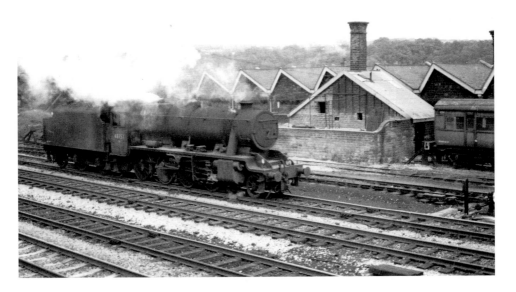

Passing Mirfield shed light engine is 8F no. 48357. (LOSA)

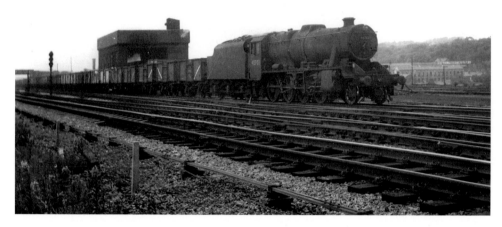

Ex LMS Stanier 8F 2-8-0 no. 48703 is seen passing Mirfield shed with a loose coupled train of open coal wagons. Much freight traffic at this time was from local collieries. (LOSA)

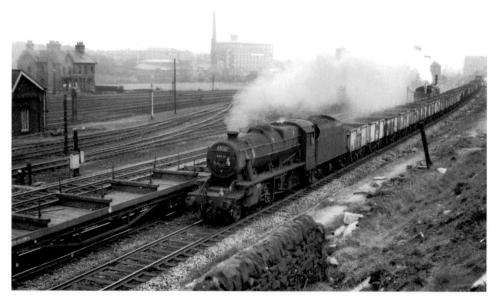

Passing Mirfield shed with a class H freight 8X60 is an unidentified ex LMS 8F 2-8-0. (LOSA)

NORMANTON, WAKEFIELD, DEWSBURY, HUDDERSFIELD, LEEDS, BRADFORD, HALIFAX,

Up. **Week Days**—*Continued.*

	mrn	mrn	aft	aft	aft	aft	aft	aft	aft	mrn	aft	aft	aft	aft	aft	aft	aft	mrn	aft	aft	aft
Waverley Station,																					
686 Edinbro'....dep.	7 45																10 0		
686 Newcastle (Cen.) "	10 28																1230		
724 Hull (Paragon).. "	11 5																	1 17			
715 Scarborough.... "		1035																2 35			
723 York........... "		1213																			
	aft	aft	aft	aft									aft	aft				aft	aft	aft	aft
Normanton......dep.	1221										2 22	43						3 12			3 21
Wakefield‡1784, 792 arr.	1237	1254									2 9	2 49						3 18			3 27
343 Doncaster 785 ..dep.	1157	1157								1 15								1 35			
785 Hull (Paragon).. "	11 5	11 5								1130								1148			
785 Goole (N.E.) "										1213								1 40			
792 Barnsley....... "	1155	1155								1010								2 43			
342 London (King's Crs) "											2 2 0							1035			
Wakefield (Kirkgate).dep.	1240	1258								1 50			2 18					3 22			3 33
Horbury Junction.....													2 23								
Horbury and Ossett....										1 58			2 28								
Dewsbury §§dep.				1244					1 30				2 15							2 45	
538 London (St. Pan.)dep.	5 30								9 30									1025 0			
539 Sheffield (Mid.) "	1140								1258									1057			
Thornhill 790.....				1249					1 35	1 38	2 6	2 11	2 35							2 51	
Mirfield 791...{788, 791} arr.	1253									Ll		2 18	2 43								3 47
Huddersfield 787, arr.	1012	1045								2 2	2 28		3 25								4 7
Cooper Bridge.....													2 48								
Huddersfield.....dep.							1 50						2 40								3 30
Brighouse, for Rastrick.. "	1 0	1 15				1 25			2 1	Ll			2 54								3 54
Elland...........						1 31			2 7	Ll			3 5								
Greetland 788				1 14	1 33				2 13	Ll			3 8								
Halifax 789..... arr.	1 11	1 39							2 7				3 21								4 18
Sowerby Bridge 785 arr.													3 14								4 6
Leeds (Central)....dep.			1 0	1 0	8 18	1 55							2 55					3 0			
710 Harrogatedep.			1224	1224		1227							2 55					2 55			
Holbeck.....			1 5	1 5	8 21	1 58							3 3								
Armley and Wortley...					8 26																
Bramley.....		1253	1253		1 6								2 14								
Stanningley, for Farsley																					
Laister Dyke 379		1247	1247		1 44																
Low Moor 790, 791 arr.			1 23	1 23		2 16												3 24			
Bradford (Exch.) dep.			1 10	1 10	1 20		2 2						3 5								
Bowling Junction....					1 25								3 10								
Low Moor...... arr.					1 29								3 15								
Low Moor......dep.			1 24	33		2 17							3 16								
Wyke ‖ 787......			1 21	21		2 13							3 20		3 26						
Lightcliffe........						2 16							3 23		3 30						
Hipperholme.....			1 27	1 32	42	2 20	2 25						3 26		3 36						
Halifax 381, 788 {arr. dep.}			1 29	1 36	45	1 50	2 29						3 31		3 40				3 43		
Copley.....						1 56													3 47		
Sowerby Bridge 785 arr.																			3 52		
Sowerby bridge ...dep.				Fi	j	1 58												3 53	4 7		
Luddendenfoot....						2 3												3 58			
Mytholmroyd.....						2 7												4 2			
Hebden Bridge.....						2 11												4 6	4 17		
Eastwood.....						2 16												4 11			
Todmorden 746 ... arr.				1 54	2 5	2 21						3 12						4 16	4 25		
746 Burnley §..... arr.						2 55						3 18						4 54			
Todmordendep.				1 58	2 7	2 23						3 19						4 18	4 28		
Walsden.....						2 27						3 15						4 22			
Littleborough.....						2 33						3 23						4 30			
Smithy Bridge[777						2 37						3 27						4 34			
Rochdale 729, 773, arr.		1 49			2 20	2 42	2 59					3 32						4 39	4 44		
777 Oldham (Mumps). arr.		2 34			3 50	4 11	3 34					4 29									
756 Southport †..... "						4 e 3						5 34									
750 Liverpool. (Ex.).. "																					
Rochdaledep.		1 52			2 36		3 2					3 35		3 48						4 47	
Castleton.....					2 41							3 40		3 53						4 52	
Middleton Junction 765												3 46								4 58	
Moston.....																					
Newton Heath.....																					
Miles Platting.....																					
Manchester (Vic.) 750 arr.		2 7	2 15		2 25	2 55	3 20			4 2								4 20			5 12
729 Bolton ‖‖‖ 774... arr.		2 41				3 13	4 15		4R18									4 52			
758 Blackpool (Cen.) "					R24	R12					5 54							6 12			
758 " (T.R.) "					4R29	4R58					5 50							6 0			
756 Southport †..... "							5 2											5 41			
Liverpool (Exch.) 750 arr.			3 10				4 10											5 10			

Above and overleaf: A 1910 L&YR timetable for the company's passenger services between Liverpool, Manchester, and the West Riding of Yorkshire. (Author)

TODMORDEN, ROCHDALE, LIVERPOOL, and MANCHESTER.—Lancashire and Yorkshire.

Up. **Week Days**—*Continued.*

Waverley Station,	aft	aft	aft	aft	aft	aft	aft	aft	aft	mrn	aft	mrn	aft	aft	aft	aft	aft	aft	aft	aft	aft
686 Edinbro'........dep.										1020		1020									
686 Newcastle (Cen.) "										1 44		1 44			2r10						
724 Hull (Paragon)... "						3 20															
715 Scarborough "						1 30					2 40										
723 York "						3 26					4 25										
Normantondep.							4 44				5 7			5 45				6 3			
Wakefield‡1784,792 arr.							4 50				5 13			5 51				6 10			
343 Doncaster 785 ..dep.									4z32	4z32							42		6x46		
785 Hull (Paragon) .. "																	55		5 5		
785 Goole (N.E.) "		2827							3 55	3 55							42		6 0		
792 Barnsley "						4 17								4z38			55				
342 London(King'sCrss)"									1 30								1 40		3 25		
Wakefield (Kirkgate) dep.			3 57			4 52			5 55	15				5y41				6 15	7 25		
Horbury Junction......			4 2															6 20			
Horbury and Ossett.....			4 7															6 24			
Dewsbury §§dep.			3y0	4 3				g 4z39	5 8					5y15				6K12			
538 London (St. Pau.) dep.					1200					1 30						3 30					
539 Sheffield (Mid.) "					3055					4 44						6 54					
Thornhill 790.......		3y40	4 15				4z44	5 16	5*28				5y55				6 33	7*36			
Mirfield 791...[788, 791			4 25		5 7		5 21	5 30	Ll								6 42	Ll	7 39		
Huddersfield 787, arr.			4n40				5 36	5n50	6 6								7 28	Ll	8 11		
Cooper Bridge........			4 30						Ll								6 47	Ll	7 44		
Huddersfielddep.			4 20				5 8						6 y 0				6 37		7 36		
Brighouse, for Rastrick.			4 35		5 14		5 38	Ll					6y12				6 53	Ll	7 54		
Elland..............	4 y 7	4 46					5Uy5	d	Ll				6y18				7 1	Ll			
Greetland 788........	4y11	4 50					d	Ll					6y21				7 6	Ll			
Halifax 789...... arr.		Ul1			5 25		5 40	6 27	6 2								7z24	8 11	8 11		
Sowerby Bridge 785 arr.		4 54					5 49				6 8						7 11		8 0		
Leeds (Central)dep.			3 57			4u2		5 0					5z10	6 0							
710 Harrogatedep.		2 25					4 22							5 14							
Holbeck		4 0				4u4	5 3						5z12	6 3							
Armley and Wortley..	3u47			3u47		4u9							5z17		5z54						
Bramley............	3u22			3u52		4u14							5z22		5n59						
Stanningley, for Farsley	3u25					4u17															
Laister Dyke 379	3u31					4u5	4u23								6u12						
Low Moor 790, 791 arr.		4 18					5 21						5z37	6 21							
Bradford (Exch.) dep.	4 5			4 20		4 45	5 8			5 18			5 45	6 8	6 25						
Bowling Junction....				4 25						5 23			5 50								
Low Moorarr.				4 29						5 27			5 54	6 16	6 32						
Low Moordep.		4 19		4 30		5 22				5 28			5 55	6 24	6 33						
Wykell 787				4 35	4 55					5 33			6 0		6 37						
Lightcliffe.........	4 16			4 39	4 58	5 18				5 37			6 4		6 40						
Hipperholme	4 19			4 42	5 1					5 40			6 7		6 43						
Halifax 381, 788 { arr	4 24	4 29		4 47	5 5	5 24	5 30			5 44			6 11	6 32	6 47						
{ dep.	4 33			4 55						5 50				6 34	7 6						
Copley............				4 59						5 54					7 10						
Sowerby Bridge 785 arr			4 41	5 4						5 59					7 15						
Sowerby Bridge....dep.			4 42	5 15		5 52				6 2					7 25						
Luddendenfoot.....			4 47	5 20	Stop					6 11					7 30						
Mytholmroyd.....			4 52	5 25						6 15					7 35						
Hebden Bridge.....			4 56	5 29						6 20					7 39						
Eastwood.........			5 2	5 35		5 52				6 25					7 46						
Todmorden 746..... arr.			5 7	5 40					6 6				6 52		7 51						
746 Burnley §arr.			5 40						6 40				7 40		8 58						
Todmorden..........dep			5 9	5 15		5 54			6 9				6 54	7 15	7 51						
Walsden..........			5 14							6 33					7 59						
Littleborough.....			5 22							6 45					8 7						
Smithy Bridge......[777			5 26							6 45					8 11						
Rochdale 729, 773, arr.	5 3		5 31						6 22				7 7		8 16						
777 Oldham (Mumps) arr.	5 36		6 9						6 52	7s23	d		7 41		8 46						
756 Southport † "	6X45								6 57				9 5		1035						
750 Liverpool (Exch.) "						aft			7 50												
Rochdaledep.	5 6			5 43		6 10			6 25	6 53			7 10		8 18						
Castleton				5 48					6 29	6 58					8 23						
Middleton Junction 765.				5 54					6 34	7 4					8 29						
Moston............				5 58																	
Newton Heath.....				6 2						7 10											
Miles Platting.....																					
Manchester (Vic.) 750 arr.	5 22			6 10		6 25			6 46	7 20			7 25		8 47						
729 Bolton ‖‖‖ 774... arr.	5R47	R6e15		7 1					6R57				7R58		9R8						
758 Blackpool (Cen.) "	7z20	R7c36							8R54				10R2	10 2	1110R						
758 " (T.R.) "			8 17						8R33				9R41	9 41							
756 Southport † "									7 57				9 5		1035						
Liverpool (Exch.) 750 arr	6 10					7 10							8s20								

THREE

WAKEFIELD

Due to the presence of coal mines in the Wakefield area, the town was always going to be an important destination for the railway companies. It was part of the GNR route which connected Leeds with the East Coast Main Line at Doncaster.

Since the opening of the L&YR from Low Moor to Bradford in 1850, pressure had been applied by businesses for a line direct to Wakefield, but difficult finances would not allow the construction of a new railway through the Spen Valley. A compromise was put forward which would have provided an east facing spur at Mirfield and a link with the LNWR at Thornhill, but it came to nothing. Instead, the L&YR had to construct a branch between Thornhill and Heckmondwike. A triangular junction was laid in 1861 at Thornhill, although the Bill of 17 June did not give authority for a west facing arm. As the L&YR was in no hurry to finish the project, the whole branch, measuring 2½ miles in length, was not completed until 1869.

In the meantime, the Bradford, Wakefield and Leeds Railway Act of 1854 allowed construction of a railway from the Leeds, Bradford and Halifax Junction Railway, near Leeds, to Wakefield. The LB&HJR opened in 1857, and ran through Laister Dyke and Morley Top to Ardsley, on the Wakefield–Leeds section of the West Yorkshire Railway.

The opening of the West Riding and Grimsby Railway, jointly owned by the GNR and Manchester, Sheffield and Lincolnshire Railway (later the Great Central Railway), on 1 February 1866, allowed access to Leeds, via Wakefield, without using L&YR and MR metals. The GNR then opened branches from Wakefield, at Wrenthorpe Junction, to Ossett and Batley in 1864, although a loop to Dewsbury did not open until 1880. Another line opened from Batley to Drightlington in 1876, making it possible to travel from Bradford to Wakefield via Dewsbury. The L&YR opened its own branch from Thornhill to Dewsbury in 1867.

Nearby Normanton was served by the Y&NMR, whose line from York was approved on 29 May 1839, to connect with the Leeds–Selby Railway. Construction as far as Burton Salmon was completed, and the line was opened on 11 May 1840, reaching Normanton soon afterwards. Once the whole line had been completed, through trains could then run between York and Leeds via Castleford and Methley. The Manchester and Leeds Railway also ran through to Normanton, along the Calder Valley, and terminated here.

Nationalisation of the railways in the 1950s and 1960s led to closure of Thornhill–Bradford services in 1957, with Thornhill–Heckmondwike passenger trains lasting until 1962. Services between Mirfield and Heckmondwike ceased in 1965, and only the ex L&YR Thornhill–Low Moor section was retained. Also in 1965, the old GNR line between Wrenthorpe Junction and Drightlington was closed. The main GNR line from Doncaster to Leeds, via Wakefield, remains open as part or the electrified East Coast Main Line.

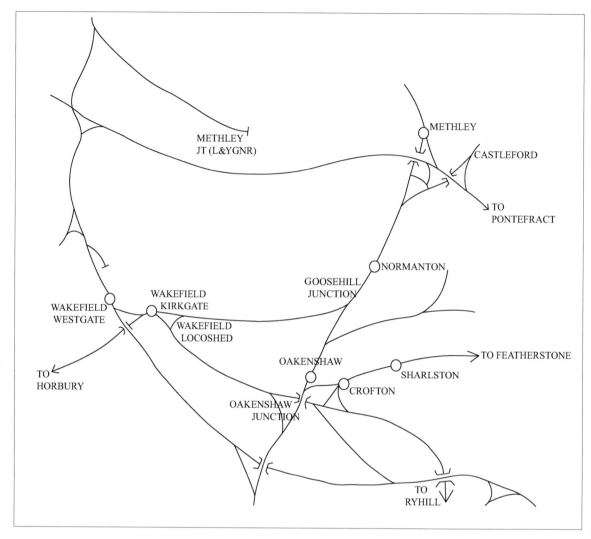

A map of the railway system around Wakefield. (Author)

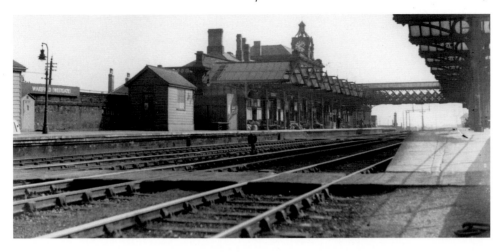

As an inland port on the River Calder, Wakefield was central to the wool trade and was an important destination for the fledgling railway companies. Thus, when railways opened in the West Riding, it was essential to ensure that the town was well served and two stations were established in the town. One was at Kirkgate, serving the L&YR, and the other was at Westgate, serving the GNR and Great Central Railway, this being on the main line from Doncaster to Leeds Central. Wakefield Westgate station is seen here in 1935. (LOSA)

WAKEFIELD, THORNHILL, and DEWSBURY. —Lancashire and Yorkshire.

Timetables for L&YR services from Wakefield Kirkgate to Dewsbury in 1910. (Author)

DEWSBURY, THORNHILL, and WAKEFIELD. —Lancashire and Yorkshire.

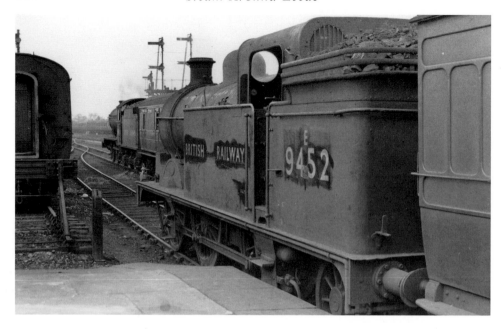

Waiting at Wakefield Westgate station just after nationalisation is ex LNER N1 class 0-6-2T no. E9452 (later to be 69452) with the 3 p.m. train to Bradford Exchange. Another passenger train, headed by a 0-6-0 tender engine, is passing with a train for Leeds. The town retained its importance for many years as a manufacturer of cloth, grain, beer and rope. There was also a thriving boat building industry here in the past, and coal mines had been established here supplying coal to the various wollen mills in the locality. (R. Carpenter)

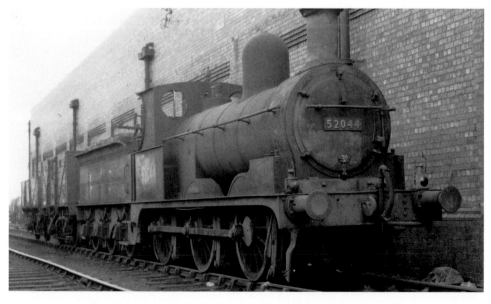

Ex L&YR Barton-Wright 0-6-0 no. 52044 at Wakefield shed on 14 September 1958. This engine remained at Wakefield shed until its withdrawal in the following year, and is now part of the locomotive collection on the Keighley and Worth Valley Railway. (F. Wycherley)

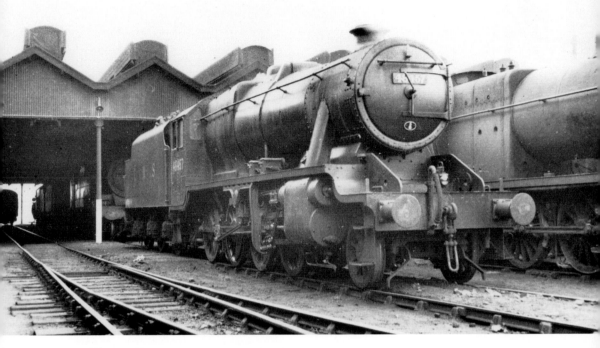

Situated close to Kirkgate station was the locoshed at Wakefield, built by the L&YR. It was a ten road straight shed and its allocation was mostly for freight work in the locality. Before nationalisation, the shed had fallen into disrepair. This was acknowledged by the LMS, but there were only plans to supply a new roof in 1947, at a cost of £17,009. However, the structure was in far worse condition, as a report on the physical condition of British railways in January 1948 showed:

> To restore railway structures to the condition necessary will require from two to four normal pre-war years of work in addition to current work. During the war years only about two thirds of the normal work was carried out on bridges, tunnels, buildings, etc.
>
> The absence of effective priorities for labour, shortages of essential materials, and the increasing delays in delivery of rolled steel sections and fabricated steel work have together prevented any general overhaul since the end of the war.
>
> Much reinstatement of glass in stations and workshop roofs remains outstanding. Many locomotive shed roofs are in deplorable condition and are worsening and complaints from the staff are frequent and growing. Unless an effective start can be made during 1948 to undertake the essential repair, replacement and protection of structures, the progressive worsening of the conditions will involve increasing day to day attention of available staff to safeguard against serious developments, e.g. the failure of structures to do their job, with consequential heavier accumulation of arrears of major repairs and replacements and difficulties arising from the resentment of operating staff at the present conditions.

Here, just after nationalisation, while the shed was awaiting significant repair, is ex LMS Stanier 8F 2-8-0 no. 48457, still with its original owner's name on the tender. (N. Glover)

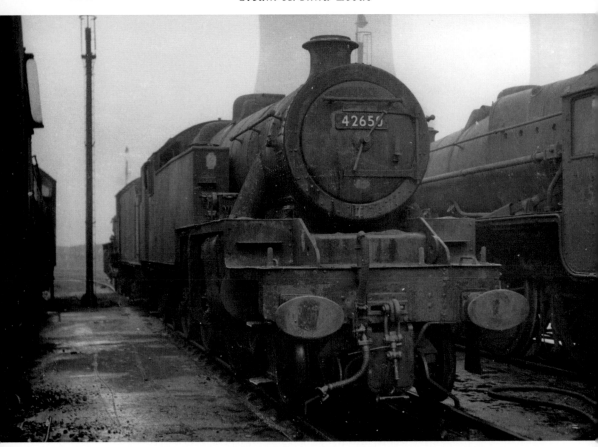

Ex LMS Stanier 2-6-4T no. 42650 at Wakefield shed in the 1950s, with 'Black Five' 4-6-0 no. 45335 alongside. The shed at Wakefield had been due for repair in the 1930s, but the Great Depression had left the LMS with a shortage of income and work was delayed. After the Second World War, the LMS made a valiant effort to undertake restoration work on its system, but progress was slow because essential construction materials were difficult to obtain. After nationalisation, Wakefield shed came under the control of the North Eastern Region and, by 1952, along with Ardsley, Sowerby Bridge, Sunderland, Bowes Bridge, and Goole, Wakefield was to have a new roof as it had one of the worst straight shed roofs in the region. Requirements for the new roofs were that they should ensure good working conditions and a reduction in maintenance requirements. The materials used were expected to be resistant to deterioration under normal use, and all parts of the structure were required to be easily accessible so that any faulty parts could be easily and simply replaced. As 're-roofing' usually meant the construction of a new shed, the shed was now made up of a set of standardised interlocking parts. Contracts were let for all six sheds and all were manufactured centrally, but individual contracts were let for erection so that standard units could be assembled to suit the site. Yorkshire Henebique were contracted for Wakefield shed and were responsible for all foundation work and drainage, as well as the construction of the shed to completion. The new shed was completed near the end of 1954 and was to last only another thirteen years, closing in 1967. (LOSA)

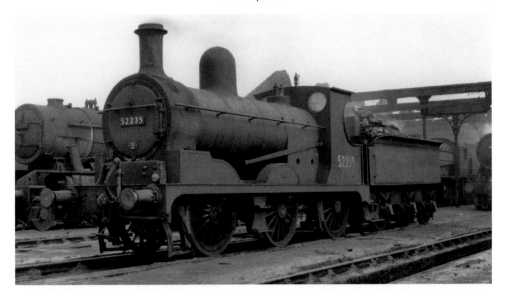

Seen at Wakefield shed on 12 April 1953 is another ex L&YR 3F Barton-Wright 0-6-0, no. 52235. At this time, there were several old L&YR types in a total of 122 engines. By 1959, the allocation was eighty-seven locomotives; by 1965 it was down to eighty-four, sixty of which were ex WD 2-8-0s. In 1948, the allocation at Wakefield was as follows:

Code 25A and 56A in 1956

Ex LMS Ivatt 2-6-2T	41250, 41251, 41252, 41253, 41254, 41255
Ex LMS Stanier 5Mt 4-6-0	45261, 45339
Ex LMS Ivatt 2-6-0	46438, 46439
Ex LMS 3F 0-6-0T	47510, 47572, 47573, 47580, 47582
Ex LMS Stanier 8F 2-8-0	48502, 48504, 48506, 48511, 48514
Ex LNWR 7F 0-8-0	49625
Ex L&Y 2P/3P 2-4-2T	50650, 50656, 50712, 50715, 50762, 50764, 50788, 50689, 50873, 50886, 50892, 50898
Ex L&YR 2F 0-6-0T	51447
Ex L&YR 3F 0-6-0	52120, 52150, 52145, 52186, 52235, 52345, 52369, 52386, 52433, 52435, 52521, 52561, 52576
Ex WD 2-8-0	90124, 90157, 90163, 90242, 90243, 90292, 90239, 90310, 90333, 90334, 90337, 90339, 90341, 90342, 90353, 90361, 90362, 90370, 90379, 90380, 90381, 90396, 90397, 90404, 90414, 90415, 90417, 90581, 90607, 90615, 90617, 90620, 90624, 90631, 90633, 90635, 90637, 90639, 90643, 90644, 90651, 90652, 90654, 90656, 90673, 90679, 90682, 90693, 90710, 90719 90722, 90725, 90729
	TOTAL: 100

(F. Wycherley)

WAKEFIELD, BATLEY, and BRADFORD.—Great Northern.

Down. — Week Days.

Mls. frm Wakefield	King's Cross, 342 Londondep.	mrn	mrn	mrn	mrn	mrn	mrn	mrn	mrn		mrn	mrn	mrn	mrn	mrn	mrn	mrn	mrn	aft	mrn	mrn		
						3 15					5	5 5	5			7 15	7 15				10 10	10 10	
	Wake-{ Kirkgate....dep.		5 8	5 8	6 40	7 8	7 8	7 50	8 30		8 30	9 5		10 0				11 30	11 30	1 12		1 12	
1	field { Westgate.... "		5 24	5 22	7 2	7 27	7 32	8 30	8 35		9 7	9 10	9 55	10 4	11 1	11 7		12 8	12 10	1 21	1 41	1 46	
2¼	Alverthorpe		5 26		7 6		7 36		8 39				10 8			11 11		12 12		1 25			
4	Flushdyke		5 31		7 10		7 40		8 44			9 16	10 13			11 15		12 17		1 30			
4½	Ossett		5 36		7 13		7 43		8 47			9 19	10 16			11 18		12 20		1 33			
6½	Earlsheaton		5 41		7 17		7 47		8 51			9 23	10 20			11 22		12 24		1 37			
7¼	Dewsbury † 736		5 46		7 20		7 50		8 54			9 26	10 23			11 25		12 27		1 40			
7¾	Batley Carr		5 48		7 22		7 52		8 56			9 28	10 25			11 27		12 29		1 42			
8¾	Batley 519, 523		5 53		7 25		7 55		8 59			9 31	10 29			11 30		12 32		1 45			
9½	Upper Batley	stall		5 57				7 59		9 3			9 35	10 34					12 36				
10¼	Howden Clough, for Bir-		6 2				8 4		9 7			9 39	10 39					12 40					
3¾	Lofthouse ‡		5 29				7 18		8 36				10 1					12 16			1 51		
5½	Ardsley		5 10	5 35	6 57		7 45		8 58		9 16		10 18			11 40		12 25			1 57		
6¼	Tingley		5 14	5 40	7 1		7 49		9 1				10 21			11 43		12 28			2 0		
8	Morley		5 18	5 45	7 5		7 53		9 5				10 26			11 47		12 32			2 4		
9½	Gildersome		5 21	5 48	7 8		7 57		9 8				10 30			11 50		12 35			2 8		
11½	Drighlington * 343, 379	5 25	5 51	6 10	7 12		8 0	8 19	9 11	9 16		9 45	10 34	10 46		11 53		12 46	12 58		2 12		
12¼	Birkenshaw and Tong.	5 29		6 14	7 16			8 15		9 20		9 56		10 50				12 50					
14¼	Dudley Hill	5 33		6 18	7 20			8 19		9 24		10 0		10 54				12 54					
16½	Laister Dyke 394	5 39		6 23	7 25			8 24		9 29		9 33	10 6	10 59				12 59			2 8		
18	St. Dunstan's 380	5 43		6 26	7 29			8 27		9 32		9 36	10 9		11 2	11 25	11 49		1 2				
18¼	Bradford(Exchange)arr.	5 47		6 30	7 32			8 31		9 36		9 40	10 13		11 5	11 28	11 52		1 6		2 10		

King's Cross, 342 Londondep.	mrn	aft	mrn	mrn	mrn	aft		aft	aft	aft	aft	aft	aft	aft		aft	aft	aft	aft	aft	aft	
	10 10		10 35	10 35	10 35			1 30	1 30	1 30	1 30	1 40				4 04	0			5 45	5 45	5 45
Wake-{ Kirkgate...dep.	1 12		2 3	2 55	2 55	4 5		4 20	4 20		4 20	4 20	5 45	6 44		7 35	7 33	8 10	8 10			
field { Westgate... "	1 53		2 50	3 8	3 15	4 13		4 43	4 58	5	1 5	18	5 15	5 16	6 49		7 51	7 58	8 25	8 30	9 18	9 18
Alverthorpe	1 57			3 19	4 17			4 47				5 18	5 55				8 2		8 34		9 26	
Flushdyke	2 2			3 23	4 22			4 52				5 23	6 0				8 7		8 39		9 31	
Ossett	2 5			3 26	4 25			4 55	5 7			5 26	6 3	7 15			8 10		8 42		9 34	
Earlsheaton	2 9			3 30	4 29			4 59				5 30	6 7	7 19			8 14		8 46		9 38	
Dewsbury † 736	2 12			3 34	4 32		5 2	5 12			5 34	6 11	7 22			8 17		8 49		9 41		
Batley Carr	2 14			3 35	4 34						5 36	6 13						8 51		9 43		
Batley 519, 523	2 17			3 38	4 38		5 6	5 16			5 38	6 17				8 20		8 54		9 46		
Upper Batley ...	stall	2 21			3 42	4 42		5 10				5 42	6 21				8 24		8 58		9 50	
Howden Clough, for Bir-	2 25			3 46	4 47		5 15				5 47	6 25				8 28		9 3		9 54		
Lofthouse ‡				3 14							5 23		6 55				8 31					
Ardsley		2 29	2 59	3 25				5 29				5 29		7 20		7 59		8 46				
Tingley		2 33		3 29				5 32				5 32		7 24				8 49		9 53		
Morley		2 37		3 34				5 36				5 36		7 29				8 54		9 57		
Gildersome		2 41		3 38				5 39				5 39		7 33				8 58		10 1		
Drighlington * 343, 379	2 46		3 43	3 44	4 53	5 21		5 42	5 53	6 32	7 36					3 59	19	9	9 10 46			
Birkenshaw and Tong.	2 35	2 50		3 58	4 57	5 31		5 57	6 36					8 39		9 13		d 10 10				
Dudley Hill	2 39	2 54		4 25	1	5 35		6 1	6 40					8 43		9 17		d 10 14				
Laister Dyke 394	2 45	2 59	3 16	4 8	5 6	5 41		6 6	6 47				8 14	8 48		9 23		10 20				
St. Dunstan's 380	2 48	2 23	19	4 11	9	5 45	5 23		6 9	6 50				8 17	8 51		9 26		10 23			
Bradford(Exchange)arr.	2 52	3 63	23	4 15	5 12	5 48	5 26		6 12	6 55				8 20	8 55		9 30	10 4		10 27		

Down. — Week Days—Continued. / Sundays.

King's Cross, 342 Londondep.	aft	aft	aft	aft				mrn	mrn	aft	noon	noon	aft	aft	aft	aft	
		6 56	56	5						12 0	12 0			5 0	5 0		
Wake-{ Kirkgate...dep.	9 44	9 44	9 44						1 10	3 55	3 55	8	5 8	5		9 45	
field { Westgate.. "	10 7	10 28	10 39					8 20	9 36	1 32	4 13	4 40	8 15	8 35	9 14	9 51	
Alverthorpe		10 32	10 43					8 24		1 36		4 44	8 40		9 54		
Flushdyke		10 37	10 48					8 29		1 41		4 49	8 45		9 59		
Ossett		10 40	10 51					8 32		1 45		4 53	8 49		10 3		
Earlsheaton		10 44	10 54					8 36		1 49		4 57	8 53		10 7		
Dewsbury † 736		10 46	10 57					8 39		1 53	5 1		8 57		10 11		
Batley Carr			10 59					8 41		1 56	5 4		9 0		10 13		
Batley 519, 523			11 2					8 44		1 59	5 7		9 4		10 16		
Upper Batley ...	stall			11 9					8 48		2 3	5 12		9 9			
Howden Clough, for Bir-			11 9					8 52		2 8	5 17		9 14		10 24		
Lofthouse ‡		10 13			11 11				9 42			8 20					
Ardsley		10 45			11 11				10 10	4 21	3 28		9 22				
Tingley		10 49			11 13				10 14	4 25	8 32						
Morley		10 53			11 19				10 19	4 29	8 37						
Gildersome		10 57			11 23				10 23	4 33	8 41						
Drighlington * 343, 379	11 0		11 13	11 27				8 59	10 27	2 15	4 37	5 24	8 45	9 20		10 32	
Birkenshaw and Tong.			11 17					9 3	10 31	2 19	4 41	5 28	8 49	9 24		10 36	
Dudley Hill			11 21					9 7	10 35	2 23	4 45	5 32	8 54	9 28		10 40	
Laister Dyke 394			11 26					9 12	10 40	2 28	4 50	5 37	9 0	9 33	9 40	10 45	
St. Dunstan's 380			11 29					9 15	10 43	2 31	4 53	5 40	9 3	9 36	9 43	10 48	
Bradford(Exchange)arr.			11 33					9 20	10 46	2 34	4 57	5 44	9 6	9 39	9 46	10 51	

a Set down from London. *a* Wednesdays only.
b Stop to set down from Doncaster and South thereof on informing the Guard at the preceding *stopping* Station.
d Via Holbeck. *l* Wednesdays and Saturdays.
* Drighlington and Adwalton. † About ½ mile to L.&N.W. and L.&Y. (Market Place) Stations. ‡ Lofthouse and Outwood.
☞ For **OTHER TRAINS** between Ossett and Batley, see pages 376 and 377
between Ardsley and Bradford, see pages 343 and 345.

Above and opposite: A 1910 Great Northern Railway timetable for passenger services from Wakefield to Bradford, via Batley. (Author)

BRADFORD, BATLEY, and WAKEFIELD.—Great Northern.

Up. — Week Days.

Miles	Exchange Station,	mrn	mrn	mrn	mrn	mrn	mrn	mrn	mrn	mrn	mrn	mrn	mrn	mrn	mrn	mrn	mrn	mrn	aft	aft	aft
	Bradford..........dep.		5 37	6 7	6 10		7 25	7 53		8 40	9 25		9 45	10 25	10 48			12 22			
¼	St. Dunstan's............		5 40	6 10	6 13		7 29			8 43	9 28				10 51			12 25			
2	Laister Dyke............	5 2	5 45	6 15	6 18		h	8 0		8 48	9 33			10 32	10 56			12 30			
4	Dudley Hill............	5 8	5 50	h	6 23			8 6	h	h				10 37	11 1			12 35			
5½	Birkenshaw and Tong.	5 12	5 54	g	6 27		h	8 10	h	h	9 42	9 50		10 41	11 5			12 39			
6¾	Drighlington *	5 16	5 58	6 13	6 31	6 35	7 4	8 15	8 19		9 42	9 50		10 45	11 10	11 21	12 4	12 43	12 47		
8	Gildersome	5 20		6 16	h	6 35	7 7		8 23		9 53			11 13		12 8		12 50			
9½	Morley	5 25		6 20	g	6 39	7 11		8 27	h	9 57			11 17		12 12		12 54			
10½	Tingley	5 30		6 23		6 47	7 14		8 30		10 0			11 20		12 15		12 57			
12½	Ardsley 376	5 33		6 27	6 30	6 50	7 19		8 37		10 4			11 24		12 19		1 1			
14¼	Lofthouse ‡...	stall	5 40									10 19			11 54		12 36				
8¾	Howden Clough, for Bir-			6 1			6 38		8 18		9 45						12 46				
9	Upper Batley			6 4			6 41	h	8 21		9 48						12 49				
9¾	Batley 519, 523 ...	5 37	6 7			6 44	7 46	8 25		9 52			10 52		11 27		12 53				
10½	Batley Carr	5 40	6 10			6 47		8 28		9 55			10 55		11 30		12 56				
11¾	Dewsbury † 523, **736**	5 42	6 12			6 49	7 49	8 32		9 57			10 57		11 33		12 59				
12½	Earlsheaton	5 45	6 15			6 52		8 36		10 0			11 0		11 36		L 2				
13½	Ossett	5 50	6 20			6 57	7 55	8 41		10 5			11 5		11 41		1 7				
14¼	Flushdyke	5 53	6 23			7 0		8 44		10 8			11 8		11 44		1 10				
16¼	Alverthorpe	5 57	6 27			7 4		8 48		10 12			b	11 12		11 48		1 14			
17¾	Wake- (Westgate 348 ar	5 45	6 1	6 31		6 38	7 29	7 8	7 29	8 1	8 52	9 10	10 16	10 23	11 16	11 58	11 53	12 40	1 17	1 34	
18¾	field (Kirkgate 784 "	5 50		6 44		6 44	7 13	7 13	8 2	9 8	9 33		10 55	10 55	11 44	12 44	12 44	12 44	1 43	1 43	
193¾	349 London (King's C.) a				10 40			11 30		1 5			1 55	3 55	4 10	4 10					

Up. — Week Days—Continued.

Exchange Station,	aft	aft	aft	aft	aft	aft	aft	aft	aft	aft	aft	aft	aft	aft	aft	aft	aft	aft	aft	aft	aft
Bradford..........dep.	1 25	1 50	2 35		3 43		4 42	5 10	5 15		6 0	6 13	6 48		7 47			9 20		9 55	
St. Dunstan's............		1 53	2 38		3 46			5 18			6 16	6 51			7 50			9 23			
Laister Dyke	h	1 58			3 51		4 48	5 17	5 23		6 7	6 22	6 56		7 55			9 28		10 2	
Dudley Hill	h	2 3	h		3 56		4 53		5 28		6 23	6 57	7 1		8 0			9			
Birkenshaw and Tong.	h	2 7	h		4 0		4 57	h	5 32		6 13	6 31	7 5		8 4			9			
Drighlington *		2 11			4 4	4 9	5 0		5 36	5 45	6 17	6 40	7 10		8 8	12 8		9 41	9 45		
Gildersome						4 12		h		5 48		7 13				8 15		9 48			
Morley			h			4 16		j		5 52		7 17				8 19		9 52	h		
Tingley						4 19				5 56		7 20				8 23		9 55			
Ardsley 376		2 57				4 22	5 32		6 0		7 24				8 27		9 59	10 17			
Lofthouse ‡...	stall						4 28				6 14		7 31				9 25				
Howden Clough, for Bir-	2 15				4 8		h		5 39		6 20	6 43			8 11			9 44			
Upper Batley	h	2 18			4 11		h		5 42		k	6 46			8 14			9 47			
Batley 519, 523 ...	1 49	2 21		2 57	4 14		5 9		5 45		6 23	6 50			8 17		9 33	9 50			
Batley Carr		2 24		3 0	4 17				5 48		6 53				8 20		9 36	9 53			
Dewsbury † 523, **736**	1 53	2 27		3 3	4 20		5 13		5 50		6 27	6 56	8 15		8 22		9 38	9 55			
Earlsheaton	h	2 30		3 6	4 23		5 16		5 54		6 30	6 59	8 18		8 25		9 41	9 58			
Ossett	2 0	2 35		3 12	4 28		5 21		6 0		6 35	7			8 30		9 46	10 3			
Flushdyke	h	2 38		3 15	4 31		5 24		6 3			7 7			8 33			10 6			
Alverthorpe		2 42		3 20	4 35		5 28		6 7			7 11			8 37			10 10			
Wake- (Westgate 348 ar	2 7	2 47	3 5	3 25	4 40	4 32	5 35	5 40	6 11	6 19	6 42	7 15	7 36		8 42	9 29		10 15		10 27	
field (Kirkgate 784 "	2 31	2 51	3 23		4 55	4 55	6 0	6 0	6 16	6 55	6 55	7 53	7 53		8 48	9 33		10 43		10 43	
349 London (King's C.) a	5 30			8 35				9 25			10 45								3 10		

Up. — Week Days—Continued. | Sundays.

Exchange Station,	aft	aft	aft	aft	aft		mrn	mrn	non	aft	aft	aft	aft	aft	aft	
Bradforddep.	10 5		11 18				8 31	10 25	12 0	4 27	5 6	30 8	7 9	9 23		
St. Dunstan's	10 8		11 21				8 34		12 34	30 5	8 6	33 8	10 9	9 26		
Laister Dyke	10 13		11 26				8 40	10 32	12 9	4 35	5 13	6 38	8 16	9 31		
Dudley Hill	10 18		11 31				8 47	h	12 16	4 40	h	6 43	8 23	9 36		
Birkenshaw and Tong.	10 22		11 35				8 51	h	12 20	4 44	h	6 47	8 27	9 40		
Drighlington *	10 26		11 40	11 43			8 56	9 10	10 40	12 24	4 48		6 51	8 31	9 44	9 49
Gildersome	10 29			11 46				9 11	10 43				6 54		9 53	
Morley	10 33			11 50				9 19	10 47			h	6 58		4 58	
Tingley	10 36			11 53				9 22	10 50					10 1		
Ardsley 376.........	10 40			11 58				9 25	10 53		5 29	7 4		10 4		
Lofthouse ‡...	stall	11 32								10 11	10 59			7 12		
Howden Clough, for Bir-							8 59			12 27	4 51			8 34	9 47	
Upper Batley				Sat.			9 2			12 30	4 54			8 37		
Batley 519, 523			11 23	11 47			9 5			12 33	4 57			8 41	9 51	
Batley Carr			11 26				9 8			12 36	5 0			8 44		
Dewsbury † 523, **736**	10 57		11 28	11 51			9 11			12 39	5 3			8 47	9 54	
Earlsheaton	11 0		11 31	Sat.			9 15			12 43	5 7			8 52	9 54	
Ossett	11 5		11 35	11 58			9 21			12 49	5 12			8 59	10 4	
Flushdyke	11 8						9 24			12 52	5 16			9 3		
Alverthorpe	11 12						9 28			12 56	5 20			9 8		
Wake- (Westgate 348 ar	11 17	11 37		12 5			9 31	10 16	11 21	5 25	4 5	26 7	17 9	11 10	12 10	35
field (Kirkgate 784 "		12 10		12 10			9 37		11 16	5 55	5 55		9 17		10 40	
349 London (King's C.) a							3 15	5 45		9 40			3 10	3 10		

b Change at Holbeck.
f Stop to set down from Bradford.
g Stops to take up for Doncaster and South thereof.
h Stop to take up for London.
i Stops when required to take up.

j Stops when required to take up for Ardsley and beyond.
k Stops on Mondays and Thursdays when required to set down from Bradford.
u Stops to take up only.

* Drighlington and Adwalton.
† About ½ mile to L. & N. W. and L. & Y. (Market Place) Stations.
‡ Lofthouse and Outwood.

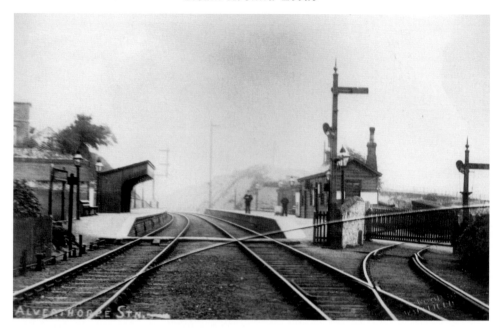

On the line from Wakefield to Bradford is the station at Alverthorpe, seen here in the early twentieth century. (LOSA)

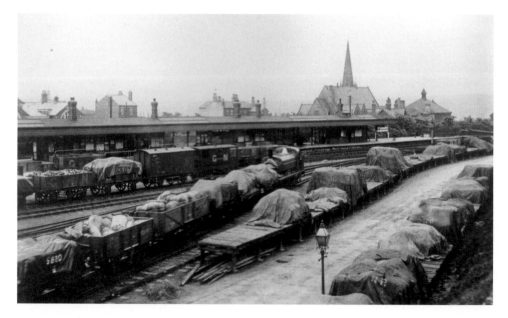

Following Alverthorpe, the GNR line passes Flushdyke and then enters Ossett, seen here in the early twentieth century. The station here seems very busy with several freight wagons in view carrying wool, with GNR Stirling o-6-oST shunting in the yard. (LOSA)

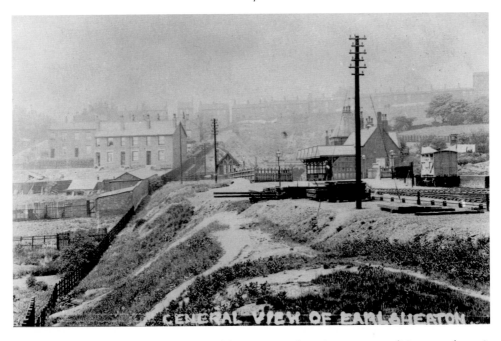

The next station along the line was Earlsheaton, seen here in snowy conditions not long, it appears, after opening. (LOSA)

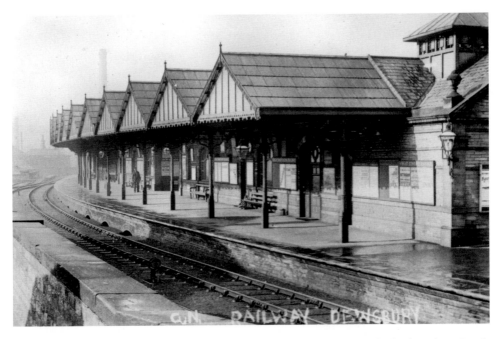

The substantial station at Dewsbury, where there was a junction with the line from Leeds Central to Barnsley. The station was jointly owned by the GNR and L&YR. Dewsbury was a town which expanded rapidly since the Industrial Revolution and was known for the recycling of woollen cloth into blankets, coats, and uniforms. (LOSA)

LEEDS, BATLEY, DEWSBURY, BARNSLEY, CLECKHEATON, and LEEDS.—Great Northern and Lancashire and Yorkshire.

Week Days. ... *Sundays.*

NOTES.

a Calls at Howden Clough at 1.29 and Birkenshaw and Tong at 1.37 aft.

k Tuesdays and Saturdays.

s Saturdays only; change at Dewsbury.

Over ¼ mile to L.&N.W. Station.

† About ½ mile to L. & N. W. and L. & Y. (Market Place) Stations.

☞ For OTHER TRAINS between Batley and Ossett, see page 379.

LEEDS, CLECKHEATON, BARNSLEY, DEWSBURY, BATLEY, and LEEDS.—Great Northern and Lancashire and Yorkshire.

Week Days. ... *Sundays.*

NOTES.

a Stop to set down on informing the Guard at the preceding stopping Station.

c Stops when required to take up for Cleckheaton Branch.

* Over ¼ mile to L.&N.W. Station.

† About ½ mile to L. & N. W. and L. & Y. (Market Place) Stations.

☞ For OTHER TRAINS between Ossett and Batley, see page 378.

A 1910 timetable for the joint GNR and L&YR passenger services between Leeds and Barnsley, via Dewsbury. (Author)

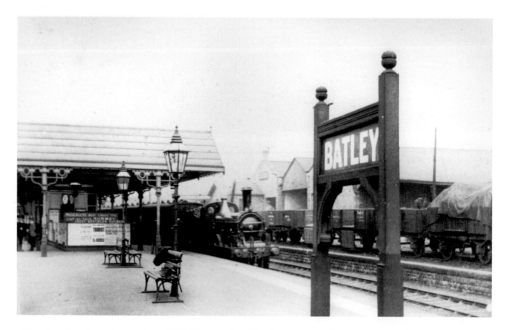

After leaving Dewsbury, the GNR line to Bradford passes Batley Carr and then enters Batley itself. Batley station is seen here in the early years of the twentieth century with a famous Stirling 'Single' 4-2-0 at the head of a stopping train as it awaits departure. In the background is a rake of open wagons waiting to be unloaded at the goods shed. (LOSA)

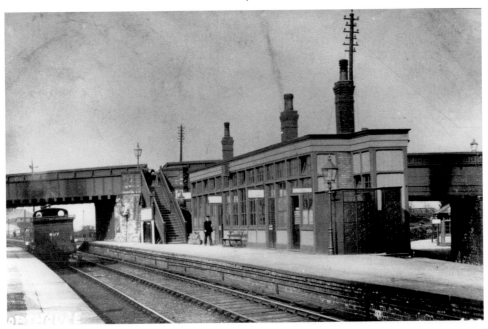

From Batley, the line passed Upper Batley and Howden Clough before arriving at Lofthouse. The station is seen here in the early years of the twentieth century with a GNR tank engine, no. 607, on shunting duties. (LOSA)

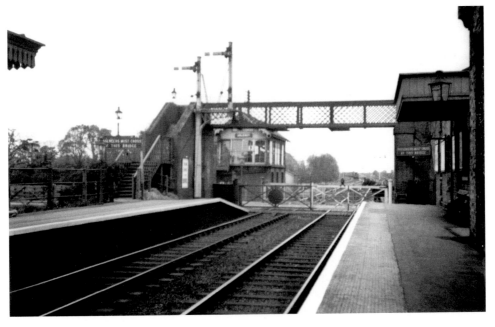

The next station on the line is the junction station at Ardsley, seen here in the 1930s. (LOSA)

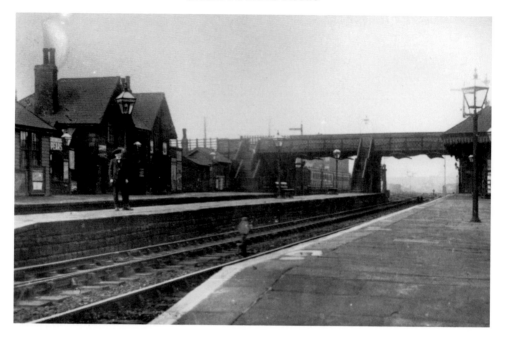

Another view of Ardsley station in GNR days. (LOSA)

Timetables for GNR services between Leeds Central and Wakefield via Ardsley. (Author)

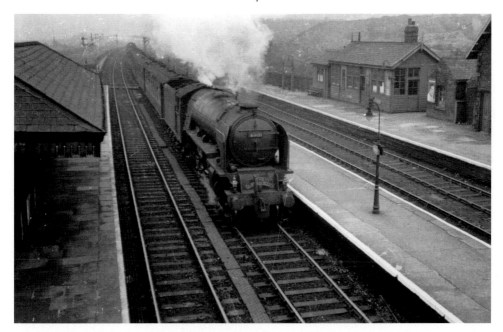

Rushing through Ardsley station in October 1956 is ex LNER A1 pacific no. 60131, *Osprey*, at the head of the *Queen of Scots* Pullman train. Pullman trains operating through Yorkshire had their origins on the Great Eastern Railway, which had acquired an American General Manager, Sir Henry Thornton, in 1914. Having had considerable experience of Pullman travel in the USA, Thompson saw no reason why Pullman services should not prove popular in East Anglia, as they were in the south. Thus, an agreement was reached with the Pullman Car Company and services began. Those operating on the Continental Boat Train from London Liverpool Street to Parkestone Quay were well used, but others were not. When the LNER was formed at the 'Grouping', it was found that there was still a long period of the Pullman Car Agreement to run and there was an urgent need to find a profitable use for these carriages. Boat trains continued to operate but other services were withdrawn; a set was made up to run between King's Cross, Leeds, Harrogate, and Newcastle, and given the name *The Harrogate Pullman*. In 1925, the service was extended to Edinburgh and, later that year, re-routed to run non-stop to Harrogate via Shaftholme Junction, Knottingley, Church Fenton, and Tadcaster. A new train, *The West Riding Pullman*, ran to Leeds. This situation continued until 1928 when a new set of all steel coaches appeared on the Edinburgh services, now titled *Queen of Scots*. At the same time, the *West Riding* moved to an afternoon departure from King's Cross and the *Queen of Scots* returned to the Leeds route, leaving London at 1.15 a.m. This service was extended to Glasgow at the same time. Such services were withdrawn at the outbreak of the Second World War. After the war, the popularity of the service grew, and by 1952/53 the train had grown to a ten car formation. The Down train was scheduled to reach Leeds from King's Cross in 3½ hours, where eight of the coaches were uncoupled and sent to Glasgow. Following Beeching, economies were introduced and the service was curtailed at Harrogate so that the cars could make the return journey on the same day. As Scotland was now no longer being served by the Pullman train, the title *Queen of Scots* was dropped and that of the *White Rose* was transferred from a normal express to the Pullman train. This, however, was short lived because Pullman trains disappeared with the introduction of 'Deltic' diesel trains. (R. Carpenter)

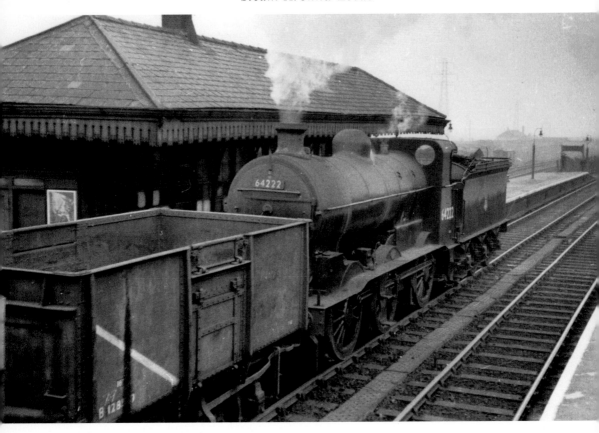

Passing through Ardsley station at the head of a freight train in October 1956 is ex LNER Ivatt and Gresley J6 class 0-6-0 no. 64222. (R. Carpenter)

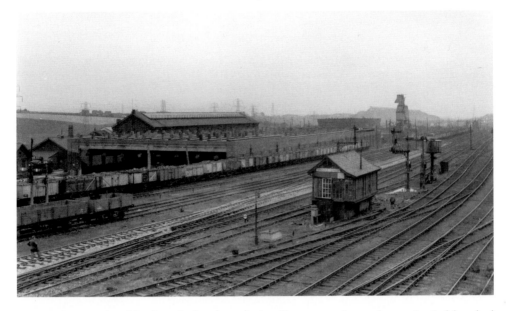

A general view of Ardsley locoshed and south signalbox on 17 September 1961. Ardsley shed was originally built by the GNR and consisted of eight straight roads. It was rebuilt in the 1950s along with the shed at Wakefield, as can be seen in this view. The shed had an allocation of eighty-eight locomotives in 1950, reducing to sixty-three in 1959. There was a further reduction to forty-five in 1965. Over time, old GNR types were replaced by LNER engines and, by 1965, the shed had four A1 pacifics, two V2 2-6-2 locomotives, and seventeen B1 4-6-01s. The shed closed in 1965 as 56B, having been allocated 37A from 1948 to 1956. The allocation for 1959 was as follows:

Ex LNER B1 4-6-0	61029 *Chamois* 61031 *Reedbuck* 61085, 61094, 61291, 61310
Ex GCR B4 4-6-0	61482 *Immingham*
Ex LNER Q4 0-8-0	63202, 63204, 63205, 63217, 63221, 63223, 63225, 63226, 63227, 63234, 63263, 63240, 63243
Ex LNER J3/J4 0-6-0	64129, 64142
Ex LNER J6 0-6-0	64174, 64182, 64208, 64214, 64267, 64277
Ex LNER J39 0-6-0	64754, 64760, 64796, 64799, 64801, 64806, 64811, 64836, 64839, 64840, 64872, 64896, 64907, 64979, 64985
Ex GNR C12 4-4-2T	67386
Ex GNR 4-4-2T	67440, 67441, 67443, 67444, 67445, 67446, 67451
Ex GNR J52 0-6-0ST	68790, 68848, 68871, 68872, 68896, 68900, 68901, 68903, 68904, 68907
Ex GNR N1 0-6-2T	69452, 69461
	TOTAL: 63

(R. Carpenter)

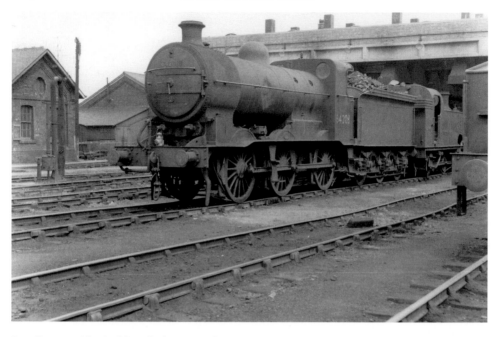

Standing outside Ardsley shed on 8 July 1956 is ex GNR J6 0-6-0 locomotive no. 64208. (R. Carpenter)

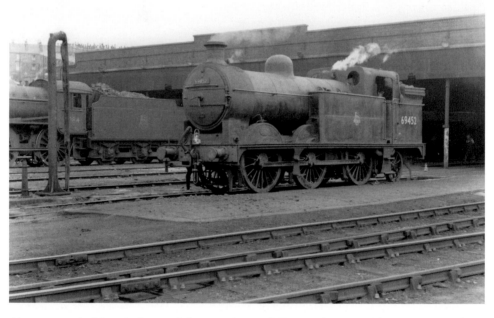

Also seen at Ardsley shed on 8 July 1956 is ex GNR N1 class 0-6-2T no. 69452 with an unidentified ex LNER Thompson B1 4-6-0. (R. Carpenter)

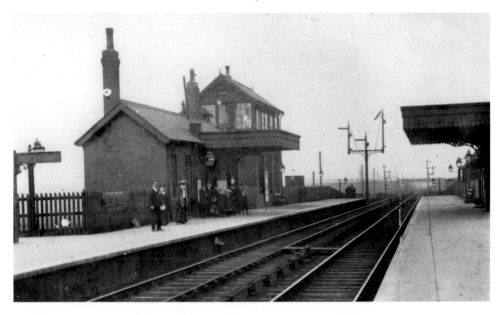

From Ardsley, the GNR line to Bradford passes Tingley station, seen here in the early twentieth century. Passengers, in Edwardian fashions, await a train which is due. (LOSA)

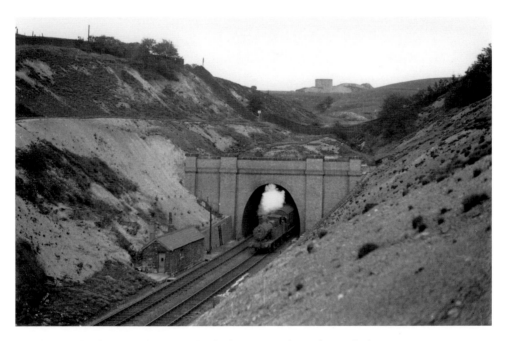

Just leaving the long Morley Tunnel, which passes right underneath the town, is an ex L&YR 2-4-2T at the head of a local passenger service from Bradford in the 1930s. (R. Carpenter)

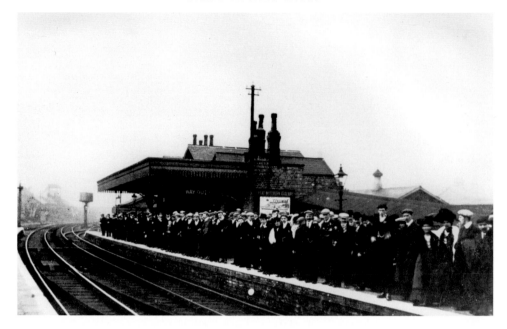

A very busy Morley station as passengers in early twentieth century fashions await an excursion train, perhaps to Scarborough or another east coast resort. (LOSA)

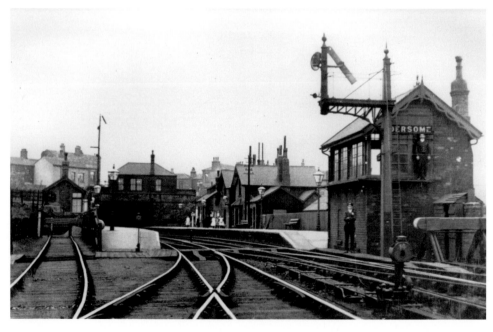

The now extinct station at Gildersome with young children posing for a photograph on the station platform. The station porter and signalman are also in view as a train is awaited. The signalbox is of typical GNR design and the signal is GNR lower quadrant. (LOSA)

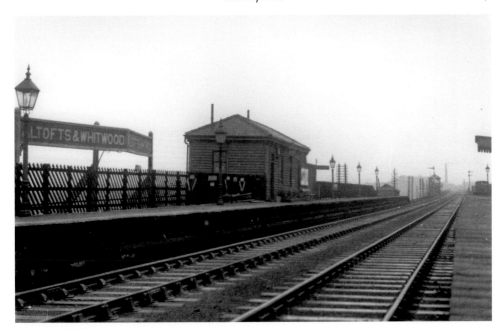

The ex MR station at Altofts and Whitewood on the line between Leeds and Normanton as it appeared in 1936. (R. Carpenter)

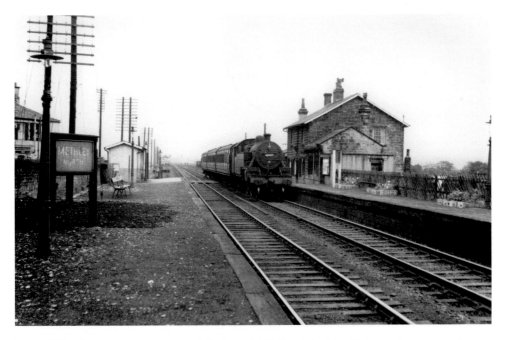

Ex LMS Fowler 2-6-4T no. 42407 of Cudworth Midland shed (53E) is seen here on 30 August 1957 standing at Methley North station, on the L&Y Knottingley line, on the 4.03 p.m. local from Leeds Wellington station. (R. Carpenter)

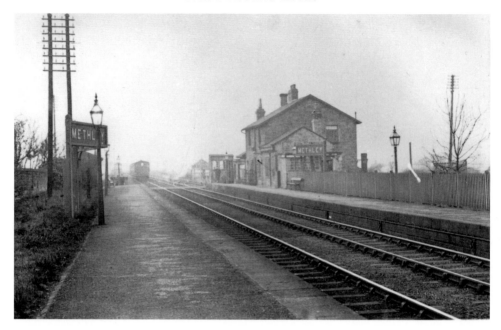

Over on the Midland line from Leeds to Wakefield is Methley station seen here after a train has departed in the years prior to the First World War. (LOSA)

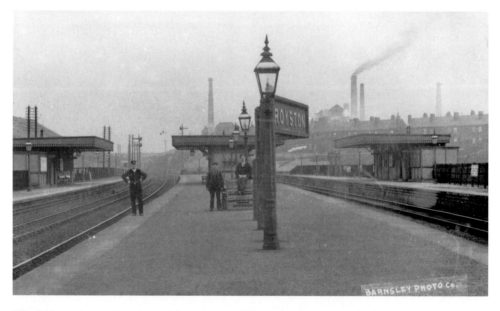

The MR station at Royston with station staff in view. Forming a background are chimneys of local woollen mills which gave employment to many in the local area and provided much revenue for the railway companies which served the West Riding. This goes some way to explaining why five pre-grouping companies fought for traffic in the area. (LOSA)

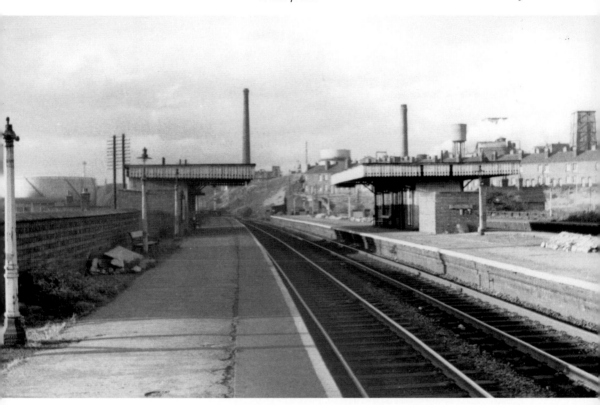

A much later view of Royston station, taken on 11 September 1964. The same mill chimneys are there, but they do not appear to be in use, perhaps because, by this stage, electricity was the favoured means of operating mill machinery. Also in view is a gasworks and water tower, but the terraced houses are still in existence at this time and were probably still occupied by mill workers. However, the economy of the area was undergoing change and many mills were closing; employment would be created in new industries to replace them. (R. Carpenter)

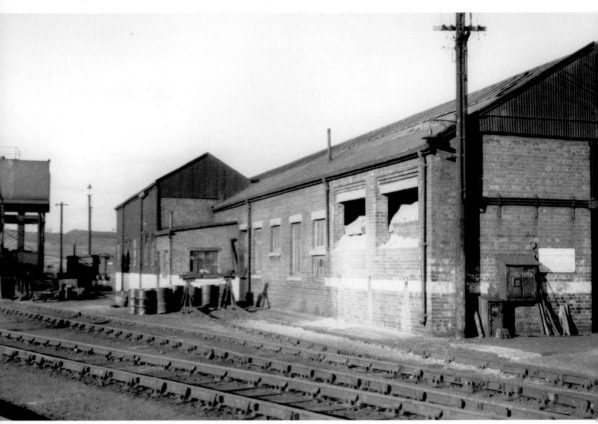

A view of the exterior of Royston locoshed as it appeared on 11 September 1964. This was the shed built by the LMS in the early 1930s, having opened in 1932. This new shed was built in response to changing patterns of traffic and was carefully designed to eliminate difficulties of cramped or poor layouts. Ample space was available and the new Royston shed was built within its own triangle. Its mechanical coaling and ash lifting devices were placed so that engines could proceed from the running lines to be serviced before running around the triangle (if turning was necessary) formed when the shed was built, or reversing back on to separate roads to gain the shed yard. Improvements at the new shed included enough roads of relatively short length to ease 'engine setting' problems, i.e. making sure an engine was properly positioned to leave the shed site. The new roof made for relative comfort in whatever fitting work was necessary. As the shed was on a triangle, no turntable was required. The shed was responsible for supplying locomotives for coal trains and shunting work, with little else being required. A later concentration of LMS Stanier 8F 2-8-0s simplified the problem of keeping a myriad of spare parts in stock. (R. Carpenter)

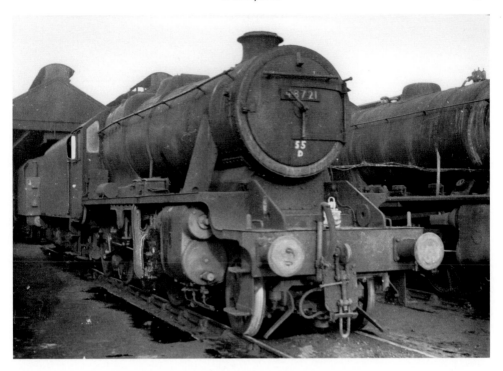

In the final few months of steam power in the area, ex LMS Stanier 8F no. 48721 is in rundown condition. The shed plate is gone, but the shed number painted on is of Royston, its home shed. (LOSA)

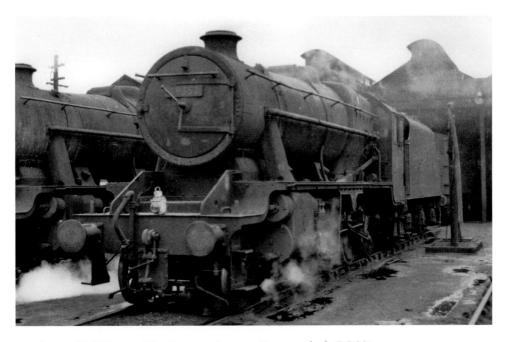

Another ex LMS Stanier 8F 2-8-0 no. 48352 at Royston shed. (LOSA)

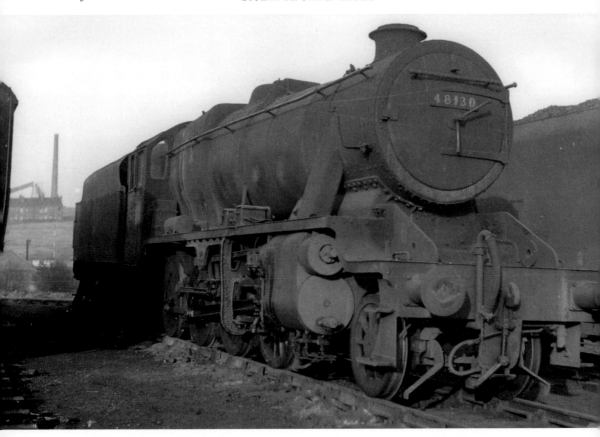

This is ex LMS Stanier 8F 2-8-0 no. 48130, one of the many allocated to Royston shed in the mid 1950s. In 1950, the shed, as code 20C, had an allocation of sixty engines, reducing to fifty-five in 1959 and thirty-two in 1965. The shed closed in 1967 having been re-coded 55D ten years earlier. An allocation in 1959 shows a total of forty-seven locomotives as follows:

Ex LMS 3MT 2-6-2T	40074, 40181
Ex MR 2P 4-4-0	40444, 40521
Ex MR 3F 0-6-0	43446, 43553, 43765, 43789
Ex LMS 4F 0-6-0	43942, 43003, 44141, 44161, 44446
Ex LMS 3F 0-6-0T	47421, 47448, 47462, 47581, 47634
Ex LMS 8F 2-8-0	48062, 48095, 48113, 48162, 48169, 48337, 48376, 48377, 48412, 48419, 48431, 48439, 48443, 48532, 48540, 48542
Ex L&YR 3F 0-6-0	52095, 52108, 52252, 52258, 52259
Ex MR 1P 0-4-4T	58052, 58066, 58075, 58090
Ex MR 2F 0-6-0	58156, 58188, 58237, 58260

(LOSA)

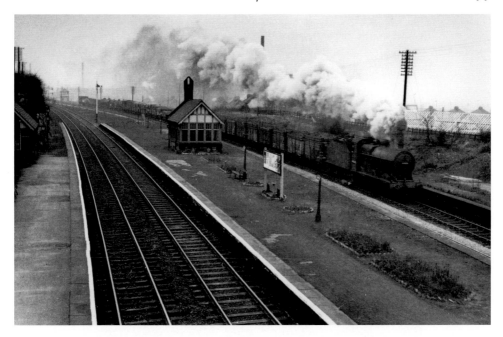

At Kilnhurst, near Normanton, is ex LMS 4F no. 44606 at the head of an Up freight on 23 November 1957. (R. Carpenter)

The signalbox at the ex MR station at Normanton on 9 September 1964. The railway here seems to be somewhat overgrown as it appears the goods yard has gone out of use. (R. Carpenter)

The coaling stage at Normanton shed on 3 September 1964. The shed was built by the L&YR
and was shared with the NER from 1860, when that company obtained accommodation for
four engines. By 1864, complaints had been made about the amount of space being taken up
by NER engines, leading to provision of a new shed at a cost of £8,800. In 1891, the L&YR
expressed a wish to stable twenty locomotives at Normanton to save light running to and from
Wakefield. This was approved in 1882 when a shed costing £10,553 8s 9d was authorised, plus
another £2,000 for a coal stage, and £194 2s 3d for gas lighting. The structure was opened
on 27 July 1884. The 1866 building was a roundhouse shared by the NER and MR, while
the L&YR shed was of the straight type, remaining in use until closure. A further shed was
proposed in 1889 but never materialised. In 1906, the MR had fifty-eight locomotives here
and the NER had twelve. The LMS, MR and L&YR sheds remained under separate control
until 7 November 1927, when L&YR locomotives came under Midland Division control.
Thenceforth, North Eastern engines used the straight shed as well as the roundhouse. From
1 October 1938, the LMS took full control of the shed and the LNER paid rent for its use.
North Eastern locomotives at Normanton was usually made up of tank engines for shunting in
the Castleford/Whitewood area and one or two mixed traffic engines for working to York or
Hull. In 1922, there were four shunting tanks with an old Fletcher 0-6-0 and a B16 4-6-0. The
B16 was used on freight during the week, but on Sundays it was used on Normanton's only
passenger working to Hull and thence Hull–Selby–Selby–Church Fenton. LNER locomotives
operating out of Normanton shed included J21/J71 0-6-0s, J72/J77 0-6-0Ts, and a Q5 0-8-0.
The Q5 left in 1951 and in January 1952 the J71s were transferred to the LM Region. On 1
January 1957, the shed was transferred to the NE Region and reallocated the code 55E from
20D, finally closing to all traffic from 1 January 1968. In happier days, the allocation of 1950
was as follows:

Ex MR 2P 4-4-0	40406, 40480, 40630
Ex MR 1F 0-6-0T	41793, 41844
Ex MR 3F 0-6-0	43497, 43509, 43514, 43639, 43656, 43714
Ex LMS 4F 0-6-0	44098, 44099, 44151, 44217, 44336, 44337, 44338, 44566, 44586, 44603, 44604
Ex LMS 3F 0-6-0T	47239, 47334, 47335, 47405
Ex LMS 8F 2-8-0	48084, 48130, 48131, 48146, 48160, 48164, 48266, 48271, 48274, 48352, 48357, 48394, 48395, 48396, 48507, 48508, 48547, 48670, 48702
Ex L&YR 2P/3P 2-4-2T	50621
Ex L&YR 3F 0-6-0	52089
	TOTAL: 47

In later years, ex WD 2-8-0s were allocated to Normanton shed for freight work, along with ex LMS types. (R. Carpenter)

The signal gantry at Normanton with a freight train passing underneath, as seen on 9 September 1964. (R. Carpenter)

FOUR

AROUND HUDDERSFIELD

Although the Manchester and Leeds Railway had opened its line across the Pennines, its wandering route was less than ideal. A more suitable route would have been via Standedge. Indeed, the M&L operated a branch from Manchester to Stalybridge, which could have provided a start for a line from Manchester to Huddersfield. Despite the possibility of 'rich pickings' from the Huddersfield area, the M&L were reluctant to build a direct line through Standedge, and the only provision made for Huddersfield traffic was a station at Cooper Bridge on the main line, some distance from the centre of town. The M&L did offer to build a branch into Huddersfield, but it was to follow the line of the canal along the valley floor, and would have terminated at Aspley on the south side of town, making a western extension very difficult.

The population were less than satisfied with the M&L and began to promote their own lines into Huddersfield. The first was the Huddersfield & Manchester Railway & Canal Company, which was to run from the joint Sheffield, Ashton & Manchester Railway and M&L station at Stalybridge, and rejoin the M&L at Heaton Lodge, just west of Cooper Bridge. A second proposal was to join the SA&MR at Penistone, providing a direct line to Sheffield and giving the company an opportunity to absorb other independent railways, thereby gaining access to Huddersfield. Protracted negotiations and intrigue followed, and people from Huddersfield felt that their interests would be better served by making agreements with railway companies who were supporting railway development in the West Riding. Thus, the M&L took control of the Huddersfield and Sheffield Joint Railway, and the LNWR absorbed the Huddersfield & Manchester Railway & Canal Company, along with the Leeds, Dewsbury & Manchester Railway (incorporated under an Act of 1845) on 9 July 1847, giving the LNWR a through line from Manchester to Leeds, via Standedge and Huddersfield.

The H&SJR opened its branch to Holmfirth on 1 July 1850, and, as the L&YR did not have enough locomotives to operate through services, it entered into an agreement with the SA&MR, who had lost out at Huddersfield. This allowed the L&YR to run trains from Huddersfield to Holmfirth, while the SA&MR ran trains from Penistone to Holmfirth. Interchange facilities were provided at Brockholes Junction, but connections were so inadequate that the M&L's reputation was brought into disrepute once again. The situation did not improve until about 1861–62, after the company had been taken over by the L&YR.

Branches were built by the H&SJR in the 1860s to Meltham and Clayton West, both being difficult to construct due to landslips and the need to build substantial retaining walls. The line did not fully open until 5 July 1869. Clayton West was not to open until August 1879.

As early as 1949, the Meltham branch lost all passenger services due to local bus competition, although freight continued until 1965 when the branch closed altogether.

Holmfirth lost passenger trains in 1959 and closed, along with the Clayton West branch, in 1965. The main Penistone line was downgraded to a secondary route in the mid 1960s, and singled between Denby Dale and Penistone in 1969. It only survives because an agreement was reached to reroute trains from Huddersfield to Sheffield via the Penistone–Barnsley line. The Clayton West branch is now part of the Kirklees Light Railway, opened in 1991.

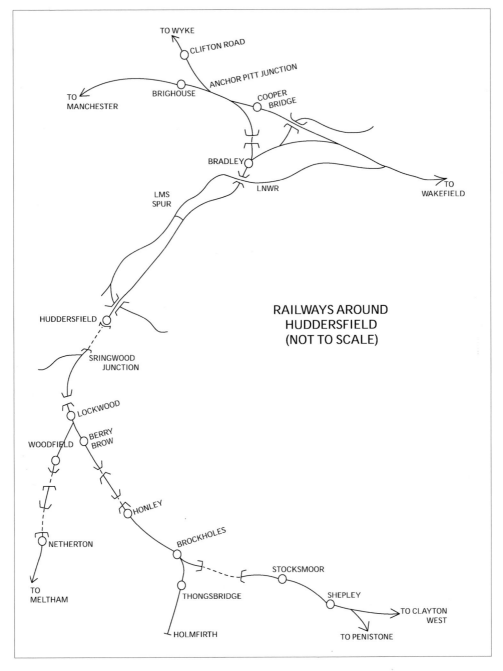

A map of the railway system around Huddersfield in steam days. (Author)

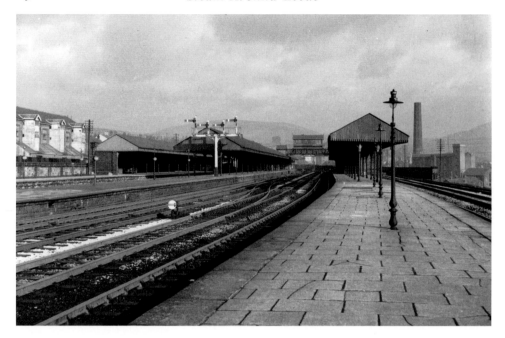

The joint LNWR/L&YR/GCR station at Stalybridge, looking towards Huddersfield on 16 January 1962. The station here, in Cheshire, is the gateway to the West Riding. A station has existed here since the Sheffield, Ashton-under-Lyne and Manchester Railway opened its line from Guide Bridge to Stalybridge, via Ashton (the company was later to become the Manchester, Sheffield and Lincolnshire Railway from 1 January 1847, and the Great Central Railway from 1910). The SA&M line opened on 23 December 1845; the contract for construction of the station was let to a Manchester company on the previous January at a cost of £2,079. On 5 October the following year, the Ashton, Stalybridge and Liverpool Junction Railway opened its own terminus at Stalybridge. This was to become the Lancashire and Yorkshire Railway route used by the LNWR to Manchester. By 1847, the L&YR and MS&L had their own single road locosheds with 40 foot turntables at Stalybridge. By 1 August 1849, the LNWR line from Huddersfield, via Standedge Tunnel, had opened, while only a month before, on 1 July, a joint L&Y/MS&L station had opened at Stalybridge, with the L&Y terminus closing. Thus, by the time LNWR services from Yorkshire entered the station, it became something of a bottleneck. To cope with this extra traffic, the station was enlarged in 1858, but, within a couple of years, it became just as inadequate. Despite complaints by townspeople about the inadequacies of the station, the three companies using it refused to spend any money on Stalybridge station; the L&YR even went as far as decamping and moving back to their own terminus in the town. In doing so, the L&YR forfeited their right to use the station, with the LNWR and MS&L paying the L&YR some £6,250 as compensation. By 1877, the situation was so bad that the town council threatened to send a deputation to the Board of Trade and Home Secretary. Eventually the MS&L drew up plans for major improvements to the station and goods depot. By December 1880, a contract was awarded for construction of a new goods depot, at a cost of £30,640 in 1883; a new station was constructed, at a cost of £23,156, in March 1883. The new station came into partial use on 21 May 1885, in time for the opening of the new LNWR Micklehurst route. The Friezland Loop for passenger traffic began operating passenger trains some twelve months later, and goods trains used the line from December 1885. (R. Carpenter)

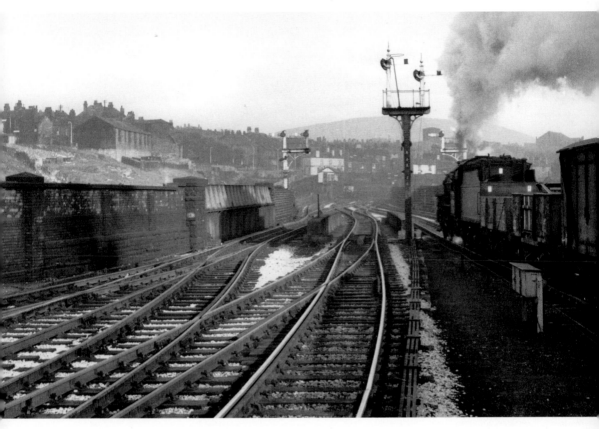

Facing Huddersfield, an ex LMS Hughes-Fowler 'Crab' 2-6-0 heads a freight train through Stalybridge on 16 January 1962. The 1880s was a time of prosperity for the railway companies at Stalybridge, with both passenger and goods traffic soaring, meaning further extensions being carried out at Stalybridge. By 1897, the station was controlled by the Great Central Railway, whose line ran through to Sheffield from Stalybridge, and the LNWR, its services operating to Leeds and Huddersfield. These arrangements continued after the 'Grouping', with the LMS and LNER taking control of the station. (R. Carpenter)

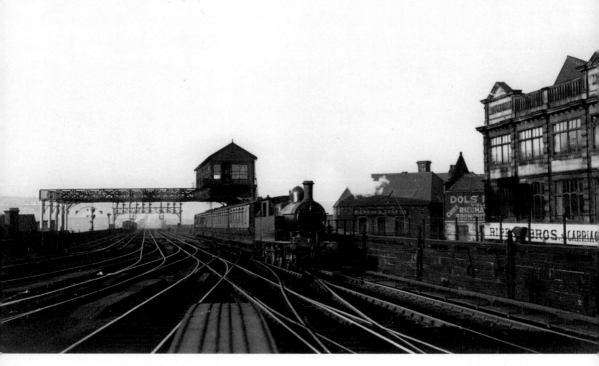

Approaching Huddersfield with a local train is a L&Y 2-4-2T, just before the 'Grouping' of 1923. The town of Huddersfield was built with the proceeds of the textile industry which left it with a legacy of fine Victorian buildings.

Indeed, it has 1,660 listed buildings; only Westminster and Bristol have more. Even the railway station at Huddersfield was built in the classical style, with eight Corinthian columns and often called 'a stately home with trains in it.' The town was also the birthplace of Rugby League, when twenty-one clubs met at the George Hotel in 1895 to break away from Rugby Union so that players could become professional and be paid. The rift between the two rugby codes lasted for nearly a century, and no rugby league player could play rugby union until the union code was professionalised in the late twentieth century. Since then, many players have played under both codes. (R. Carpenter)

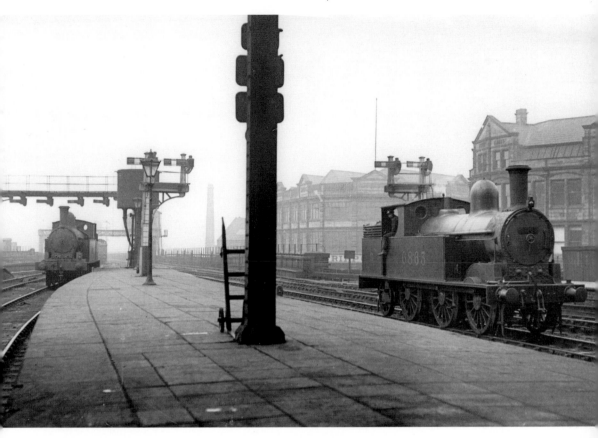

Huddersfield station as it appeared in the early LMS period with ex LNWR 0-6-2T engines in view, one awaiting duties in the station and the other bringing in a short train. While the engine on the right appears to have its new LMS number 6863 in Midland Railway style and no smoke box number plate, the locomotive on the left still carries its LNWR cast number plate on the tank side. (R. Carpenter)

LIVERPOOL, MANCHESTER, ROCHDALE, TODMORDEN, HALIFAX, BRADFORD,
Offices—Hunt's Bank, Manchester. Gen. Man., Arthur Watson, Euston.

Down. **Week Days.**

Miles from Manchester	Station	mrn	mrn	mrn	mrn	mrn	mrn	mrn	mrn	mrn	mrn	mrn	mrn	mrn		mrn	mrn	mrn	mrn		mrn
	551 LIVERPOOL (Exch.)...dep.																	6 50			8 35
494	" (Lime St.) "																				
553	SOUTHPORT (Chapl St.) "										6 5		5a45			7 3			8 5		8R17
536	BLACKPOOL (Tal. Rd.) "												7 3			7 0		7 0			
538	" (Central).. "										5 45					7 0		7 28			
545	BOLTON (Trin.St.) 559 "				5 20			6R25		7R13			5A45 7 35			7 26				9R4	
—	Manchester (Victoria)...dep.	4 30 5 8					6 10 6 57		7 10 7 33			8 20			7 50		8 17 8R47		9R25		
1¾	Miles Platting	5 14					7 15										9 a				
2¾	Newton Heath	5 17					6 18		7 19 7 42												
4	Moston	5 20					6 21		7 22 7 45						9 15						
5¼	Middleton Junction	5 25					6 26		7 26 7 49						9 19						
8¾	Castleton	5 33					6 33 7 15		7 29 7 56						9 23						
10¼	Rochdale 562 arr.	4 50 5 37					6 37 7 19		7 38 8 4			8 40				9 30		9 45			
—	554 OLDHAM (Mumps)...dep.	Stop					6 8 6 37		7 27			8 16				8B55					
—	Rochdale dep.	4 56		6 10			6 41 7 21		7 55			8 43			9 0	9 32		9 47			
12¾	Smithy Bridge			6 15			6 46		8 0						9 5						
13¾	Littleborough	5 2		6 18			6 52 7 27		8 4						9 8 9 38						
17¾	Walsden	5 12					7 2		8 12						9 16						
19¼	Todmorden 529 arr.	5 16		Stop			7 7 7 37		8 16 8J47			8 57 9 17 9 20				9 47		10 1			
—	524 BURNLEY (Man. Rd.) dep.						6 41		8 33			8 59						9 29			
—	Todmorden dep.	5 21					7 13 7 41		8 18 8J48			9 0			9 49		10 2				
21¼	Eastwood	5 26					7 18		8 23			9 32									
22¾	Hebden Bridge	5 32					7 26 7 48		8 29 8 56			9 8 Stop 9 38 9 57									
24¼	Mytholmroyd	5 36					7 30		8 33 9 0			9 41									
26¼	Luddendenfoot	5 41					7 35		8 37 9 4			9 45									
28¾	Sowerby Bridge 568 arr.	5 46 mrn					7 40 7 53		8 41 9 8			9 15 9 50 10 4					1015				
—	Sowerby Bridge dep.	5 56 6 22					7 43		8 10 8 43			9 17 9 55					1016				
30¼	Copley								8 15 8 47			10 0									
32¾	Halifax 370 { arr.	6 3 6 30					7 51		8 20 8 52			9 25 mrn 10 5					1024				
	{ dep.	6 7		7 0			7 55		8 22			9 27 9 53					1026 10 30				
34¼	Hipperholme	6 12		7 5			8 0		8 27			9 58									
35	Lightcliffe	6 15		7 8			8 3		8 30			10 1									
36¼	Wyke and Norwood Green	6 18		7 11			8 6		8 33			10 4									
38	Low Moor 569 arr.	6 23		7 15			8 10		8 37			9 36 10 8					10 39				
—	Low Moor dep.	6 29		7 17			8 12		8 40			9 41 10 10					10 41				
39¼	Bowling Junction	6 34		7 22			8 17		8 45												
41	Bradford (Exch.) 872 arr.	6 38		7 26			8 21		8 49			9 49 10 18					10 49				
—	Low Moor dep.	6 25							8 44			9 33									
41¼	Laister Dyke 369	6 33		7 55					8 53			10 55									
44	Stanningley, for Farsley	6 37		8 0								10 59									
45	Bramley			8 3			8 44					11 2									
47	Armley and Wortley			8 8								11 7									
48¼	Holbeck 672, 682, 751	6 47		8 11			8 51		9 5			9 54 11 10					1049				
66	751 HARROGATE arr.	8 44							10 10			10 44					1134				
49	Leeds (Central) arr.	6 51		8 14 mrn			8 55		9 8			9 58 11 13					1053				
—	Sowerby Bridge dep.	5 50		6 56			7 38 8 2					9 20			10 7						
	Halifax dep.	5 45		6 45 7 13			7 45					9x10			9 43						
31	Greetland 568, 572	5 55		7 1 7L17		7 43 8 J 2					9 25					10 37					
31¾	Elland	6 0		7 3 7L19		7 45 8J32					9 28					10 39					
34¾	Brighouse, for Rastrick	6 5		7 8 7L24		7 50 8 11					9 33			10 15		10 44					
39¾	Huddersfield 574 arr.	6 40		7 56		8 11 8 53					10 7			10 56		10 56					
36¼	Cooper Bridge	6 15		7 16		7 59					9 41			10 23							
38¾	Mirfield	6 20		7 21		8 4 8 21					9 46			10 27							
—	Huddersfield 486, 572 dep.	6 5		6 25 7L11		7 42 8 6					9 30			9 54							
—	Mirfield dep.	6 25		7 25 7L32		8 7 8 23					9 48			10 23							
40¼	Thornhill 569	6 32		7 32 7L51		8 15 8 28					9 56			10 34							
42¾	Dewsbury arr.	6 45				8 25 8 42					10 35			11 0							
44	Horbury and Ossett	6 39		7 38		8 21 8 37					10 2			10 40							
45¼	Horbury Junction 571, 576			7 42		8 24															
47¼	Wakefield 341,571,576 ar.	6 46		7 46		8 30 8 43					10 8			10 46							
224¾	339 London (King'sCross)arr.	1220				1 55 1r55								3 40							
58¾	571 BARNSLEY "	7 55				8 53 10 3								11 28							
74¾	576 GOOLE "	8 28				1012								12 6							
98¾	576 HULL (Paragon) "	1020				12 0								12 50							
72¾	341 DONCASTER 576 "	7K52		9 30		1025								11K58							
—	Wakefield (Kirkgate)...dep.	5 2 6 51		7 50		8 38 8 46					10 30										
50¼	Normanton 616, 767 arr.	5 18 6 57		7 56		8 44 8 52					10 36										
77¼	616 SHEFFIELD (Midland)arr.	8 28		9 24 9 42		1023					12 3										
235¼	617 London (St. Pancras) "			1 30 1210		2 10					4 10										
75¾	767 YORK arr.	8 17				9 48															
117¾	75 SCARBOROUGH "	10 5				1115															
98¾	770 HULL (Paragon) "	9 23				1115															
145	728 NEWCASTLE (Central) "	1110				12 0															
269¾	728 EDINBRO' (Waverley).. "	1 45				9 48															

Above and opposite: A 1910 timetable for LNWR services between Manchester, Leeds, and Bradford, via Huddersfield. (Author)

LEEDS, HUDDERSFIELD, DEWSBURY, WAKEFIELD, and NORMANTON.—L. & N. W.

Sec., R. C. Irwin, Euston. Gen. Supt. (Northern Division), Ashton Davies, Manchester (Victoria).

Down. **Week Days**—*Continued.*

Station	mrn	mrn	mrn	mrn	mrn	mrn	mrn	mrn	mrn	mrn	mrn	non	mrn	aft
551 Liverpool (Exch.) dep.	9 50	9 0	9 40	1020	1135
494 " (Lime St.) "	11 a 6
553 Southport (Chpl St.) "	8 55	8 55	9 20	11 R 0
53 Blackpool (Tal. Rd.) "	8 30
538 " (Central) "	8 23	9 35	9 8	9 55	1010
545 Bolton (Trin. St.) 559 "	9 52	9 52	1057	1150
Manchester (Victoria)..dep.	9 50	10 5	10 36	10 35	1110	11 20	12 15	1225
Miles Platting............
Newton Heath	10 43
Moston....................
Middleton Junction	10 49	11 33	12 0
Castleton.................	10 56	11 40	12 8
Rochdale 562arr.	10 11	10 23	11 0	11 44	12 33	1212	1243
554 Oldham (Mumps)...dep.	9 35	9 35	1012	Stop	1215
Rochdale...........dep.	10 14	10 27	10 27	11 2	12 35	1246
Smithy Bridge...........	11 7	Stop
Littleborough...........	10 33	10 33	11 11
Walsden.................	11 19
Todmorden 529arr.	10 27	10 42	1030	10 42	11 23	1249
524 Burnley (Man. Rd.) dep.	10 12	10 12	11 52
Todmordendep.	10 30	10 45	10 45	11 26	12 11
Eastwood................	11 31
Hebden Bridge...........	11 37	12 19
Mytholmroyd............	11 41	12 24
Luddendenfoot..........	11 53	12 28
Sowerby Bridge 568 ...arr.	10 58	10 58	11 58	12 33	1 0
Sowerby Bridgedep.	1110	11 16	Stop	12 36
Copley	12 42
Halifax 370........{arr. / dep.	1117	11 24	12 47	1 15
Hipperholme............	11 27	11 32	12 50	1 17	1 27
Lightcliffe...............	11 37	12 53	1 30
Wyke and Norwood Green	11 40	12 58	1 33
Low Moor 569arr.	11 36	11 43	1 1	1 25	1 37
Low Moordep.	11 43	11 50	1 6	1 39
Bowling Junction	1 8	1 44
Bradford (Exch.)§ 372 arr.	11 51	11 58	1 17	1 48
Low Moordep.	11 40	1 30
Laister Dyke 369	1226
Stanningley, for Farsley.	1230
Bramley	1233
Armley and Wortley.....	1238
Holbeck 672, 682, 751...	11 58	1241	1 46
751 Harrogate........arr.	1 48	1048	3 1
Leeds (Central) ¶.....arr.	12 5	1244	1 50
Sowerby Bridgedep.	12 9	1 9
Halifaxdep.	10 50	11 0	11 0	1126	1225	12 20	1 45
Greetland 568, 572	1054	10 32	12 14	118	1 59	1 49
Elland.................	1056	11y45	12 16	1y20	1 51
Brighouse ∥ for Rastrick.	11 1	11 0	11 9	11y47	1136	12 21	1 10	1 56
Huddersfield 574 ...arr.	12 5	12 5	11y52	12 5	12 47	1 43
Cooper Bridge	12 29
Mirfield	11 17	11 17	1145	12 34	1y35
Huddersfield 436, 572 dep.	1045	1045	12 20	1 53
Mirfielddep.	1118	11 18	11 18	1148	12 36	2 L7
Thornhill 569..........	1123	1157	12 43	2 20
Dewsbury *arr.	12 50	2y11
Horbury and Ossett.....	12 49
Horbury Junc. 571, 576
Wakefield † 341, 571, 576 ar	11 7	11 30	11 30	1210	1220	12 55	1 30
335 London (King's Cross) arr.	4 0	6 20	6y30
571 Barnsley "	12 18	12 18	1 43
576 Goole............. "	12 19	12 19	12 19	1 42	1 42	1 10	2 34
576 Hull (Paragon) "	12 50	12 50	12 50	2 4	2 40	2 47
341 Doncaster 576 "	12 47	1247	aft	2 K 7	2 47 aft
Wakefield (Kirkgate)...dep.	11 11	11 32	11 32	12 12	1225	1 0	1 34	1 53
Normanton 616, 767...arr.	11 18	11 38	11 38	12 18	1232	1 6	1 41	1 59
616 Sheffield (Midland) arr.	12 15	1 44	4 50	3 14
617 London (St. Pancras) "	4 10	5 45	9 5	7 10
767 York............arr.	12 5	12 22	12 22	1 15	2 23
758 Scarborough "	1 32	1 32	1 32	2 52	3 48
770 Hull (Paragon)..... "
72 Newcastle (Central) "	2 53	2 53	2 53	3 18	5 28	6y45
72 Edinbro' (Waverley) "	6 20	8 45	9 50

Column notes (read vertically): Through Train, Sheffield and London (St. Pancras). — Saturdays only. Through Train, Manchester to Hull (Paragon), York, and Scarborough. — Through Carriages, Liverpool and Manchester to Hull (Paragon). — Via Burnley. Except Saturdays. — Through Train from Blackpool (Central). Through Train, Manchester to York and Scarborough. — Saturdays only. Thro' Train, Liverpool (Exc.) to Hull (Par.) and York. — Saturdays only, to Wakefield. Through Train, Blackpool (C.) to Hull. Stop. — Dining Car, Liverpool and Manchester to York and Newcastle. Saturdays only. — Via Burnley. Stop. — Through Train, Manchester to York. — Through Carriage, Halifax to London (St. Pancras, see page 620). Through Train, Halifax to Sheffield. — Through Train, Blackpool (C.) to Bradford. — Saturdays only.

For Continuation of Trains, see pages 514 to 517. For Notes, see page 517.

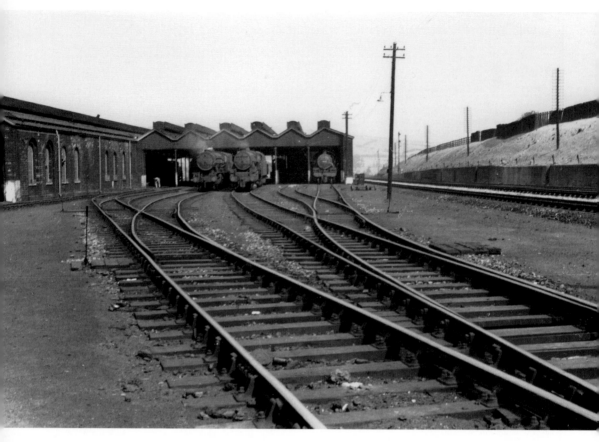

As an important town, Huddersfield had its own locoshed, built by the LNWR as a traditional eight road straight structure. The shed was extensively rebuilt by the LMS and is seen here on 17 September 1961 with a 'Black Five' 4-6-0, an ex WD freight engine, and ex LMS Fowler 2-6-4T on shed. By this time, the shed was being run down and its allocation would be down to twelve by 1965, from a peak of forty-two in 1950. (R. Carpenter)

Another view of the old LNWR locoshed at Huddersfield on 17 September 1961 with several locomotives in view. Coded 25B after nationalisation in 1948, the shed was coded 55G when the regions were reorganised. The shed finally closed in 1967. The types of engines allocated here can be recalled with the list of engines which operated out of Huddersfield shed just after nationalisation in 1949.

Code:

Ex LMS Fowler 2-6-4T	42310, 42311, 42312, 42384, 42408, 42409, 42410, 42412, 42413, 42414
Ex LMS Stanier 2-6-0	42861, 42862, 42863, 42866, 42869
Ex LMS Stanier 'Black Five'	44780, 44824, 44949, 45099, 45215, 45237, 45238, 45340
Ex LMS Stanier 'Jubilee' 4-6-0	45596 *Bahamas**
Ex LNWR 0-8-0	49648
Ex L&YR Aspinall 2-4-2T	50731, 50735, 50736, 50887
Ex L&YR Aspinall 0-6-0T	51408, 51524
Ex WD 2-8-0	90527
	TOTAL: 32

* *Bahamas* is preserved locally on the Keighley and Worth Valley Railway. (R. Carpenter)

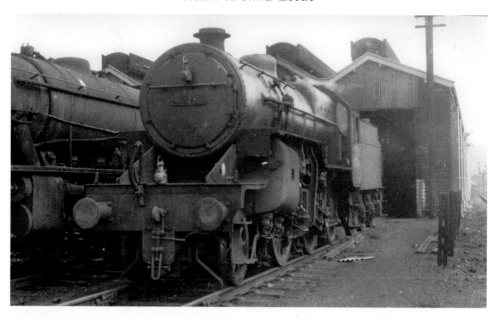

Ex LMS Hughes-Fowler 'Crab' 2-6-0 no. 42766 is seen outside Huddersfield locoshed in 1954. (LOSA)

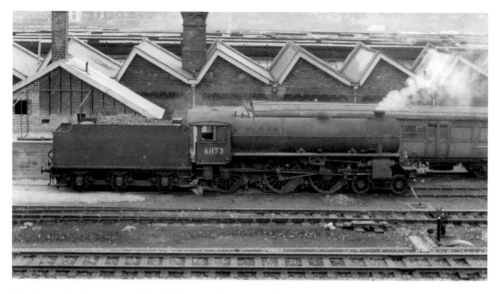

An unusual visitor to Huddersfield was ex LNER Thompson B1 4-6-0 no. 61173, seen close to the locoshed. The locomotive spent most of its life in the north of England. Having been built by the Vulcan Foundry Company, the engine entered traffic as LNER no. 1173 on 9 June 1947 and was allocated to Gorton shed, Manchester, before moving on to Darlington on 13 June 1947. From there, she went to Stockton in 1951, and then to Thornton in 1959. The locomotive received her BR number on 3 March 1949 while still at Darlington. From 25 November 1962 she was shedded at nearby Ardsley. She was then transferred to Wakefield from 5 January 1964, and to York from 13 November 1966. The engine was condemned on 23 January 1967, and sold in March of that year to scrap merchants T. W. Ward of Brighton. At least she met her fate in warmer climes. (LOSA)

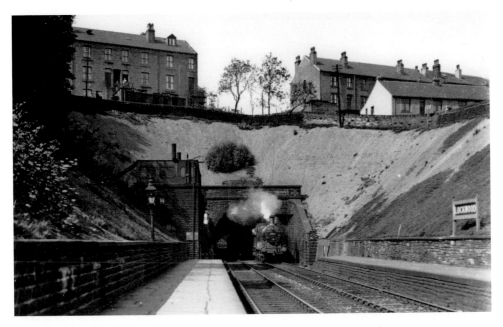

Lockwood station, on the Huddersfield–Penistone line of the L&YR, in the 1930s. Ex L&YR 0-6-0 LMS no. 12321 is at the head of a local train from Huddersfield. (R. Carpenter)

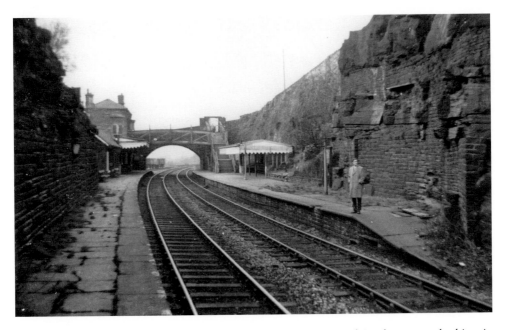

Also on the Penistone line is Berry Brow station as it appeared in the 1950s, looking in the Huddersfield direction. Coal wagons can be seen in the goods yard beyond the bridge. (R. Carpenter)

PENISTONE, CLAYTON WEST, HUDDERSFIELD, and BRADFORD.—Lancashire and Yorkshire.

Down. Week Days.

Miles from Penistone	Marylebone Station,	mrn	mrn	mrn	mrn	mrn	mrn	mrn	mrn	mrn	mrn	mrn	mrn	aft	mrn	aft	mrn	aft	aft	aft
	636 Londondep.						2 45				8 45				10 0					
	636 Leicester (Central) .. "					4 43			8 15	8 15	11 4			1213						
	636 Nottingham (Victoria) "					6 28			8 52	8 52	1137			1241						
	655 Sheffield (Victoria) .. "		5 50			9 5			10 52	1052	1233			1 36						
4	Penistonedep.		7 25			9 42		11 30	1135	1 5			2 20							
	Denby Dale and Cumberworth		7 33			9 50		11 38	1143	1 13			2 28							
—	Clayton Westdep.	7 5	8 20	9 32		1121		1230	1 25				4 15							
—	Skelmanthorpe	7 10	8 25	9 37		1126		1235	1 30				4 20							
6¾	Shepley and Shelley	7 17	7 38	8 32	9 44	9 55	1133	11 44	1149	1243	1 18	1 37	2 33	4 27						
7	Stocksmoor	7 20	7 41	8 35	9 47	1136	11 47	1152	1246	1 21	1 40	2 36	4 39							
9¼	Brockholes 788	7 29	7 46	8 40	9 51	10 1	1140	11 51	1156	1250	1 25	1 45	2 41	4 35						
10	Honley	7 33	7 50	8 44	10 4	11 55	12 0	1254	1 29	2 45	4 38									
11¼	Berry Brow	7 36	7 53	8 47	10 7	11 58	12 3	1257	1 32	2 48	4 42									
12¼	Lockwood 791	7 39	7 56	8 50	1010	12 1	12 6	1 0	1 35	1 52	2 51	4 45								
13¼	Huddersfield 519, 520, { arr.	7 45	8 2	8 56	1016	12 8	1213	1 6	1 41	1 58	2 57	4 51								
	523, 730, 738, 788 { dep.	7 38	7 47	8 6	9 12	9 37	1018	1145	12 20	1220	1 43	2 24	12 4	4 5						
16¼	Bradley	7 43	h	t	h	1023		1 55												
18¼	Clifton Road, Brighouse	7 50	9 48	1030	1156		3 23	4 56												
20¼	Bailiff Bridge	7 55	9 52	1035	12 1	2 0	3 28	5 0												
21¼	Wyke and Norwood Green 788	7 58	8 33	10 49	9 56	1038	12 5	2 5	3 32	4										
23¼	Low Moor 730, 790	8 2	8 37	8 43	10 8	10 1	1042	12 9	12 57	1257	2 9	3 37	5 8							
25	Bowling Junction	8 44	1216	1 4	1 4	2 16	5 15													
26¼	Bradford (Exch.) 610, 616 arr.	8 12	8 48	8 53	1018	1011	1052	1220	1 8	11 8	2 20	2 50	4 75	5 19						

Down. Week Days—*Continued.* Sundays.

Marylebone Station,	aft	aft	aft	aft	aft	aft	aft	aft	aft	aft	mrn	mrn	aft
636 Londondep.	1215				4 30	6 20			1115		5 30		
636 Leicester (Central) "	2 35			3 15	4 35	6 43	8 16		1 26		7 48		
636 Nottingham (Victoria).. "	3 8	3 20	5 5	6 17	8 43		2 5		8 17				
655 Sheffield (Victoria)..... "	4 5	5 19	7 17	8 13	9 53		6 40	4 5	9 13				
Penistonedep.	4 40	5 50	6 45	8 45	1055		8 25	7 15	9 45				
Denby Dale and Cumberworth..	4 48	5 58	6 53	8 53	11 3		8 33	7 23	9 53				
Clayton Westdep.	5 20	6 20	8 20	9 55									
Skelmanthorpe	5 25	6 25	8 25	10 0									
Shepley and Shelley	4 55	5 32	6 3	6 32	6 58	8 32	8 58	10 5	11 8	8 39	7 28	9 58	
Stocksmoor	4 56	5 35	6 6	6 35	7 1	8 35	10 9	1111	8 41	7 31	10 1		
Brockholes 788	5 1	5 40	6 11	6 40	7 6	8 40	9 4	1014	1116	8 46	7 36	10 6	
Honley	5 5	5 44	6 15	6 44	7 10	8 44	1017	1120	8 50	7 40	1010		
Berry Brow	5 8	5 47	6 18	6 47	7 13	8 47	1021	1123	8 53	7 43	1013		
Lockwood 791	5 11	5 50	6 21	6 50	7 16	8 50	9 13	1024	1126	8 56	7 46	1016	
Huddersfield 519, 520, { arr.	5 17	5 56	6 28	6 56	7 22	8 56	9 19	1020	1030	1132	9 2	7 54	1024
523, 730, 738, 788 { dep.	5 26	6 32	7 28	9 30	1028		9 36	9 0	1027				
Bradley			9 41		h	h	h						
Clifton Road, Brighouse	5 36	6 43	9 46										
Bailiff Bridge	5 42	6 48	9 50										
Wyke and Norwood Green 788	5 47	6 52	9 55	1057									
Low Moor 730, 790	5 51	6 56	8 8	9 41	10 2		1015	9 49					
Bowling Junction	6 0	7 3	9 48	10 6									
Bradford (Exch.) 610, 616.. arr.	6 4	7 7	8 18	9 52	10 6	11 7		1030	10 0	11 5			

a Stops if required to set down. J Stops if required to set down from beyond Sheffield.
c Stops if required to set down from London (Marylebone) n Stops to set down from Sheffield and beyond.
 and Great Western System only. t Via Mirfield.
h Via Halifax. v Stops to set down from Penistone and beyond.

For OTHER TRAINS between Brockholes and Huddersfield, see page 789; between Lockwood and Huddersfield and between Huddersfield and Bradford, see pages 789 and 791.

Above and opposite: A Lancashire and Yorkshire Railway timetable of 1910 for passenger services operating between Bradford, Huddersfield, and Penistone. (Author)

BRADFORD, HUDDERSFIELD, CLAYTON WEST, and PENISTONE.—Lancashire and Yorkshire.

Up. — Week Days.

Miles	Exchange Station	mrn	mrn	mrn	mrn	mrn	e	mrn	mrn	mrn		f	mrn	aft		mrn	aft		aft	aft	aft
	Bradford dep.		5 56	6 38	7 15	7 20	8 40	9 28		10 0	1120		1155			1 35	2 15		
1½	Bowling Junction			6 43	7 20	7 25	8 45			1&3	1125					1 40	2 20		
3	Low Moor	5 30	6	4 46	49	7 26	7 30	8 51	9 36		1130		12 4			1 45	2 25		
4⅜	Wyke and Norwood Green......		6 8	t	7 31	t		9 40					12 8			1 49	2 29		
6	Bailiff Bridge..........		6 11	7 34			9 43					1211			1 53	2 32		
7½	Clifton Road, Brighouse		6 14	7 40			9 46					1214			1 56	2 35		
10	Bradley..........			7 47															
12½	Huddersfield 519, 520, {arr.	6 0	6 27	7 37	7 53	6	9 26	10 0		1027	12 3		1227			2 11	2 48		
	523, 730, 736, 788 {dep.	5 50	6 32	7 52		8 18	9 26	10 2	1022		1033	12 9		1230	1245		2 13	2 27			
14	Lockwood	5 54	6 36	7 56		8 22			1027			1213		1234	1249		n.	2 31			
15	Berry Brow..........	5 57	6 39	7 59		8 25			1030			1216		1237	1252			2 34			
16⅜	Honley	6 1		8 3		8 29		1010	1034			1220		1241	1256		2 25	2 38			
17	Brockholes	6 5	6 45	8 20		8 35	9 39	1014	1048		b	1224	1229	1245	1 0			2 42			
19½	Stocksmoor	6 10	6 49	8 26				1019	1053			1234		1250	1 5			2 47			
20	Shepley and Shelley	6 15	6 53	8 30		8 42	9 46	1023	1057			1238		1254	1 9		2 33	2 51			
22⅞	Skelmanthorpe	6 20		8 35					11 2			1243			1 14			2 56			
24	Clayton West arr.	6 25		8 40					11 7			1248			1 19			3 1			
22½	Denby Dale and Cumberworth.		6 58			8 47	9 51	1028						1259			2 38				
26¾	Penistone 642, 648, 655 .. arr.		7 6			8 55	9 59	1036						1 7			2 46				
39⅝	648 SHEFFIELD (Victoria).... arr.		7 33			9 31	1042	1111				1116		1 42			3 24				
77½	642 NOTTINGHAM (Victoria).. "		9 28			1027		1212				1212		2 37			4 17				
100½	642 LEICESTER (Central) "		10 8			1055		1244				1244		3 12			4 46				
204	643 London (Marylebone)... "		12 5			1 30		3 0				3 0		5 45			6 43				

Up. — Week Days—Continued.

Exchange Station	aft	aft	aft		aft	aft	aft	aft	aft	aft		aft	aft		mrn		aft	aft	
Bradford dep.	2 43	3 e5	4 28		5 0		5 55	6 25	7 35	9 17		9 30	1112				4 0	6 15	
Bowling Junction	2 48	3e10			1&3		6 0		7 40	9 22			1117					6 20	
Low Moor	2 53	3e16	4 36				5 6	6 33	7 47	9 28		9 38	1125				4 9	6 27	
Wyke and Norwood Green......	t	3e20					6 9	6 37	7 51	9 32		t	1132				4 14	t	
Bailiff Bridge..........		b	4 42				6 12	h	h	9 35			1137				b		
Clifton Road, Brighouse			4 45				6 15			9 38			1142						
Bradley..........										9 43									
Huddersfield 519, 520, {arr.	3 25	4 e4	4 58		5 23		6 29	7 15	8 41	9 51		1022	1154				4 55	7 0	
523, 730, 736, 788 {dep.	3 30	4 37	5 1		5 27	5 32	6 32	7 18	9 15	9 54		1045			7 35		5 08	45	
Lockwood	3 34	4 41				5 36	6 36		9 19	9 58					7 39		5 4	8 49	
Berry Brow	3 37					5 39	6 39	7 24	9 22	10 1					7 42		5 7	8 52	
Honley	3 41					5 43	6 43		9 26	10 5					7 46		5 11	8 56	
Brockholes	3 45	4 52	5 13			5 47	6 53	7 30	9 30	10 9		1056			7 50		5 15	9 0	
Stocksmoor	3 50	4 57				5 52	6 58	7 35	9 35	1014		11 1			7 55		5 20	9 5	
Shepley and Shelley	3 54	5 1	5 20			5 57	7 2	7 39	9 39	1018		11 5			7 59		5 24	9 9	
Skelmanthorpe		5 6				6 17	7 7		9 44										
Clayton West arr.		5 11				6 67	7 12		9 49										
Denby Dale and Cumberworth.	3 59		5 25					7 44		1023		1110			8 4		5 29	9 14	
Penistone 642, 648, 655 .. arr.	4 7		5 33			Tu		7 52		1031					8 12		5 37	9 22	
648 SHEFFIELD (Victoria).. arr.	4 44		5 55		6 16			8 36		1119					8 59		6 11	1029	
642 NOTTINGHAM (Victoria).. "	5 46		7 12		7 12			9 46	1043	1246					1040		7 34	
642 LEICESTER (Central).... "	6 18		7 41		7 41					1 21					1114		8 3	
643 London (Marylebone). "	8 39		9 55		9 55					3 44					2 28		1015	

n Stops to take up if required for Sheffield and beyond.
b Stops to take up if required for Nottingham and beyond.
e Through Carriages, Halifax to Bristol and London (Marylebone), leaving at 7 47 mrn.
ė Except Saturdays.
f Through Carriage, Bradford to Bournemouth.
g Stops to take up for Sheffield and beyond.
h Via Halifax.
n Stops if required to take up for beyond Sheffield.
p Stops on Mondays and Thursdays.
t Via Mirfield.
u Stops to set down.

☞ For **OTHER TRAINS** between Bradford and Huddersfield and between Huddersfield and Lockwood, see pages 788 and 791 ; between Huddersfield and Brockholes, see page 788.

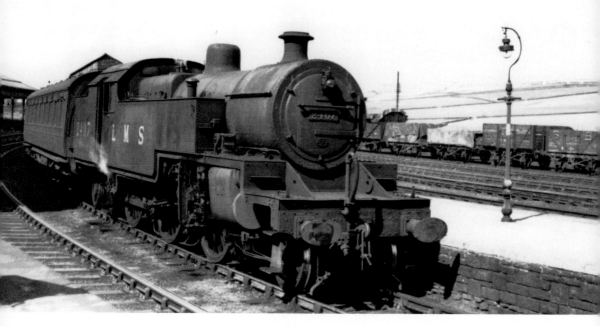

LMS Fowler 2-6-4T no. 2407 arrives at Penistone with a train from Huddersfield on 16 April 1947. This is the point where the L&YR met the GCR for connections to Sheffield and Marylebone. (E. Johnson)

LEEDS LOCOMOTIVE BUILDERS

Along the main line network, several mines, quarries, and companies in Yorkshire and beyond had their own private railway systems within factory, mines and quarry sites which required motive power. Many locomotive building manufacturers were established in Britain to meet these requirements, notably the North Britain Company in Scotland, Bagnall's of Stafford, and the Vulcan Foundry, Manchester, to name a few. Leeds was a pioneering city in locomotive manufacture; one Matthew Murray built the first commercially successful steam locomotive, *The Salamanca*, in 1812 at Holbeck.

By the mid 1850s, the centre for private locomotive building in Leeds was at Hunslet. One early manufacturer was E. B. Wilson & Co. of Pearson Street, which went bankrupt in 1858. Its designs were purchased by Manning Wardle & Co., whose headquarters were the Boyne Engine Works in Jack Lane, established in 1840. Manning Wardle concentrated on specialised locomotives for contractors; many standard gauge locomotives, along with several sizes of narrow gauge engines, were exported to Europe, Africa, India, Australia, and South America. Employing traditional construction instead of more common methods of mass production, the company gradually became uncompetitive and ceased trading in 1927, having produced more than 2,000 steam locomotives. Manning Wardle's last complete locomotive was no. 2047, a standard gauge 0-6-0ST, which was delivered to the Rugby Cement Company works in August 1926, and is still in existence as a static exhibit at the Kidderminster museum of the Severn Valley Railway. Following closure, all Manning Wardle drawings, designs, equipment, and customers went to Kitson's, who built a further 23 Manning Wardle locomotives.

Kitson's history went back to 1835, when James Kitson opened the Airedale Foundry off Pearson Street with Charles Todd (who had been apprenticed to Matthew Murray at the Round Foundry, Holbeck). The Kitson firm started out building components for other companies until David Laird, a wealthy investor, joined in 1838, changing the company to Todd, Kitson, and Laird. Todd, however, left the firm shortly afterwards to form his own company, and the firm became Kitson and Laird. At this time, the Airedale Foundry began building complete engines for the North Midland Railway and the Liverpool and Manchester Railway.

By 1842, Laird felt that his investment was not receiving as good a financial return as he expected, so he left the partnership. Kitson was then joined by Isaac Thompson and William Hewitson, and the company became Kitson, Thompson and Hewitson. Only a few years later, in 1851, the company won a gold medal at the Great Exhibition for its early tank locomotive. In 1858, Thompson left the company, and Hewitson died in 1863. The firm then became Kitson and Co.

In its 101 year existence, Kitson's built some 5,400 locomotives, including engines for the Midland Railway, the Lancashire and Yorkshire Railway, and the South Eastern Railway. From 1855, Indian railway companies were important customers.

By 1869, Kitson's were building engines for Russia, and five designs were made for the Victoria railways in Australia. Two of these engines were built in Leeds and exhibited in Melbourne (a 0-6-0 tender engine and a 2-4-2T) and earned awards. The remainder of the order were built in the Colonies. A large order or 4-6-0s were built by Kitson's for the Cordoba Railway in Argentina between 1889 and 1891, some or the earliest British examples with this wheel arrangement. Between 1876 and 1901, over 300 steam tram engines and steam rail-motor units were built by Kitson's. Between 1894 and 1935, around fifty Kitson-Meyer 2-8-8-0 and 2-8-8-2 articulated locomotives were built for Chile, Rhodesia, and Jamaica. Also, some 0-8-6-0 locomotives were built for rack railways in the Andes, two or which survive in Chile and one in Argentina.

Although Kitson's remained busy during the First World War, trade fell off badly in the depression years of the 1920s. During this period, an experimental Kitson-Still 2-6-2T steam/diesel hybrid locomotive was tested on the LNER between York and Hull on revenue earning trains, but high research costs meant that Kitson's could not develop the locomotive into a commercially viable form. These research costs contributed to the demise of Kitson and Co.; in 1934, receivers were called in. The company limped on until 1938, when patterns, drawings, and goodwill were transferred to Robert Stephenson and Hawthorn's.

Perhaps the most famous of the Leeds locomotive building companies, bearing the name or the district associated with this industry, was the Hunslet Engine Company, thanks to its famous 0-6-0STs and 0-6-0 diesel shunters. The original company was founded in Jack Lane by John Towlerton Leather in 1864, who served his apprenticeship with his uncle, George Leather, Engineer of the Aire and Calder Navigation and of Goole Docks. The works were purchased for his son Arthur as a potentially good commercial venture. James Campbell, whose father Alexander was running the Manning Wardle Company, became manager, and the two companies collaborated in the manufacture of small industrial locomotives.

James Campbell and his brother, George, bought out the Leather family in 1871. The firm became a private limited company in 1902, and a new works manager, Edgar Alcock, was appointed in 1912. Alcock had been Assistant Works Manager at Beyer-Peacock and had been apprenticed at the Horwich works of the Lancashire and Yorkshire Railway. He became a major shareholder, and director in 1917. When Manning Wardle went into liquidation, part of the Boyne works was bought by Hunslet's, and in 1930 the goodwill of Kerr-Stuart was purchased, along with that or the Avonside Engine Company in 1934. Hunslet Engine Company also worked in cooperation with Robert Hudson & Co. at the same time. Edgar's son, John, became interested in diesel engines, and, having been trained in the business, designed the gearbox for the 90hp Kerr-Stuart diesel engine which had been brought to Hunslet. He went on to propose construction of a standard gauge diesel shunter and received backing by the company. Engine no. 1697 was developed in 1932 and went on to work as a shunter on the LMS until 1943, when it went to war with the army. The engine was then returned to the Leeds factory and was used as the works shunter. It was also John who was responsible for the development of the famous *Austerity* 0-6-0ST.

In 1958, the firm became a public limited company, Hunslet (Holdings) Ltd, being the parent company for the Hunslet Engine Company. Locomotive construction ceased in Leeds in 1961 and the company became part of the Telfos Group in 1987, following an £8.6 million takeover. The Leeds site was sold in 1996 to Schneider of France, and was occupied by Merlin Gerin which was transferred from Meanwood in 1998.

With closure of the Hunslet Engine Company, the long history of engine building in the city came to a close; only preserved locomotives, some on the nearby Middleton Railway, give an indication of how important this industry was to the economy and population of Leeds.

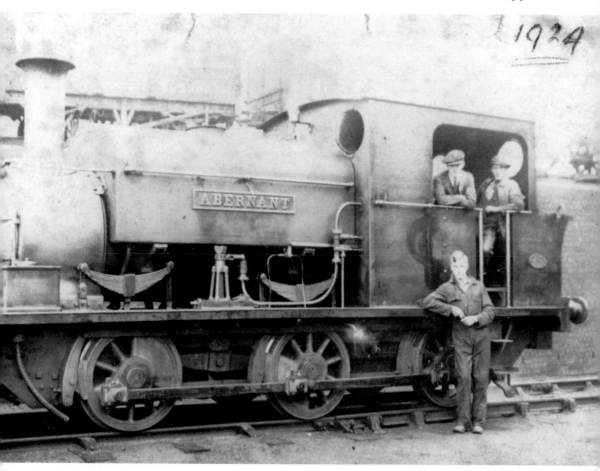

Manning Wardle 0-6-0 saddle tank, with the Welsh name of *Abernant*, was built in 1921 for the Austin Motor Company of Longbridge, Birmingham. It is seen here at the works with its crew in 1924, only three years before the company went into liquidation. Some seventy-three years after the company ceased to exist, the name of Manning Wardle came back into existence thanks to two directors of the Lynton and Barnstaple Light Railway Company, Devon. David Hudson and Brom Bromidge needed an engineering and manufacturing base for the preserved line after taking over an industrial unit at the Old Tannery in Swimbridge, just east of Barnstaple. The company has plans to offer railway construction and maintenance services to other railways and to undertake general engineering work. (Author)

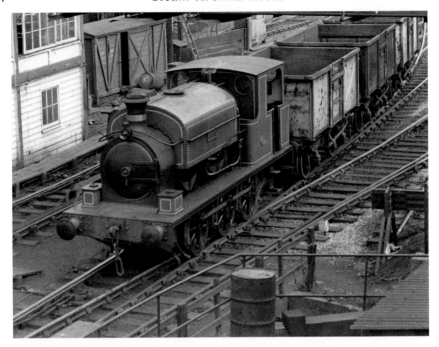

The Austin Motor Company must have been happy with the products of Leeds because here in the 1930s is another example of that city's locomotive products, namely the Kitson built 0-6-0 saddle tank, *Austin 1*, built in 1932. The engine is seen at work transporting empty coal wagons from the foundry and back to the Midland main Birmingham–Bristol line close by. (Author)

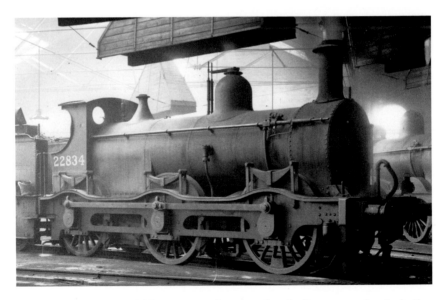

Kitson's went on to build locomotives for several main line companies, including the Midland Railway when the company obtained contracts for Kirtley 0-6-0 goods engines. One of these picturesque locomotives, LMS no. 22834, is seen inside the roundhouse at Bournville locoshed, Birmingham, on 2 March 1935. (H. C. Casserley)

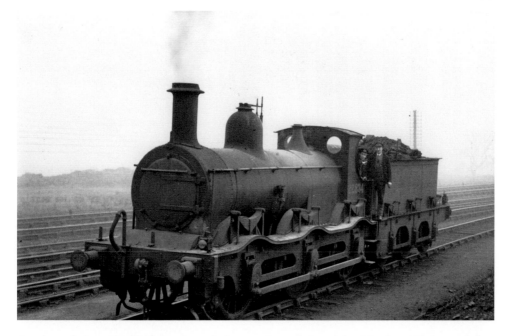

Another of these double-framed goods locomotives, designed by Matthew Kirtley and first produced in 1866. Also seen at Bournville is the same engine with driver and fireman on the footplate. (H. C. Casserley)

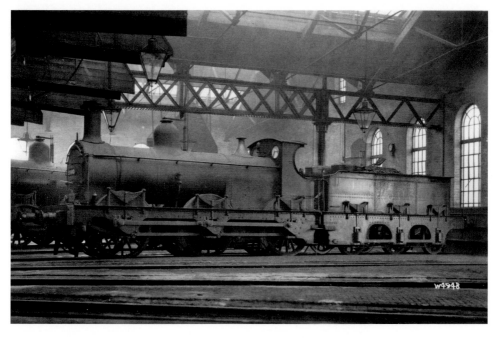

Back in Midland Railway days, another of Kirtley's double-framed goods engines, no. 2303, built by Kitson's, is seen at Bournville shed. The last main line order for large engines to be built at Kitson's was for twelve London and North Eastern Railway 'Improved Director' class 4-4-0s, with cut-down boiler mountings for use on the Scottish system. These engines were classified D11/2 by the LNER and the last one was withdrawn in 1962. (Author)

Another of the products of Kitson's works was 0-6-2T no. 29, built for the Lambton, Hetton, and Joicey Collieries of County Durham in 1904. The rear of the engine is seen in the locoshed at Grosmont of the North Yorkshire Moors Railway in 2007. This was not the first 0-6-2T built by Kitson's; they had built several which went to the Great Central Railway as GCR class A and later LNER class N6. These locomotives were constructed in 1899 for the Lancashire, Derbyshire and East Coast Railway, but they could not afford to pay for all of them, so the final five went to the Hull and Barnsley Railway. At Grouping, they went to the LNER. (Author)

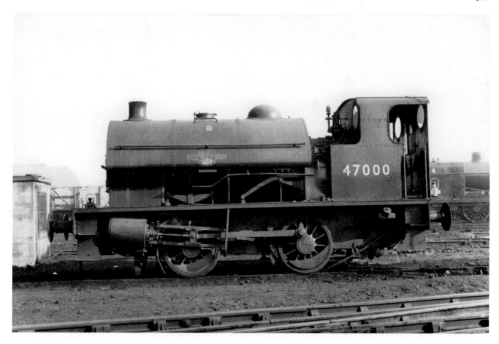

Although the company did not build any more large engines for the mainline companies, they did receive an order from the LMS to build five 0-4-0STs for use as dock shunters in Liverpool, or on colliery and quarry lines which had severe curves, unsuitable for larger shunting engines. The first of these engines, seen here at Derby works as no. 47000, found its way on to the Cromford and High Peak Railway in Derbyshire, and spent most of its working life there. (R. Carpenter)

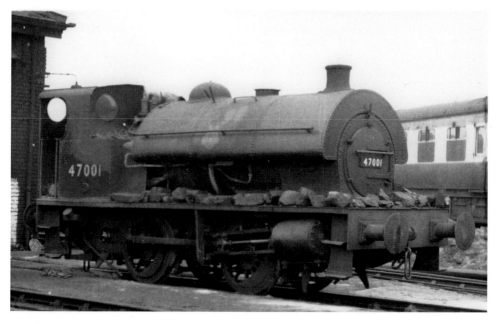

The next few photographs show all five members of the class, with no. 47001 (LMS no. 1541) at an unknown location. (R. Carpenter)

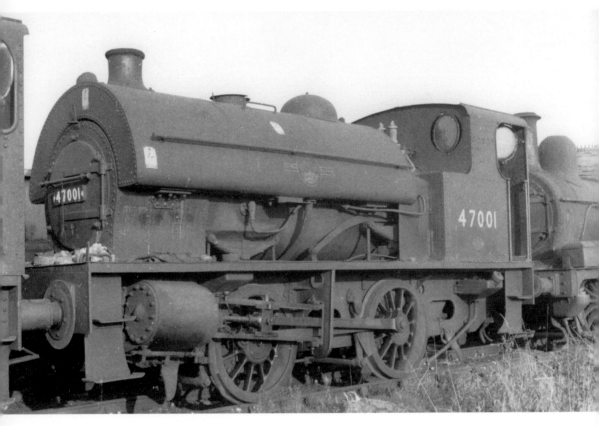

Another view of no. 47001 awaiting withdrawal. These Kitson engines were all withdrawn between 1964 and 1966, no. 47000 probably being the last as it was used on the Cromford and High Peak Railway until its closure in 1966. (R. Carpenter)

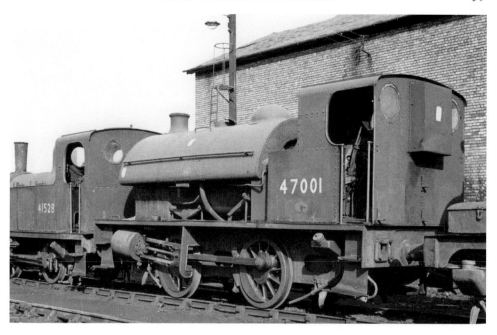

A rear view of no. 47001 as it awaits its fate. (R. Carpenter)

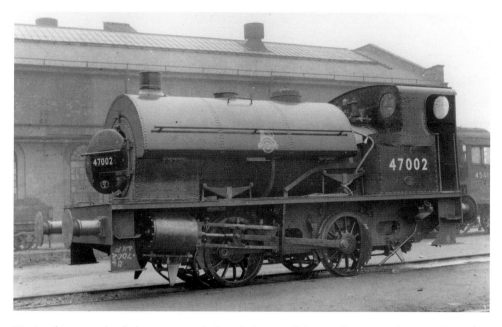

Having been overhauled, no. 47002 is in pristine condition at Crewe works on 6 December 1953. In the background is the cab of Stanier 'Black Five' 4-6-0 no. 45419. (A. Glover)

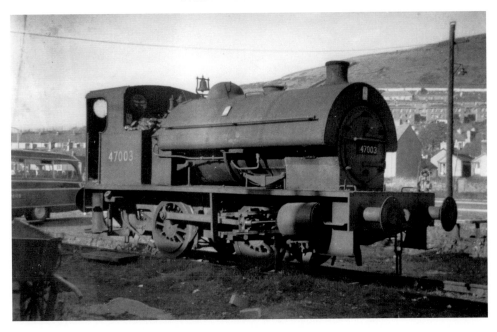

No. 47003 at the foot of the Cromford and High Peak Railway in the 1960s. (R. Carpenter)

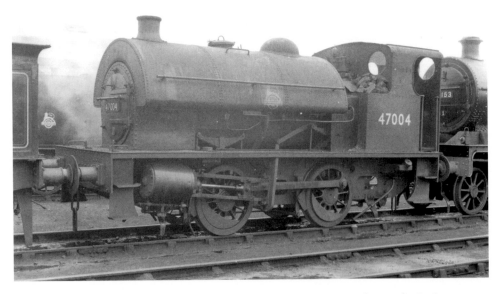

The last member of the class is no. 47004 (LMS no. 1544) at Derby works in June 1953. These locomotives must have been successful as British Railways built a further five examples (47005–47009) with larger tanks at Horwich works between October 1953 and January 1954. These BR locomotives were scrapped between 1963 and 1966. (R. Carpenter)

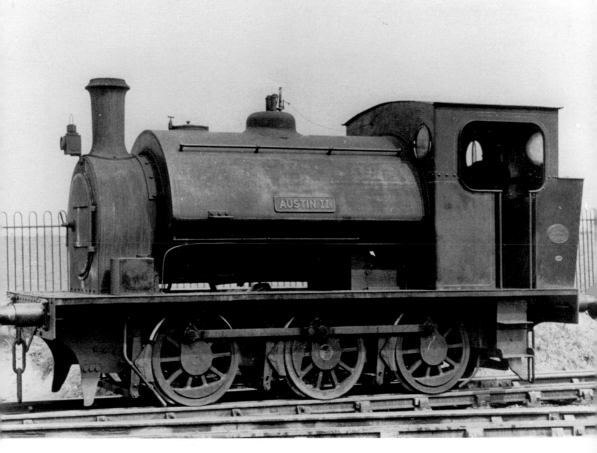

Yet another product from Leeds at the Austin Motor works in Birmingham. This time it is 0-6-0ST *Austin 11*, built at the Hunslet works in 1936. As well as building standard gauge locomotives for industrial use, the Hunslet Company also built a large quantity of narrow gauge engines mostly for slate quarry companies in Snowdonia, North Wales, principally the Dinorwic and Penrhyn quarries. (Author)

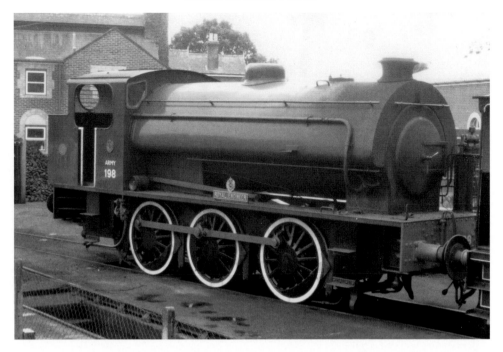

Perhaps Hunslet is best remembered for its 0-6-0 saddle tanks, built for the War Department from 1942, one of which is no. 198 *Royal Engineer*, seen at the Isle of Wight Railway in 2008 as originally built. In the summer of 1942, it was recognised that when the Allied invasion of Europe began, huge quantities of material would have to be transported by rail. Thus, a heavy freight locomotive and a robust shunting engine would be required, which could be operated over both UK and continental railway systems. A meeting was called by the Ministry of Supply, attended by Robert Riddles, Deputy Director-General of Royal Engineers' Equipment, and Edgar Alcock, Chairman of the Hunslet Engine Company, as representatives of the locomotive Manufacturers Association. Locomotives suggested for such work were LMS Stanier 8F 2-8-0 and Fowler 'Jinty' 3F 0-6-0T, but Alcock offered the Hunslet standard industrial 0-6-0ST (the 50550 class) as a more suitable shunter because it would involve less design work to comply with wartime material specifications, with fewer man hours required to build and maintain it, and a stronger frame with shorter wheelbase would give greater route availability. In the end, the Hunslet design won the argument and the rest is history. The final design showed a change in the cab roof profile and the bunker was given a vertical back instead of a raked one to increase coal capacity by five hundredweight. Driving wheel diameter increased to 4 feet 3 inches and the locomotive was to be capable of starting and hauling a freight train of 1000 tons on the level, and negotiating a minimum curve of 2° chains. The first of these locomotives left the Hunslet works on 1 January 1943, after taking 4½ months to build. Contracts for these engines were also placed with Hudswell Clark, Robert Stephenson & Hawthorn, Andrew Barclay & Sons, W. G. Bagnall, and the Vulcan Foundry. In total, some 377 locomotives were built up to 1946. After the war, further locomotives were supplied to the War Department, colliery companies, the National Coal Board, and several steelworks. Altogether, a total of 485 of these 0-6-0STs were built. (J. Thurston)

The nameplate of ex WD Hunslet 0-6-0T no.198 *Royal Engineer* in 2008. This 1953 built 'Austerity' was operated by the Royal Corps of Transport Institute Museum Trust and loaned to the Isle of Wight Steam Railway from 1991. The locomotive was finally given up by the MoD in February 1992, and is now owned by the Isle of Wight Steam Railway at its Haven street depot. (J. Thurston)

The maker's plate for Hunslet locomotive *Royal Engineer*, showing the year of manufacture and its Leeds birthplace. (J. Thurston)

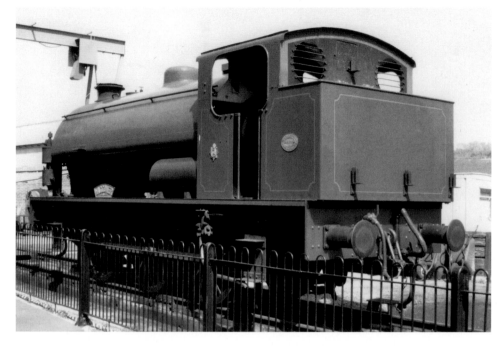

The rear end of a Hunslet 'Austerity' 0-6-0ST, showing the straight back to the coal bunker. This locomotive was owned by the National Army Museum and was on static display at the former Museum of Army Transport in Beverley, east Yorkshire, until it was loaned to the Isle of Wight Steam Railway in 2005. (J. Thurston)

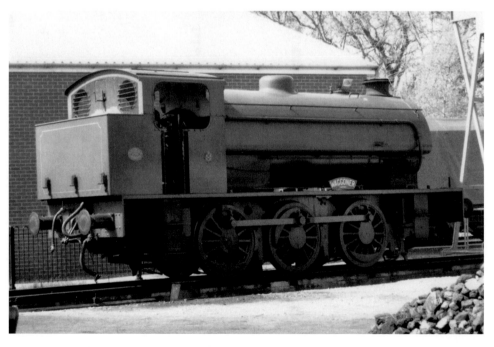

Another view of the same locomotive, no. 92 *Waggoner*. This Hunslet locomotive was originally WD 192 and was restored to working order on the Isle of Wight in 2006. Like *Royal Engineer*, ownership of this locomotive was transferred to the Steam Railway in 2008. (J. Thurston)

The Hunslet Engine Company's maker's plate for *Waggoner*, showing the year of manufacture, the serial number, the size of the cylinders, the name of the manufacturer, and the city in which it was built. (J. Thurston)

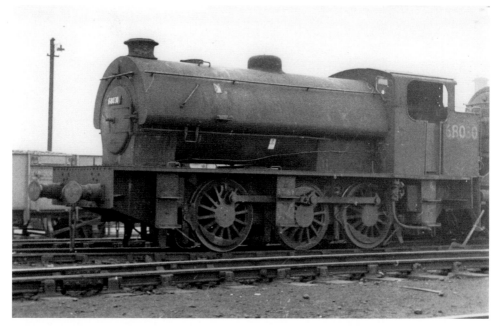

A total of seventy-five ex WD Hunslet 0-6-0STs were purchased by the LNER in 1945, numbered 8006 to 8080 (becoming 68006 to 68080 after nationalisation). Here, ex LNER 0-6-0ST no. 68030 is seen at Derby works on 6 May 1962. When purchased by the LNER they became class J94. (P. Wheeler)

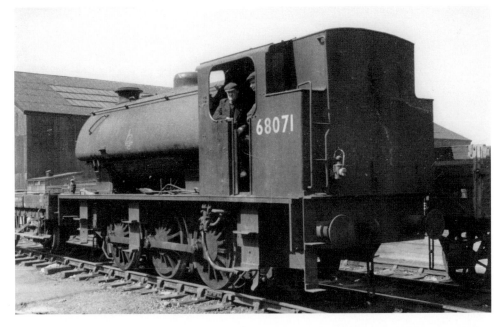

The rear end of J94 0-6-0ST no. 68071 at Gorton works, Manchester, on 2 May 1953. After entering BR ownership, hopper type bunkers were applied to many of the class, as seen in this picture. (H. Wheeller)

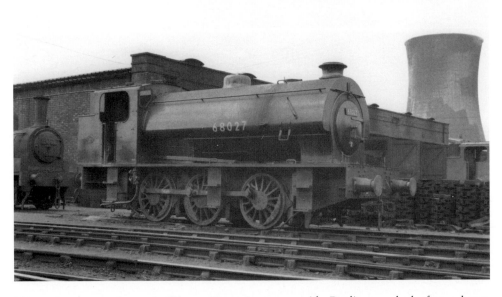

On 22 June 1952, J94 0-6-0ST no. 68027 is seen outside Darlington shed after a heavy overhaul. Many of these engines had their numbers on the tank, while others had them on the bunker. (N. Glover)

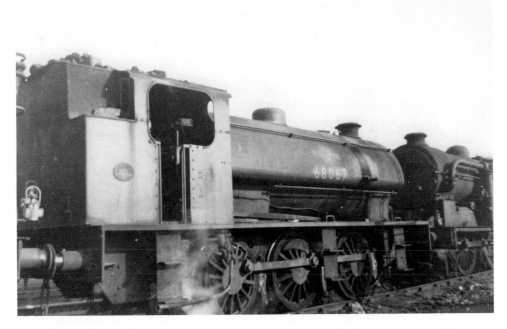

Awaiting her fate is J94 no. 68067 at Hornsey. The withdrawal of the J94s commenced in 1960; the last two, nos 68006 and 68012, lasted until 1967 and were withdrawn when the Cromford and High Peak Railway, where they had been working, closed. (R. Carpenter)

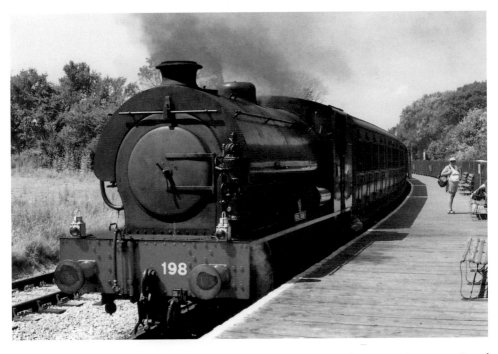

Waiting at Havenstreet with its passenger train is ex WD Hunslet 0-6-05T no. 198 *Royal Engineer*. Many of these engines found their way into preservation, and J94 no. 68077 has been preserved on the Keighley and Worth Valley Railway. (J. Thurston)

Ex WD 0-6-0ST no. 198 at Haven street shed in 2008, in company with another ex WD locomotive, *Invincible*, from the Woolwich Military Railway. (J. Thurston)

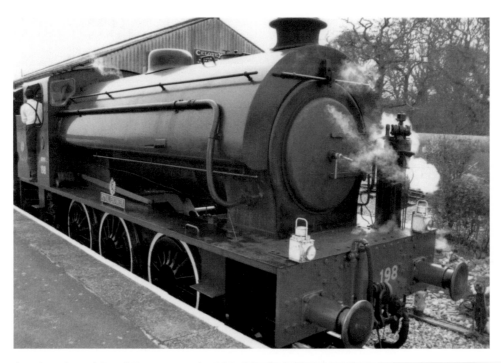

Another view of *Royal Engineer* on the Isle of Wight Railway. (J. Thurston)

Rear end of no. 198 with 0-4-0ST *Invincible* at the shed. (J. Thurston)

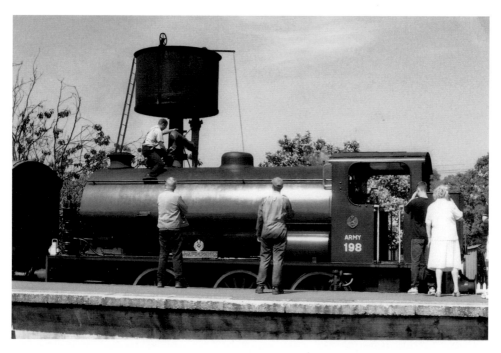

No. 198 takes water at Haven Street in 2008, watched by a few admirers. (J. Thurston)

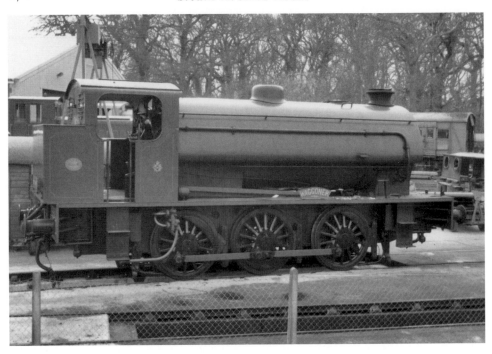

A side view of Hunslet 0-6-0 ST *Waggoner* on shed at the Isle of Wight Steam Railway.
(J. Thurston)

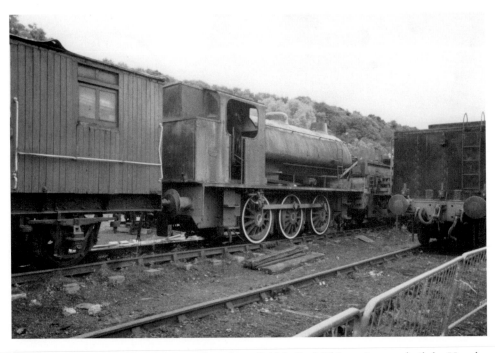

Another ex WD 0-6-0PT, *Antwerp*, on loan from British Coal. This engine was built by Hunslet
in 1944 and was operated by the Wheldale Colliery in west Yorkshire. (B. Unsworth)

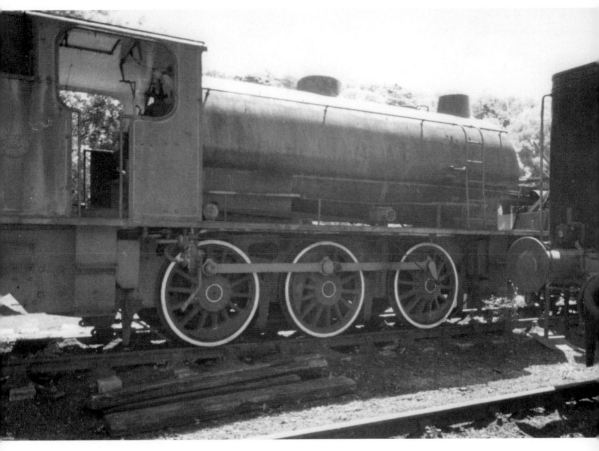

A close up view of *Antwerp* awaiting restoration at Grosmont on the North Yorkshire Moors Railway. (B. Unsworth)

37 H.P. "HUNSLET" DIESEL LOCOMOTIVE
0-4-0 TYPE

LEADING DIMENSIONS etc. when made for a Rail Gauge of 3 ft. 3⅛ in.

Diameter of Wheels	2 ft. 0 in.
Wheelbase	3 „ 6 „
Weight in Working Order	7 tons 9 cwts.
Fuel Capacity	16 gallons.
Weight of Lightest Rail	28 lbs.
Radius of Sharpest Curve	45 ft. is the minimum, double this if an easy curve is wanted.
Number of Speeds	3 forward and 3 reverse.
Speeds	3, 6, and 9 miles per hour.
Tractive Effort at 3 miles per hour	3,930 lbs.
„ „ 6 „ „	1,965 „
„ „ 9 „ „	1,310 „

NOTE—The Locomotive can be built to give 2, 3, or 4 speeds ranging from 3 m.p.h. (tractive effort 3,930 lbs.) to 16 m.p.h. (tractive effort 735 lbs.). The Engine is capable of delivering 40 h.p. for short periods.

Approximate Loads (in tons of 2,240 lbs.) hauled in addition to Locomotive, based on Wagons with a Rolling Resistance of 20 lbs. per 2,240 lbs.						
Speed m.p.hr.	Level	1 in 200	1 in 100	1 in 75	1 in 50	1 in 30
3	189	118	85	71	53	34
6	91	55·5	39	32	23	13
9	58	35	23·5	19	13	6·5

Ratio of Adhesive Weight to Tractive Effort	4·25 to 1
Height Overall	9 ft. 4¹⁄₁₆ in.
Width Overall	5 „ 9 „
Length Over Buffer Beams	9 „ 10½ „

NOTE—When sending inquiries please state Rail Gauge and Modifications (if any) **required.**

ROBERT HUDSON LIMITED *Light Railway Engineers* **LEEDS**

Sheet RH 25 2000 1 35 **Order 47440**

In the 1930s, the Hunslet Company took an interest in diesel engines as motive power for railway systems. Here, a 37hp 0-4-0 diesel shunter is being advertised. This example was built for a 3 feet 31/8 inch gauge railway. (Author)

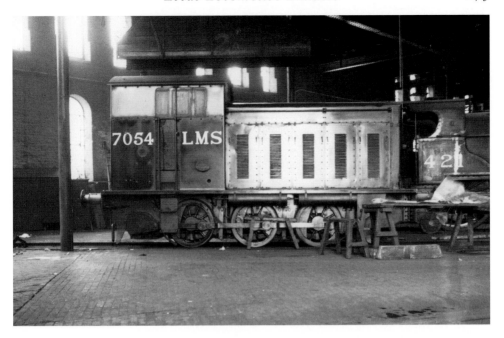

By the mid 1930s, the LMS was developing an interest in using diesel engines for shunting purposes, and several types were experimented with. Here, Hunslet 0-6-0 diesel shunter no. 7054 is seen at Holbeck shed, Leeds, on 14 July 1935. (LOSA)

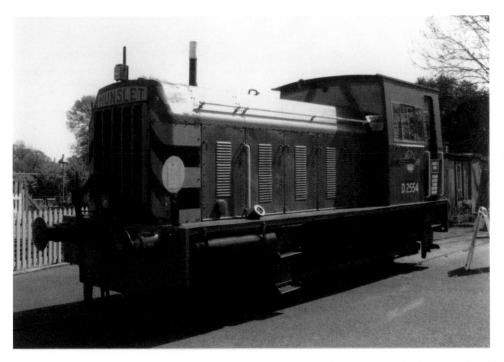

Preserved on the Isle of Wight Steam Railway is another of the Hunslet-built 0-6-0 diesel shunters, BR no. 02554, seen here in 2009. (J. Thurston)

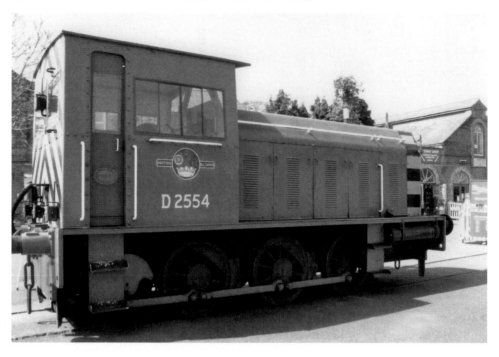

A side view of Hunslet 0-6-0 diesel shunter no. D2554 at the Isle of Wight. (J. Thurston)

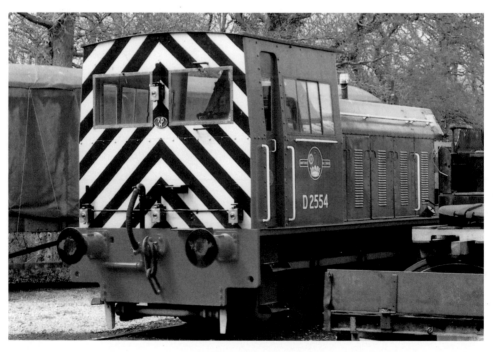

A rear view of no. D2554 at the Isle of Wight. (J. Thurston)

THE PRESERVATION STORY

Along with the Bluebell Railway in Sussex, two railways in the West Riding were pioneers in preserving standard gauge railways at a time when BR was closing much of its system. The first of these was the Middleton Railway in Leeds, following the running of a special train from Moor Road to Broom Pit and back to celebrate the line's bicentenary in June 1958. The railway has a special place in history. It was the first to be authorised by an Act of Parliament in 1758, the first to use steam locomotives, and the first standard gauge line to be operated by unpaid volunteers. Such was local interest in the railway that, by September 1959, a group of local enthusiasts from Leeds University were determined to save the line as a working museum. This resulted in the formation of the Middleton Railway Preservation Society, becoming the 1758 Middleton Railway Trust in 1962.

As early as 18 June 1960, the Middleton Railway was reopened with the running of a diesel hauled special. Although no plans had been made to operate the railway on a regular basis, two companies, Robinson & Birdsell and Clayton's, agreed to use the railway, and a daily diesel hauled service was introduced. The Middleton Railway also operated a commercial goods service for private sidings belonging to companies along the original route; it was the first preserved railway to do this. Another first for the line was its status as the first standard gauge line to be opened by enthusiasts.

Initially, passenger services ran for only one week, using an ex Swansea and Mumbles double-decker tram, with regular trains only beginning in 1969, using one steam or diesel locomotive. Open wagons were used to carry passengers until two vans were converted to coaches. Commercial freight services continued until 1983.

The Middleton Railway was closed for the first time in its history in 2005 for a short period, the Heritage Lottery Fund having given the railway a £37,000 grant to build an improved visitor and education centre at the Moor Road Hunslet site. The line was reopened in 2006, when the centre had been completed, and operates passenger trains over a distance of around a mile from Moor Road to Park Halt, on the outskirts of Middleton Park.

In the same year that the 1758 Middleton Railway Trust came into being, the Keighley and Worth Valley Railway Preservation Society was formed in an attempt to save the 5 mile line from Keighley and Oxenhope, following a public meeting at Keighley on 24 January 1962, the line having been closed to passengers the previous year. Such was the support that a further meeting, on 1 March 1962, allowed the formation of the society. The hope was that the line could be rented from BR and finance could be raised by operating a freight service. However, BR withdrew all freight traffic and wanted outright sale of the branch. Negotiations were then undertaken and BR finally agreed that the society could purchase the branch from Bridge 5 at Keighley to Oxenhope for £34,000, to be paid over twenty-five years. In April 1966, after the society had become a limited company, BR allowed the railway to buy the Worth

Valley side of Keighley station, and the contract was signed on 6 April 1967. A Light Railway Order to operate trains over the branch was obtained by BR on 16 October 1967, and transferred to the KWVR on 27 May 1968. After official inspection of the branch and its rolling stock on 8 June, reopening was set for 29 June 1968, just 101 years after the ceremony to open the original line.

The first public KWVR train departed from Keighley station at 2.35 p.m. hauled by ex BR Ivatt 2-6-2T no. 41241 (in crimson lake livery and lettered K&WVR), along with USA 0-6-0T no. 72, in golden brown with silver smoke box. Both locomotives still operate over the branch. Initially, services were confined to weekends, with diesel rail buses working early trains and steam taking over in the afternoons. Winter services quickly dwindled to a small locomotive and single coach. By 1969, the railway's fortunes began to improve as people became aware of its existence and, in 1970, investigations were made to increase the branch's capacity. A loop was laid at Damems in 1971, as more locomotives and coaches arrived. Over the next decade, the railway developed into a major tourist attraction. As traffic increased, ex main line locomotives arrived from Barry scrapyard for restoration, and more coaches arrived from BR.

The yard and goods shed at Haworth were converted into a workshop and locoshed, while Oxenhope became the workshop for wagons and carriages, a small museum also being established here. All of the stations on the branch received much needed maintenance, but Ingrow was so derelict that its buildings were demolished and replaced by those from the closed Foulridge station on the old Skipton–Colne line. Damems station had originally closed to traffic in 1949, but it was reopened by the KWVR in 1971, using the Checker's Hut from Keighley goods yard as a ticket office and a signalbox from Earby Gates (ex Skipton–Colne line) to control signals and the loop. Ingrow became headquarters of the Vintage Carriage Trust, and the Bahamas Locomotive Society developed its own workshop here when the Dinting Railway Centre was closed.

Nowadays, the line is marketed as an example of a 1950s London–Midland Region branch, with locomotives and rolling stock in authentic liveries, replacing the 'house style' originally used when the railway was first run.

Keighley station is shared between the electrified Leeds–Skipton main line, who use old BR platforms one and two, while old platforms three and four are now the terminus of the preserved Worth Valley Railway. Thus, it is possible to cross the footbridge from the 'shiny' modern electric railway and have the unique experience of travelling back in time to the 1950s, into an 'old-fashioned' world of newspaper kiosks, booking offices, old station signs, numerous uniformed station staff and, of course, ex BR steam trains operated by the KWVR.

The shed yard at the Middleton Railway, Leeds, on 17 May 2009, with ex LNER class Y7 0-4-0T no. 68153 undergoing restoration. This was the only locomotive in the fleet that was used on the main line system. The railway owes its existence to coal deposits below open fields to the south of Leeds. As early as 1646, a coal mine existed in Middleton. By 1717, one Ralph Brandling was owner of a coal mine at Middleton, and it was he, in 1755, who obtained powers to build a 960 feet long wagon-way on Woodhouse Hill Lane for better access to the River Aire. So large was the output of coal that Brandling obtained a private Act of Parliament, on 9 June 1758, to construct a railway to supply coal to Leeds which, by 1801, was the eighth largest town in Britain, with a population of some 53,000. (Author)

Saddle tanks at the Middleton Railway yard awaiting fitting to relevant locomotives. In 1862, Brandling Estates was sold to Tetley Co., who formed the Middleton Railway Estate and Colliery Company, the gauge then being 4 feet 1 inch. Two 0-4-0STs were built locally by Manning Wardle in 1866 and 1869. The line was regauged to 4 feet 8½ inches in 1881, and a link to the Midland Railway was completed in 1895. The GNR opened a connection with the Middleton Colliery near New Pit at around the same time. (Author)

This is another of the Middleton Railway's locomotives awaiting restoration. When the mines were nationalised, the Middleton came under the control of the National Coal Board and the line was used by Hunslet to test its locomotives before they were sold to customers. The NCB cut back the railway as coal mines were worked out and road transport made the railway uneconomic. Closure became inevitable, but, as can be seen, the little line did survive as testament to the fact that this was the first railway to be given an Act of Parliament. (Author)

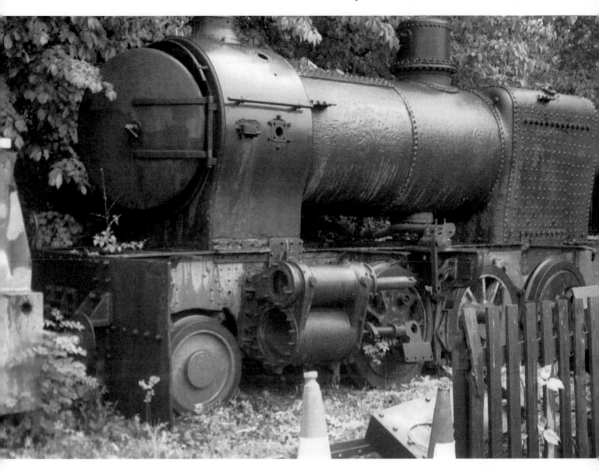

Awaiting restoration at Middleton is Hunslet 2-6-2T *Picton*, built in 1927, on 17 May 2009. Steam traction on the Middleton Railway arrived out of necessity. Demands of the Napoleonic Wars meant that the cost of horses and fodder to operate the wagon-way was increasing rapidly; the invention of a rack railway by a local man, John Blenkinsop, was allied to Matthew Murray's first steam locomotive, solving these financial problems. Indeed, Murray's locomotive was capable of doing the work of thirteen horses and could pull twenty-seven wagons at 3 mph. The first two locomotives went into service on 12 August 1812. By 1827, an inclined line built from Belle Isle to Middleton village and, by 1832, a rail link existed between Fanny Pit, New Lane, and the top of the incline. By 1840, the line had been extended to West Pit. (Author)

The interior of the locoshed at the Middleton Railway on Sunday 17 May 2009.
At this time the following locomotives were in the railway's collection:

Steam Locomotives
68153 ex LNER Sentinel 4wVBGT, built 1933
1310 NER 0-40-0T, built 1891
2702 Bagnall 0-4-0ST, built 1943
53 *Windle*, Borrows 0-4-0WT, built 1909
1309 *Henry De Lacy II*, Hudswell Clark 0-4-0ST, built 1917
6 Hawthorn Leslie 0-4-0ST, built 1935
385 Ex DSB Hartmann, Chemnitz 0-4-0WT, built 1895
2003 *John Blenkinsop*, Pecket 0-4-0ST, built 1941
1882 *Mirvale*, Hudswell Clark 0-4-0ST, built 1955
1625 Cockerill 0-4-0VBT, built 1890
1210 *Sir Berkeley*, Manning Wardle 0-6-0ST, built 1891
2387 *Brookes No.1*, Hunslet 0-6-0ST, built 1941
1369 Manchester Ship Canal No. 67 Hudswell Clark 0-6-0T, built 1921
2103 Peckett 0-4-0ST
1601 *Matthew Murray*, Manning Wardle 0-6-0ST, built 1903
1684 Hunslet 0-4-0T, built 1931
1540 *Picton*, Hunslet 2-6-2T, built 1927
1493 Hunslet 0-4-0ST, built 1925

Diesel Locomotives
1697 *John Alcock*, ex LMS Hunslet, built 0-6-0DM of 1932
3900002 Fowler 0-4-0DM, built 1945
1786 *Courage*, Hunslet 0-4-0DM, built 1935
631 *Carroll*, Hudswell Clark 0-4-0DM, built 1946
577 *Mary*, Hudswell Clarke 0-4-0DM, built 1932
138C Thomas Hill 0-4-0DH, rebuilt 1965
91 Brush/Beyer Peacock 0-4-0DE, built 1958
OB998901 *Olive*, Drewry car, built 1950
5003 Beckett 0-4-0DM, *Austin No.1*
420452 Greenwood and Batley Cokke Oven locomotive, built 1979

Many of the locomotive stock at the Middleton Railway were locally built and have become a
record of the steam and diesel locomotives built by Leeds locomotive builders. (Author)

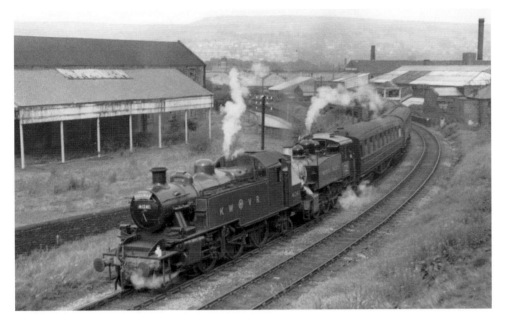

The first train to leave Keighley station with its train for the Keighley and Worth Valley Railway on 29 June 1968 at 2.35 p.m., with ex BR Ivatt 2-6-2T no. 41241, in crimson lake livery and sporting the 'KWVR' lettering and crest, and USA 0-6-0T no. 72 in golden brown with silver smokebox at the head. From these humble beginnings, the railway began to develop. (LOSA)

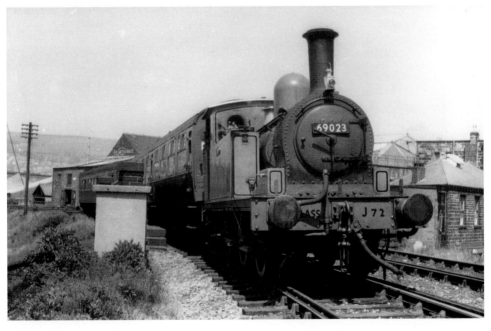

The ex BR North East Region J72 0-6-0T no. 69023 departs from Keighley with a train for Oxenhope in the early days of preservation. After a quiet start to preservation, services picked up considerably over the next few years; by the end of the 1970s the K&WVR was running some 2,000 trains during the summer season. (LOSA)

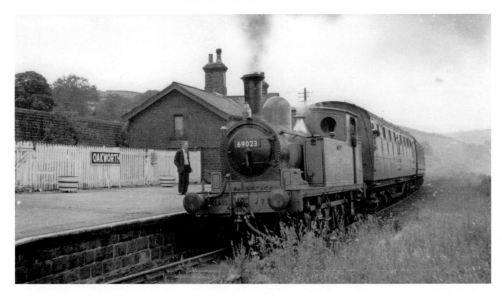

Waiting at Oakworth station is another view of J72 no. 69023 with its train for Oxenhope. Oakworth is well remembered as the station used in Edith Nesbitt's novel *The Railway Children*; the scene with 'Perks' the station porter rushing around closing level crossing gates and awaiting 'the express' as he meets the children for the first time is one of the famous parts of the film, as is the emotional ending. The K&WVR insisted that the station name should not be changed when the film was made, and it did much to attract visitors to the railway following its release in 1970. Indeed, such was the interest in the film that, in 1971, some 125,000 passengers were carried over the line and Oakworth became winner of the 'Best Preserved Station' in that year. (LOSA)

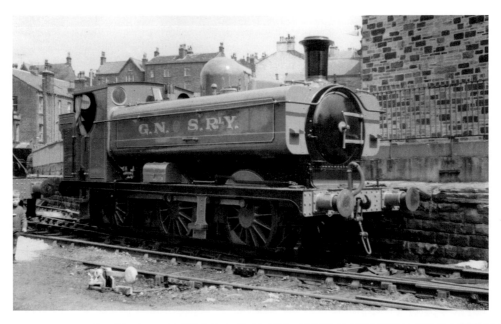

Preserved ex GWR 0-6-0PT was used in the making of *The Railway Children*; it was repainted in a brown livery and lettered 'GN&SRY', as can be seen in this view at Haworth in 1970. (LOSA)

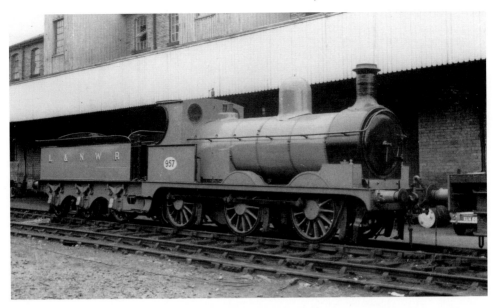

In the early days of preservation, the K&WVR came up with some rather 'garish' liveries for its locomotives. Here, at Haworth, ex L&YR 2F 0-6-0 no. 52044, built in 1887, is seen in a speculative LNWR livery with no. 957 on the cabside. Along with *The Railway Children*, the railway has been used for several feature films and television programmes, including *Yanks*. Having USA type locomotives here would have helped to create a sense of the wartime period as this film was set at the time of the D-Day landings. Television programmes include *Last of the Summer Wine* and *Some Mothers Do 'Ave 'Em*. (LOSA)

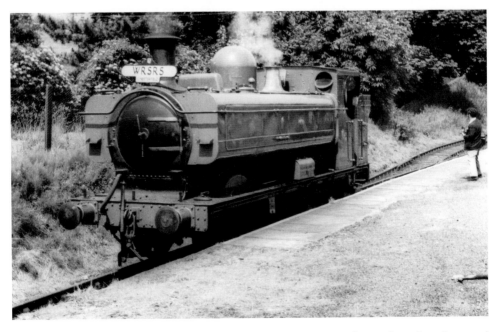

At the terminus of Oxenhope, ex GWR 0-6-0PT no. 5775 is seen shorn of number plates and painted in readiness for its role in *The Railway Children*. (LOSA)

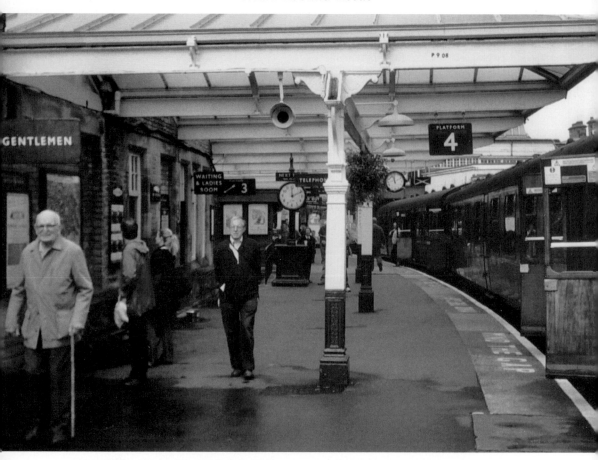

The start of the K&WVR is at Keighley station, seen here on 30 June 2009. This old Midland Railway station has been restored to give the impression of an LMR station of the 1950s; it can be compared with the modern 'Network Rail' station next door. There are several period features at the station, made up of structures imported from other British railway stations. The booking office was a Findlay's tobacco kiosk from Manchester Central station, while the ticket collector's box was a telephone box from Wakefield Kirkgate station. The station seats are ex LNWR, but the platform canopy, of MR 'ridge and furrow' design, is original to the station. The signalbox came from Shipley. (Author)

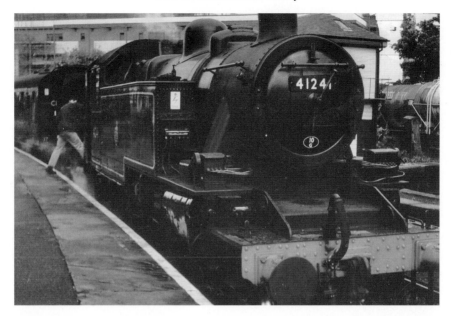

About to depart from Keighley is ex BR Ivatt 2-6-2T no. 41241, the very engine which operated the first public train from here in 1969, though it has been restored to its original BR black livery with 'cycling lion' crest. In recent years, Keighley station has been used in a television advertisement for shampoo, trying to recreate a scene from the 1940s film *Brief Encounter*, only, this time, using a BR 2-6-4T no. 80002. (Author)

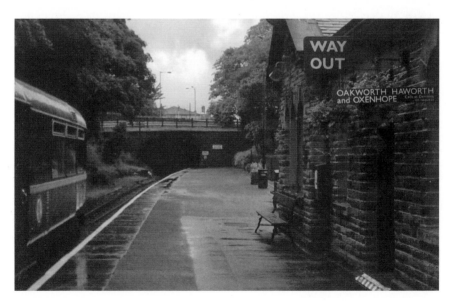

On a wet day in June 2009, the railway's little diesel railcar arrives at Ingrow West station, first on the line out of Keighley, just over a mile away. Until 1955, there used to be another station at Ingrow which belonged to the GNR's line from Keighley to Queensbury. Initially, Ingrow West was only a Halt, but in the 1980s funds were raised to purchase the old MR station buildings at Foulridge, on the Skipton–Calne line, which were rebuilt here. A building at the end of the yard at Ingrow West is the home of the Vintage Carriage Trust where several Victorian carriages are kept, many of them used for filming. (Author)

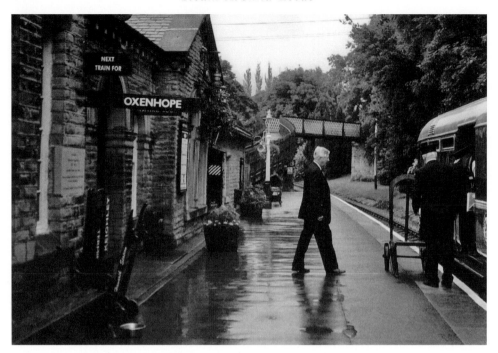

After leaving Ingrow West, the railway climbs and passes Damems station, now fully restored, having been closed by BR in 1949, followed by Oakworth. The line then enters Mytholmes Tunnel, where the 'railway children' met, by chance, the owner of the railway. The line then enters Haworth station. Famous as the home of the Brontë family, Haworth is also the location of the locomotive works and engine shed, where a collection of locomotives are kept. In 2004, the collection was as follows:

Ex MR 4F 0-6-0 no. 43924
Ex LMS 2MT 2-6-2T no. 41241
Ex LMS 5MT 4-6-0 no. 45212
Ex LMS 'Jubilee' class 4-6-0 no. 45596, *Bahamas*
Ex LMS 8F 2-8-0 no. 48431
Ex LMS 3F 0-6-0T no. 47279
Ex LNWR 0-6-2T no. 1054
Ex SR USA 0-6-0T no. 30072
Ex SR 'West Country' class 4-6-2, *City of Wells*
Ex BR 4MT 2-6-4T no. 80002
Ex BR 4MT 4-6-0 no. 75078
Ex BR 2MT 2-6-0 no. 78022
Ex GWR 5700 class 0-6-0PT no. 5775
Ex L&Y 2F 0-6-0 no. 52044
Ex L&Y Pug 0-4-0ST no. 19
Ex L&Y Pug 0-4-0ST no. 51218
Ex L&Y 0-6-0ST no. 752
Ex TVR 02 class 0-6-2T no. 85
Ex USATC S160 class 2-8-0 no. 5820
Ex MoS WD 2-8-0 no. 90733
Ex LNER J94 class 0-6-0ST no. 68077
Ex BR 0-6-0DE no. D226
Ex BR 0-6-0DM no. D2511
Ex BR 08 class 0-6-0DE no. 03336

Ex BR 25/1 class Bo-Bo
Ex BR class 20 Bo-Bo no. D8031
Ex BR class 108 DMBS no. 50928
Ex BR 108 class DMC no. 51565
Ex W&M Railbus no. 79962
Ex W&M Railbus no.79964

Industrial Locomotives

31 *Hamburg*, Hudswell Clarke 0-6-0T
Nunlow, Hudswell Clarke 0-6-0T
118 *Brussels*, Hudswell Clarke 0-6-0ST
Tiny, Barclay 0-4-0ST
Merlin, no. 231 Hudswell Clarke 0-6-0DM
MDHB No. 32 Hunslet 0-6-0DM

(Author)

From Haworth, the next station on the line is at Oxenhope, terminus of the K&WVR, seen here on 30 June 2009. This station was fully restored in the 1980s; the original plan was to have the Locomotive Department here, but plans were altered and the old goods shed at Oxenhope was extended and used for carriage restoration. An exhibition centre is now on the site, with locomotives awaiting restoration on view, along with historic carriages. (Author)

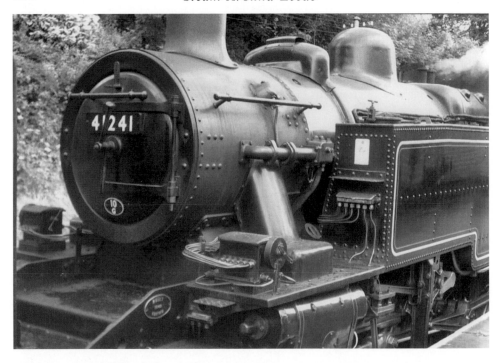

Waiting to depart for Keighley is ex BR 2-6-2T no. 41241 at Oxenhope. (Author)

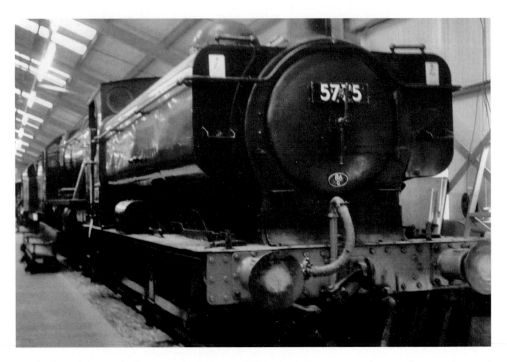

Inside the exhibition hall at Oxenhope is ex GWR 0-6-0PT no. 5775, the very locomotive used in the film *The Railway Children*. (Author)

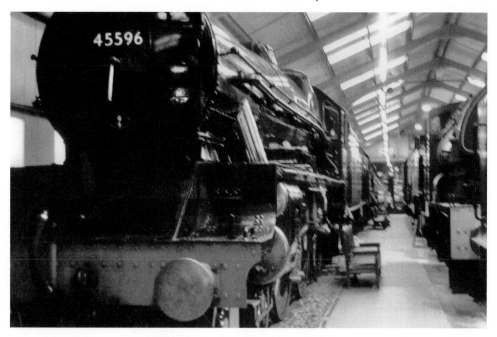

Seen in the exhibition hall at Oxenhope on 30 June 2009 is ex LM5 Stanier 'Jubilee' class 4-6-0 no. 45596 *Bahamas*. The Bahamas Locomotive Society moved to the K&WVR after Dinting Railway Centre was closed. It established its own workshops at Ingrow West, where a small museum exists and the society's engines are restored. (Author)

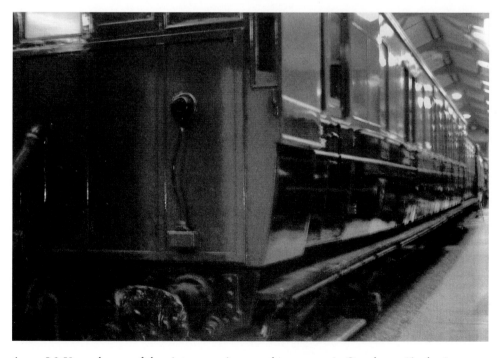

An ex L&Y coach, one of the vintage carriages at the museum in Oxenhope. (Author)

The L&YR crest on a carriage at Oxenhope, the old railway operating in the West Riding of Yorkshire. (Author)

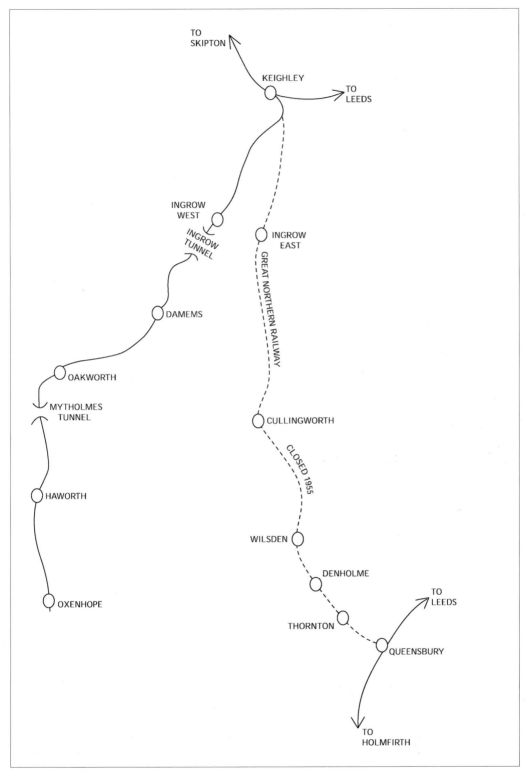

A map of the preserved Keighley and Worth Valley Railway, with the old GNR line between Keighley and Queensbury to the right, which was closed in 1955. (Author)

ACKNOWLEDGEMENTS

It is with grateful thanks that I acknowledge the many people who assisted in bringing together this rather complex project; without their help and support, I would have faced great difficulties. Among the organisations who offered assistance, whether knowingly or not, were: The West Yorkshire Archive service, Leeds; Leeds Central Library; Scarborough Library; and the staff at the Keighley and Worth Valley Railway, who were very patient when dealing with my many questions. It was, indeed, a pleasure to ride on the railway when doing my research, and I hope to be back there soon to enjoy its delights once again. Individual assistance was given by Sandra Bates who spent much of her very valuable time searching for information on the internet on my behalf, and to her husband, Richard, who drove me around areas in west Yorkshire and showed me many points of interest, being very patient with me as I asked many questions and passed comments. My thanks also go to Bernard Unsworth, who undertook the work of finding the various locoshed allocations, and there were plenty of them in the West Riding. And to other individuals who provided pictures and other information, including John Thurston, William Arthur, LOSA, and Roger Carpenter. I should also like to thank Hilary for allowing me to take over the dining table and cover it with bits of paper, photos and other items; she can now have it back to use for its original purpose. My thanks go to Gary and I hope that he has finally passed his nursing exams, despite not being a lot of help while attempting to complete the project, and to my colleagues at Bridlington Hospital who have been bored, no doubt, as I have been muttering about where the book is going.

To all, and the many that I may not have mentioned, I offer my grateful thanks for your patience.